Speedlights & Speedlites

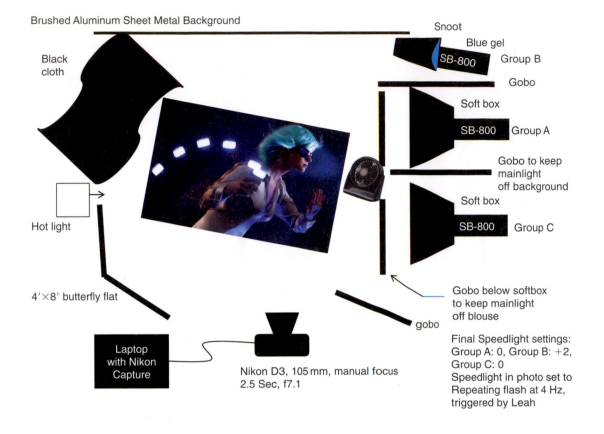

Brushed Aluminum Sheet Metal Background

Snoot

Blue gel

SB-800 Group B

Black cloth

Gobo

Soft box

SB-800 Group A

Gobo to keep mainlight off background

Soft box

SB-800 Group C

Hot light

4′×8′ butterfly flat

Gobo below softbox to keep mainlight off blouse

gobo

Laptop with Nikon Capture

Nikon D3, 105 mm, manual focus
2.5 Sec, f7.1

Final Speedlight settings:
Group A: 0, Group B: +2,
Group C: 0
Speedlight in photo set to
Repeating flash at 4 Hz,
triggered by Leah

Traveling at Lightspeed

We mulled over the cover of this book for quite a while and rejected a lot of ideas. By accident I struck upon featuring the Speedlight in the photograph. I also wanted to incorporate a number of the techniques that we talk about on the pages of this book. But like everything, it all comes down to money. There was a budget. We searched a lot of models' portfolios to find the perfect subject. In the end I pressed my studio manager into service.

I wanted to imply movement. We handled this in a couple of ways: the photograph was shot on a slant so the woman's hair hung at an angle. We used a fan to add to the illusion. A tungsten light was placed behind the model to create some blur.

Four Speedlights, in three groups, doing separate jobs: lighting her face and hair with daylight; adding the comet-like background light; emphasizing the blue color but keeping it off her face. The trick was timing when to have Leah initiate the stroboscopic Speedlight in her hand each time we made an exposure.

We used lots of gobos to keep each light from "contaminating" the others. So there was a great deal of fine tuning. But the whole shot was done in about twenty exposures which is a testament to the methods we have at our fingertips today.

Speedlights & Speedlites

Creative Flash Photography at Lightspeed

Lou Jones

Bob Keenan

Steve Ostrowski

AMSTERDAM • BOSTON • HEIDELBERG • LONDON • NEW YORK • OXFORD
PARIS • SAN DIEGO • SAN FRANCISCO • SINGAPORE • SYDNEY • TOKYO
Focal Press is an imprint of Elsevier

Focal Press is an imprint of Elsevier
30 Corporate Drive, Suite 400, Burlington, MA 01803, USA
Linacre House, Jordan Hill, Oxford OX2 8DP, UK

Library of Congress Cataloging-in-Publication Data
Application submitted

British Library Cataloguing-in-Publication Data
A catalogue record for this book is available from the British Library.

ISBN: 978-0-240-81207-6

For information on all Focal Press publications
visit our website at www.elsevierdirect.com

09 10 11 12 5 4 3 2 1

Printed in Canada

Contents

Speed of Light ..viii

Color Coding Key ...ix

Ten Tenets of TTL Speedlights ..x

Introduction ..xi

The Authors ...xiv

Chapter 1: One Light ..1
 TTL Flash ...2
 Electronic Flash: Definition ..2
 Speedlight/Speedlite: Definition3
 Fundamentals of Electronic Flash9
 Comprehending Flash Exposure11
 TTL Electronic Flash: Definition14
 TTL Exposure System ...16
 TTL Flash and Exposure: A Primer16
 TTL Flash and Aperture ...17
 TTL Flash and Distance ...17
 Inverse Square Law ..18
 TTL Flash and Subject Size ..20
 TTL Flash and Shutter Speed: Synchronization20
 TTL Flash: Flash Anatomy and Features20
 Speedlight Components ..20
 The LCD ...30
 Measuring Light ...31
 Understanding the Light Meter32
 Stops, F/Stops, Exposure Value35
 Histogram ...40
 RGB Histogram ..43
 Exposure Bias for Digital ..44
 Middle Tonal Value ...44
 Exposure Compensation ...44
 Excessive Contrast ...45
 Mastering Distance: Near and Far46
 Main Light and Fill Light: Definitions48
 Philosophy ..50

Light .. 50
Characteristics of Light: Analysis and Decisions 54
Quantity, Intensity, or Brightness 54
Quality .. 56
Contrast .. 61
Color ... 62
Color Spaces and the Color Triangle 65
Direction .. 67
Mixing TTL Flash with Available Light: Quantities
of Light ... 68
Available Light as Main ... 68
TTL Flash as Fill .. 68
TTL Flash as Main ... 70
Available Light as Fill .. 71
General Guidelines .. 73
Balancing TTL Flash and Available Light: Colors
of Light ... 73
Bounce Flash: Direction and Quality of Light 75
Moving Light ... 77
Comprehending Directions of Bounce Flash 77

Chapter 2: Two Lights ... **87**
Light .. 89
Lighting ... 91
Design .. 91
Execute ... 92
Review .. 92
Postproduction .. 92
Wireless .. 96
Wireless TTL: Remote/Slave Flash 96
Wireless TTL: Additional Trigger Devices Need
Not Apply! .. 96
Nikon SU-4 Mode ... 97
Wireless TTL Transmitters: Master 99
Wireless TTL Receivers: Remote/Slave 99
Wireless TTL Communication: Line of Sight 102
Wireless TTL: Remote/Slave ID Groups 105
Wireless TTL: Channels ... 106
Wireless TTL: Privacy .. 108
Travel ... 108
Wireless TTL: Basic Settings for Master and Slave 110
Wireless TTL: Controlling Exposure and Contrast 112
Manual Flash ... 121
How It Works .. 121
Flash LCD ... 126
Wireless Manual Flash ... 128

Mixing Speedlights with Studio Flashes..129

Modifying Flash: Quality of Light132

Softboxes: Notes ...132

Equipment, Accessories, Products ...136

Equipment...137

Batteries: Powering the Flash ..144

Battery Types: Power Decisions145

Accessories ...147

Summary ..**153**

Lighting Diagrams ..**155**

Index ...**201**

Speed of Light

soot soaked shadows
projecting moving pictures
upon a cavedwelling wall
as toxic bonfires choke life from the artist
prehistoric transfers to permanent
pale paraffin candles melt dimension into painted canvases
oily pigments made more unctuous
baked by their heat
zoetropes
magic lanterns
klieg lights
and their wrath of flame
illuminate all things
seen and unseen
and take their turn substituting for day
flashflashblindingflash
when we finish here
like gods
we will learn to move the sun

Lou Jones
December 2006

Color Coding Key

Brand-specific information is indicated by the following colors:

Green: Canon Speedlite 550EX/580EX/550 EXMKII/580 EXMkII flashes, used with compatible Canon EOS cameras.

Purple: Nikon Speedlight SB-900/SB-800, Nikon Speedlight Commander SU-800, used with compatible Nikon cameras.

Some of the information in the book has been categorized in an effort to increase accessibility. Six aspects are differentiated with the following background colors:

Solutions: Olive green

Warning: Red

Example: Orange

Anecdote: Tan

Textbook: Gray

Vocabulary: Yellow

Ten Tenets of TTL Speedlights

1. Separate. Get those Speedlights off camera.
2. Bounce. If you can't separate, bounce It. Bounce it anyway.
3. Resist using Speedlights strictly on manual. The computer can outthink you.
4. In any camera exposure mode, when correctly exposing for existing light, the camera computer will automatically reduce TTL flash to a fill light.
5. LCD = aesthetic; histogram = exposure. Use them both.
6. Exposure Compensation is used to change the TTL ambient exposure and Flash Exposure Compensation is used to correct the flash exposure on the subject.
7. Expose to the right (on the histogram). Underexposure provides no benefit.
8. Take your camera seriously, don't abuse postproduction.
9. No Fear. Just do it.
10. The elegant solution is often the simplest solution.

Introduction

Once upon a time I pushed a thumb-sized red button and exposed a roll of black and white film. Several months later I retrieved an envelope filled with postcard sized pictures of my friends marching in a Boy Scout parade. Memories forged a lifetime ago. In fact not only do I still have most of those photographs but I still cherish the original camera, a marvel of modern technology, the Kodak[1] Brownie Starflex. Not only was it a symbol of a decades-long race to permanently capture an image on paper, but it was small, light, and foolproof. Somewhere in my attic I have also saved the silver dish into which I inserted golf ball sized flashbulbs that miraculously "focused" the sun for the briefest fraction of a second. In a relatively short time those innovations morphed into today's digital miracles.

Photography *is* cameras. But a better axiom dictates that **good photography is lighting**. Distinguished craftspeople, artists are masters of light. Whether photographers are striving to imitate Renaissance painters and their classic "Rembrandt lighting" or experimenting with cutting edge, unorthodox sources, such as ring lights or HMIs, the camera is secondary — the light paramount. Learning to "see" or "re-create" light can take a lifetime. Designing stylized illumination, or mimicking the sun, may be opposite ends of the visual spectrum but they are equally difficult to accomplish.

Cameras have historically been the major focus of photographic innovations. Wooden frames, accordion bellows, twin lens reflex, rangefinder apparitions, pentaprisms, and instant gratification films have dotted the imaging landscape. Millions and possibly billions have been invested in making the proclivity for taking pictures as foolproof as those original mass produced box cameras.

A vast majority of photographers are the "shutterbug" equivalent of the motor "gearheads" who enjoy lifting their car hood, changing their own oil, fixing the transmission, and dropping a new engine into vintage automobiles cadged away in cramped garages. Hardware "equipment junkies" thrive in equally cramped darkrooms, buy the latest equipment, and argue incessantly about the merits of each lens and gadget. This dialogue is what keeps camera manufacturers awake at night.

Motordrives, zoom lenses, autofocus, and autoexposure are all improvements that have made the process of taking a usable photograph easier and less obscured by a mastery of craft. The main reason these devices were invented was to enable the consumer to more easily produce acceptable results. But more important, the byproduct of these advances allows skilled practitioners

[1] "You press the button, we do the rest." George Eastman, Kodak.

to do things they never dreamed of doing before: react instantaneously to a new environment, compose a complicated landscape, measure a difficult light condition, chase a fast-changing combat situation, document a slowly evolving wildlife metamorphosis, adjust for bad eyesight caused by the natural burden of aging, and produce better, more provocative images.

It stands to reason that if cameras are keeping up with the photographer's rigorous demands, the lighting equipment needs to keep pace also. Even after cameras became small and compact, lights remained ponderous and complicated. Techniques were artistic, but also idiosyncratic and sacrosanct, requiring a *lot* of practice to be considered competent.

Lighting has always taken a long time to learn. Lights have gotten a little smaller but their mysteries have remained large. Just monitoring their application has always been slow and tedious. Measuring lumens, color temperature, and ratios was formulaic and imperfect.

After flashbulbs, **Doctor Harold Eggerton** of **Massachusetts Institute of Technology** has been credited with giving us the first practical electronic strobes. For the first time since the invention of photography we were able to easily and safely transport our own reusable light to the photograph instead of always bringing our subjects into the light.

Then came a major breakthrough when the "thyristor"[2] strobes made tremendous advances in artificial lighting and variable output. The infamous **Vivitar 283** revolutionized the industry for years. Up to that point in history a slide rule and several complicated calculations extrapolated *usable* lighting. And a degree in mathematics or physics did not hurt either.

Since that innovation there has been masterful progress in portable flash. Many companies make their own versions catering to every size, preference, and price range. Whereas amateurs employ portable flashes to quickly produce convenient but clumsy illumination, professionals have long been adept at both wresting beautiful results out of the same equipment and exceeding the design specifications.

Power has always been a major issue. Capacitors and power packs grew large and cumbersome. To assemble enough light for interesting scenarios required multiple light heads and energy sources. This was heavy to carry. Anticipating the outcome was also complicated. Shooting Polaroids was slow. And every step called for experience.

Compact flashes, strobes, and flash guns have partially addressed the portability issue. They are built smaller than their studio counterparts, however, size limits power. And any more than one proves hard to coordinate because you have to reposition or recalibrate each separate light and hardwire them together or set up some kind of electronic triggering system.

[2]A thyristor is a semiconductor switch capable of automatically switching the flash on and off at very high speeds. It is used to control the duration and output of the flash tube.

Enter the **Speedlight**/**Speedlite**.[3] Every photographer taking pictures today is familiar with this revolution in photography, as it changed from film to digital. There is an equally dramatic evolution in lighting — from flash to Speedlight/Speedlite. They look, feel, and work, albeit more versatile, like traditional portable flashes. In fact, they so closely resemble their "cousins," most photographers continue to use them like old fashioned flashes. But Speedlights/Speedlites are the most significant technological advance in the history of lighting. A quantum leap forward. Flash powder with computers attached. Digital sunlight.

Small and portable, Speedlights/Speedlites are easy … and nearly infallible. The ambitious photographer who needs more "juice" can pack more than one without breaking the bank. They use proprietary technology, currently utilized by two camera manufacturers.[4] Only their products are compatible with all the features: dozens of flashes ignited simultaneously, wirelessly, each flash programmable to insert different predetermined power outputs, every flash able to be controlled from a single central source, and the final result immediately reviewable on the camera LCD screen. Additionally they can be programmed for stroboscopic effects, rear curtain synchronization, fill flash, higher shutter speed usage, and much more. It is a 35 mm revolution.

"Take a picture, take a look." The modern digital photographer can quickly set up a battery of Speedlights/Speedlites in inaccessible locations, designate outputs for each one, snap a picture, observe the histogram, readjust each light to taste, and start all over without changing position. It is a "closed system." Speedlights/Speedlites are fully integrated with their specific camera for automatic through-the-lens exposure and the camera, in turn, gives instant feedback, monitors the aesthetics of the photograph, measures the contribution, interacts directly with the Speedlights/Speedlites, and stores the results. No more wires or clumsy accessories. The flexibility in continuously orchestrating "pieces" of light to accompany the tempo of your imagination is unprecedented.

The potential of the ubiquitous desktop or laptop computer today is barely realized. Because they are so overwhelming the average person only uses a small portion of the computer's capability. The computers in Speedlights/Speedlites are equally sophisticated. Most photographers barely test them. This book proposes to uncloak the complexities of Speedlights/Speedlites in plain, systematically organized segments. There are no ratios to calculate. No formulas to memorize. Using your eyes, imagination, intuition, and the LCD/histogram, you can design, meter, and modify one or many Speedlights/Speedlites to create drama, color, mood, effects, depth of field, or just more natural looking images. This text will showcase examples and their respective lighting diagrams for your perusal. It is set up so you can read from cover to cover or just those parts you need for your next assignment. Combined with the camera and Speedlight/Speedlites manuals, you can quickly perfect a whole new set of skills.

Light a la carte. We decipher the basics. The art is up to you.

[3] See book definition of Speedlight/Speedlite on page 3.
[4] Canon and Nikon.

The Authors

Lou Jones is one of Boston's most diverse commercial and art photographers. This prolific, award-winning photographer specializes in photo illustration and location photography for corporate, advertising, and collateral projects. His client list is as impressive as are his photographs — IBM, FedEx, American Express, Oldsmobile, AETNA, Museum of Fine Arts, Fortune Magazine, *U.S. News & World Report*, and *National Geographic*. Jones' assignments have taken him to Europe, Central and South America, Africa, Japan, and 46 of the 50 states. Assignments have placed Jones on location at NASA, Boeing, Universal Studios, British Telecom (England), and Saab (Sweden).

Bob Keenan is a Boston-area photographer. A retired Electrical Engineer, Bob spent his career designing and developing Radio Frequency communications equipment, so working with the wireless speedlights and the concept of light pulses is a natural fit. Bob is a graduate of the Boston University's Center for Digital Imaging's Photography Program

Steve Ostrowski is an award winning photographer with over 30 years experience in Commercial, Editorial, Annual Report, Fashion, Portrait, and Event photography. He has worked with small flash as a studio and location lighting tool since 1977. He is currently an instructor at The New England School of Photography in Boston, MA; teaching Editorial Photography as a major course of study, digital camera techniques, and specializing in teaching lighting with Wireless TTL Flash.

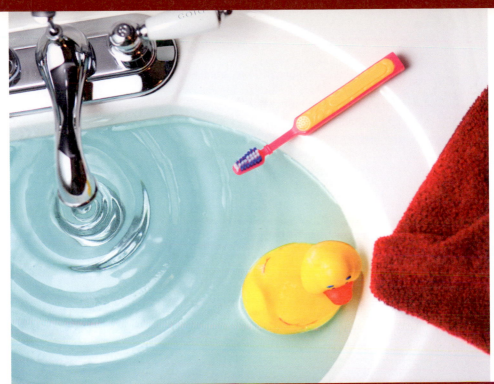

One Light

During the Hollywood heyday of black and white movies, the stereotypical tabloid newspaper photographer was played by a man dressed in a loud sport jacket and tie wearing a fedora with his press card stuffed into the hatband. Garrulous and unctuous, he has changed only sartorially. His ubiquitous camera was always an oversized **Speed Graphic** 4 × 5. And perched on top was a huge outrigger flash gun with protruding magnesium flash bulbs. This technique defined lighting for several generations.

Photography is more than a medium for factual communication of ideas. It is a creative art.

Ansel Adams

Rubber ducky The idea for this photograph came to me while I was brushing my teeth. Years ago I had commissioned a model maker to fabricate a plastic water ripple for a photograph. He had done such a good job that I put it away for future use. It took years to find the perfect client. Even though it was tight quarters, we shot the job in the new studio sink. Since the plexiglas ripple was only a quarter of a circle we had to crop the composition tightly. To add contrast to the white-on-white shot we tinted the water with food coloring. My assistant took great care to suspend the model on top of the water surface. We added a couple of large black "show cards" along the walls to reflect contrast in one side of the ripple and then bounced one SPEEDLIGHT into a white "show card" which was the only light source in the image. Shooting from the top of a ladder we moved all the elements around until we got something we liked. A fair amount of postproduction was done to smooth out sharp edges in the water but nothing else was modified (see lighting diagram on page 197).

One blinding light. Red Eye. Profound black shadows became iconic in image making. Other than the daily papers, nowhere else in nature have we ever encountered that kind of light. But photographs pockmarked history with this telltale technique embraced by millions as it spread to the most remote corners of the world. Group pictures, crime scenes, sports moments, and award ceremonies all grew dark apparitions behind every object in the photograph. Eventually we got used to it.

Amateurs in too much of a hurry to care, professionals moving too fast to know better, artists in a world only their own, utilized the "deer-caught-in-headlights" pictorials: everybody in front, recognizable, everyone and everything in back, in limbo. Cameras sprouted strobes of all shapes and sizes. Hot-shoes were molded into the Bakelite.[1] Many were made with built-in, mini flashes. Big cameras. Point and shoot cameras. Disposable cameras. The method became commonplace. Bad pictures were acceptable.

Then there was a sea change. Rising above the fray, gifted artists made fascinatingly crafted pictures with those on-camera flashes. Documentary, fine art photographers, and paparazzi rejected any effort to imitate other art forms. Necessity was the mother of its own art. Photographs looked like photographs and nothing else. Black and white, vivid colors, high contrast, high key. Zone One.

Photography changed the world's way of seeing … forever. And the new omnipresent illumination made us rethink aesthetics, ethics, art, politics, and truth. But eventually photography was also entrusted with resembling reality. It was the only art form truly capable of that responsibility. In between all the surrealism and abstraction for which it was also well suited, the viewer demanded to see things the way they were. To do that photography's "artificial sun" had to be separated from the camera.

Diffused, bounced, as fill, that *one light* changed shapes and became diverse and more talented. There are not enough terms to describe all the ways that one light can be reconfigured to make a photograph more useful. There were not enough trade names for the modifiers used to reshape light. Real artists continue to master using just one light source. The prototypical Weegee[2] character is no longer with us, but his skill set informs modern shutterbugs and road warriors alike. Wherever quick light is needed we revert back to classic "old school" ways.

Weddings, events, photojournalism, art. One light. Portable. Efficient. One light is not much, but in the hands of an expert it is all that is necessary.

TTL Flash

Electronic Flash: Definition

A flash is a device that produces a brief burst of artificial light at a color temperature of approximately 5500° Kelvin. Flashes can freeze motion in

[1]Bakelite — polymer, 1909, precursor to plastic.
[2]Weegee — Arthur Fellig (1899–1968) Newspaper photographer of legend.

quickly moving objects, help provide smaller f/stops for greater depth of field, and correct color temperature of the available light. But are mostly used to illuminate scenes that do not have adequate lighting to properly expose a photograph.

Using a strobe is like taking a pistol to the opera.
Henri Carter-Bresson

Speedlight/Speedlite[3]: Definition

Speedlight has become a generic term. It is interchangeable with flash, strobe, etc. But for the purposes of this book its definition is very specific. All of the pictures in this book were made using Nikon or Canon shoe mountable flash heads. These flash units work with their respective manufacturers' digital cameras in new and exciting ways. While most of the processes can be done easily and automatically, certain features allow for an unprecedented array of possibilities and creative control. Since there will always be newer and more advanced cameras and flash units arriving on the market, we want to state what makes the current products distinct and revolutionary.

There are three key attributes to the current state-of-the-art Speedlight:

- **The Speedlight is automatic.** The metering of the flash, while also through the lens, is separate from the metering of available light. Having the two exposure values separated allows you the creative control to alter either one to achieve dramatic results, or you may choose to let the camera make the decisions and balance the ambient and flash lighting. The simplest example of this is choosing to deliberately underexpose a background, such as a cloudy sky, to make a simple portrait much more dramatic.
- **The Speedlight can be wireless.** Communication between compatible lights is accomplished with light pulses. No wires or external devices are needed to fire off camera lights. Although there is usually a master Speedlight mounted on the camera, even a single Speedlight can be separated from some cameras by using the pop-up flash as a Commander.
- **Multiple Speedlight units can be used** and controlled wirelessly by a master flash from your camera position. Multiple Speedlight heads can be assigned to groups and controlled as one larger unit. The master Speedlight unit can also control multiple groups.

Weegee had an esthetic predilection for artificial light. He liked the way in which an object is highlighted and flattened by the freeze action of flash, and slowly dissolves into a saturated background. He called this "Rembrandt light."
John Coplans,
Art in America

[3]Speedlight™ (Nikon) and Speedlite™ (Canon) are trademarked names for their products. In general, we will use the generic spelling, i.e., Speedlight, except in the description and lighting diagrams of photos made with the Canon Speedlite.

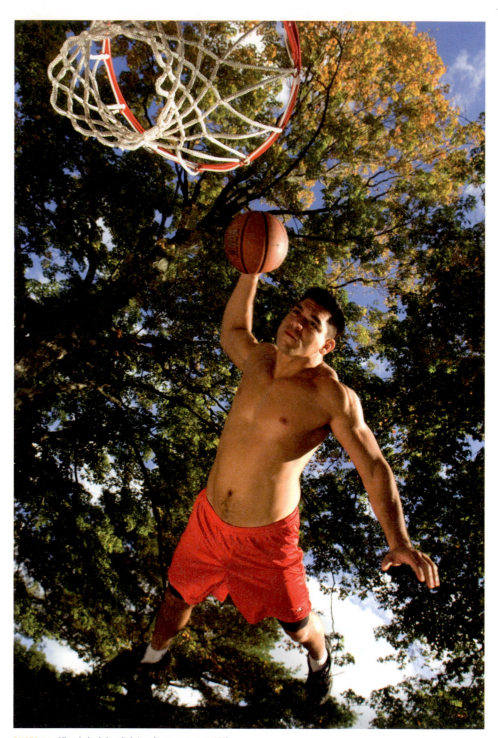

PHOTO 1.1 Albert's dunk (see lighting diagram on page 155).

While all of these features may evolve, and other companies may eventually add these capabilities to their camera and flash units, we believe this step in technology is significant and well worth the effort to master, no matter what your level of photography.

A to Z

barn doors (bärn dōrz) n. 1. light blocking accessory for controlling direction and width of light beam. 2. device usually with two adjustable hinged panels that attach to opposite sides of light source to modify and direct the width of the light. 3. colloquial term for flaps surrounding the front of a light source to control size and spread of light, considered to be grip equipment.

PHOTO 1.1 *Albert's dunk*

This photograph was taken in a suburban driveway. We erected the net at the optimum height after borrowing gymnastics pads from a fitness center. The model was one of the personal trainers there. The pads were to protect him as he attempted dozens of flying dunk shots. Lying flat on my back he repeatedly jumped onto the exercise pads inches from my head. Nothing protected me.

The trees with their fall colors were deliberately chosen as backdrop suggesting height. The angle is also intentionally disorienting. We stretched a queen-size bed sheet across the surface and bounced a Speedlight into it. We chased the sun so that it backlighted the subject. By constantly checking the LCD I was able to design the exact way the basketball player positioned himself, the ball, and his arms and legs as he flew through the air. I also used it to time the exact moment to snap the picture.

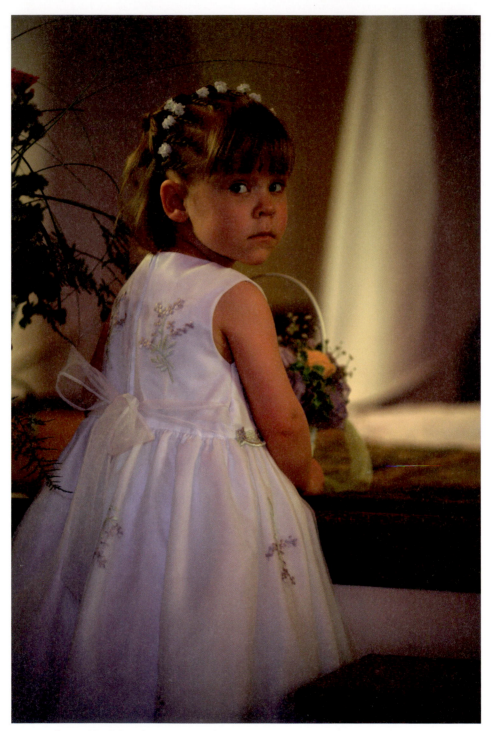

PHOTO 1.2 Flower girl (see lighting diagram on page 156)

PHOTO 1.2 *Flower girl*

She kept looking over her shoulder at all the people. Kneeling in the center aisle gave me the perfect vantage point at her eye level. My knee served as a brace for the long lens. The 80–200 zoom gave the intimate perspective and isolated her from the surroundings. The existing light was soft, wonderful, and warm. A touch of flash idealized the contrast and cleaned up the color.

Flash photography is no longer formulaic and uncertain. I did not want too much flash here. It was important to maintain the feel, the mood and the moment. With film, I would have to run calculations in my head, figure, guess, not until days later see if my decisions were sound. Digital allows me to respond visually, emotionally, technically, and immediately. In seconds, I was able to make and evaluate several test images, perfecting existing light and flash to my satisfaction.

I'm living proof you can teach an old dog new tricks. I get digital. I know when I get the shot.

Several independent manufacturers produce flash units that interface to varying degrees with the TTL flash metering systems of the Canon and Nikon digital cameras. This book, however, deals specifically with the professional 550EX, 580EX, 580EX MkII, and SB-900/SB-800 TTL Speedlights produced by Canon and Nikon, respectively.

All future references to Speedlights, flash, or strobes pertain to this narrow definition, unless otherwise indicated.

A to Z

Chimping (chĭmp-ēng) n. A term that has been coined with the advent of digital photography and the LCD on the back of a DSLR. Usually it is a pejorative term referring to the "oohs and ahhs" that follow looking at the image immediately after taking it. Often it is done in a group as everyone's admiring each image and grunting approval that is similar to the **chimp**anzee social activity.

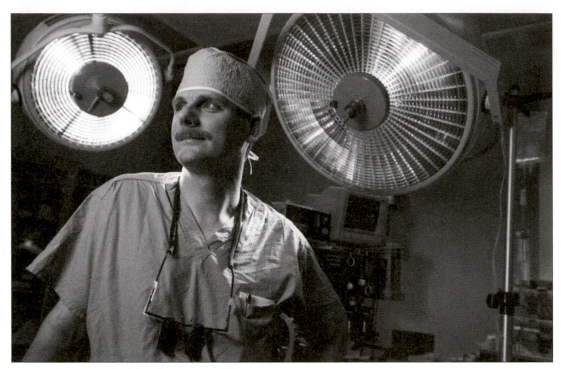

PHOTO 1.3 Operating room (see lighting diagram on page 157).

PHOTO 1.3 *Operating Room*

An editorial assignment from a national magazine allowed me to test the limits of a single Speedlight. I had to shoot a photo-essay about the ethics committee of a local hospital. The logistics were cumbersome. Doctors, nurses, ministers, and administrators are busy people.

We made appointments with each subject and did photographs in Neonatal Intensive Care Units (NICUs), libraries, boardrooms, X-ray rooms, etc. I wanted maximum flexibility because I intended to light everything. The amount of time we spent with each person varied enormously but the surgeon evaded us continuously.

The whole project was done with one Speedlight. Most of the images that were used in the story were done with a small softbox handheld by an assistant who followed the subjects in their daily routines. We finally got the surgeon who operates on fetuses *in utero* to agree to pose. I pushed him to let us photograph in an operating room. We scrubbed in and put on sterile surgical caps and gowns. One Speedlight on a custom-made TTL cord allowed my assistant to get as close as possible to the doctor. We just turned on all the operating theater lights and made them part of the image and used Program Mode to balance the available light.

Flash scares us. It is the monster lurking in a dark corner of photographers' brains.

Joe McNally

8

Fundamentals of Electronic Flash

To effectively use electronic flash, it is useful to know how it works.

Electronic flash has a hollow glass flashtube filled with the rare gas **Xenon**.[4] Xenon (notice the similarity to the word neon) produces blue light when exposed to electric current. Electronic flash stores voltage from the batteries or AC current source in a capacitor. The capacitor discharges electricity into the flashtube. The amount of electricity discharged, the "flash power," determines how long the flashtube is lit, i.e., the flash duration. The brightness of the flashtube remains constant. The flashtube only "turns on" for longer or shorter periods of time.

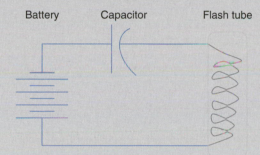

Battery Capacitor Flash tube

FIGURE 1.1 Flash schematic.

The flash duration of TTL electronic flash is very brief, 1.2 milliseconds or less. Therefore, if the shutter is open longer than the flashtube is illuminated, **the shutter speed itself will have no effect on the amount of flash** in the photograph.

The quantity of flash recorded by the camera is a function of the flash duration, the flash-to-subject distance, the ISO, and the aperture. Electronic flash is always expressed as an **aperture value** worth of light.

[4]Xenon (**Xe**, atomic number 54), noble or inert gas, of the family helium, krypton, argon, and radon.

At any given shutter speed, "f/16 worth of light" falling on the subject is more light than "f/8 worth of light."

Guide Number

Manufacturers express the light output of their flashes as guide number. Guide number defines the maximum intrinsic aperture value worth of flash available from a flash unit at any given flash-to-subject distance, giving the photographer a realistic expectation of the capabilities and maximum power of the flash. Guide number may be expressed for feet or meters, and is dependent on ISO, flash reflector efficiency, zoom head setting, and flash power. Guide number is useful and meaningful when applied in a simple traditional equation:

$$\frac{\text{Guide number}}{\text{Flash-to-subject distance}} = \text{Aperture value of light falling on the subject}$$

(Guide number divided by the flash-to-subject distance = aperture value, etc.)

This equation can also be expressed as:

Guide Number = Aperature x Distance

A flash with a guide number of 160 (for ISO 100, and 50 mm zoom head setting) makes a versatile lighting tool capable of actually overpowering sunlight. A flash with a guide number of 160 provides f/16 worth of flash at a 10 foot flash-to-subject distance, i.e., 160/10 = f/16. A standard ISO 100 sunlight exposure (based on "sunny 16" exposure guidelines) is 1/60 sec at f/16. With most current digital cameras, flash can be used at 1/250 sec. The flash exposure can be made at 1/250 sec at f/16, underexposing the sunlight by two stops, and making the flash the predominant light source.

War Stories

Church

I was selected to do much of the action photography for the 125th anniversary commemorative book of historical Trinity Church in Boston. The enormous, dark wood edifice soaked up dozens of rented 2400 and 5000 watt/second strobe units. The place was a "light sink." I could not pump *enough* power into the cathedral. But when confronted with an intimate setup at the baptismal font, I relied on the inherently faster flash duration of a Speedlight to freeze the pouring of holy water.

I backlit the liquid splashing into the frame. The minister repeated the actions for me until I thought I had enough. Droplets were suspended in midair with all the gilded pomp and circumstance out of focus in the background. It made a very iconic image in the book.

LAJ

Comprehending Flash Exposure

Electronic flash can be directly compared to continuous light sources. The physical behavior of light remains the same whether it is constant or intermittent. *Light is light, is light, is light.*

A fluorescent light is a glass tube filled with gas producing light continuously when exposed to electric current in the same way as a flash tube. Imagine a camera in a completely dark room. The shutter is opened for one hour. During that hour, the fluorescent light is turned on for five seconds. Five seconds of light is recorded. Another one-hour exposure is made with the fluorescent light turned on for five minutes. Five minutes of light is recorded. In both examples, the brightness of the light remains constant. In both examples, the quantity of light recorded by the camera is not dependent on the shutter speed.

The similarities and the differences in exposure for continuous light sources and for electronic flash can be expressed in the following manner:

Continuous Light Exposure → ISO

+ Time value (shutter speed)
+ Aperture value (f/stop set on the camera)
+ Quantity of continuous light falling on the subject

Flash Exposure → ISO

+ Time value (flash duration)
+ Aperture value (f/stop set on the camera)
+ Quantity of flash falling on the subject

Where the quantity of flash falling on the subject depends on the *guide number* and the *flash-to-subject distance*.

PHOTO 1.4 *Sunset Bride*

The bride chose the location and time of the wedding for the city skyline and the sunset. Beautiful day … challenging problem. By turning the bride's back to the sun, I was able to capture the view she wanted and simplify the process. By taking the sun completely off of her front, the exposure for the background and the brightness value provided by the flash became two separate, controllable elements.

The first piece of the puzzle was to reach a satisfactory exposure for the background. The camera mode was set to Manual, the shutter speed was set to "X" maximum synchronization speed of 1/250 sec, and the sky stopped blinking at f/20. Manual exposure mode kept the background value the same for full length through close-up images. I did not need to constantly adjust existing light exposure compensation for differing amounts of shadow and highlight appearing in the viewfinder. I now only needed to deal with flash exposure compensation.

Direct flash was required to give f/20 at the flash-to-subject distance. The flash was on the hot shoe. The camera was held vertical with the flash on camera left, placing the shadow behind the subject's back. Holding the camera with the flash on the right would have placed the shadow "in front" of her. The flash was zoomed to prevent a lighted band appearing on the grass at the subject's feet. Flash Exposure Compensation was adjusted as needed, +2 for this image.

A gust of wind blew the bride's hair across the chin, giving a more spontaneous, fun feel helping to express this happy bride's bubbly personality. The setting sun is in the upper center of the image.

I am often in situations, such as photographing ballroom dancers, where I only have a split second to capture an image as the dancers twirl by. The lighting is minimal and dark. One of my most important accessories is my speed-light flash! Using it, I have a source to capture the motion, beauty and ambience of the event as the dancers perform.

Jeff Dunn

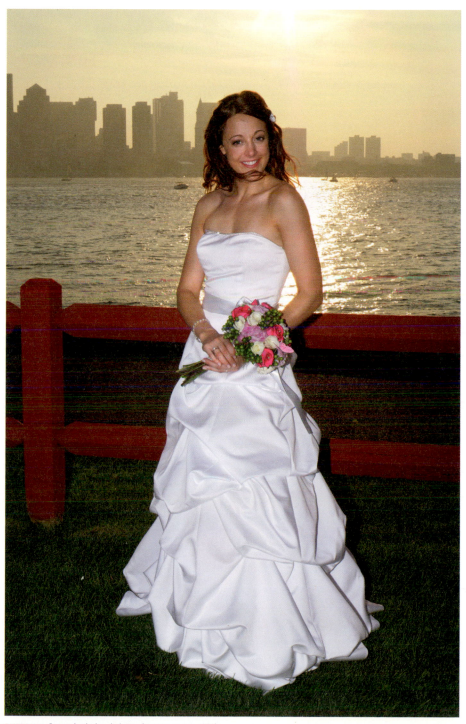

PHOTO 1.4 Sunset bride (see lighting diagram on page 158).

TTL Electronic Flash: Definition

TTL Electronic Flash is a proprietary, integrated, computerized, automatic flash exposure system. A through-the-lens (TTL), in-camera flash meter works with brand-specific flash units. The lens, camera, and flash all communicate through a series of connections between camera and lens and a five-pin hot shoe between camera and flash. The flash's meter reads the amount of flash entering the camera and the camera's computer automatically adjusts the flash duration to provide a "standard" or "balanced" flash exposure. The flash meter evaluates the same scene the photographer sees in the viewfinder. The flash automatically responds to changes in focal length, aperture, ISO, flash-to-subject distance, subject reflectance, filters, and close-up accessories. The camera's computer automatically alters the flash exposure instantaneously to balance flash and ambient light in response to changes in the existing light exposure. **TTL electronic flash is the most technologically sophisticated automatic flash system in the history of photography.** I TTL, E TTL, E TTL II, etc., are all proprietary versions of TTL Electronic Flash.

With the introduction of computers making such a vast array of choices possible, there has been a paradigm shift. No longer is linear thinking applicable. With parallel metering systems at play — one for available light, one for flash — there is a similar but different logic.

In manual mode, f/stops and shutter speeds perform as they always have, but in the many versions of automatic, the camera's computer integrates many more parameters. To take advantage of all the benefits this new logic affords, it may make more sense if the photographer understands these automatic systems and the camera's logic.

Of all the camera inventions of the 80's auto focus, auto exposure, and auto strobes, it was the strobes, specifically "smart flash" that had the biggest impact on my photography. To be able to automatically dial in the correct amount of fill flash, balancing the ambient light with subtle strobe light on the subject, made me feel like an instant lighting expert. I could light even the biggest interiors with the flick of a few buttons. It changed my life as a photojournalist, lightening my excess baggage considerably, as I could leave my 2 case lighting kit of big battery strobes, at home.

Michael Yamashita,
National Geographic

PHOTO 1.5 *Tanzi with veil*

We were doing full lengths with the scarf and Tanzi started wrapping it over her head. In a moment of inspiration, I grabbed the slave Speedlite, mounted in a 12" × 16" softbox, softbox bracket, and stand adapter — the complete assembly — right off the light stand and balanced the whole thing handheld on the top of my head. Holding the camera in my right hand and the Speedlite assembly on my head with my left, I moved in for close-ups. The stand adapter served as a convenient and comfortable handle for the slave/softbox setup. The master 580EX, on camera and bounced off the back wall, continued to fire the slave held above. I was able to lock autofocus, frame, and shoot one handed. I maneuvered the softbox so as not to appear in the frame, at times the edge of the softbox was touching the lens hood. The resulting gentle light served the intimate portrait well. I had a wonderful time exploring this image. I had the flexibility to change angles and distances with complete freedom and fluidity. Here, the idea of the lighting literally came "right off the top of my head."

PHOTO 1.5 Tanzi with veil (see lighting diagram on page 159).

Synchronizing Photo Flash Lamp With a Camera Shutter

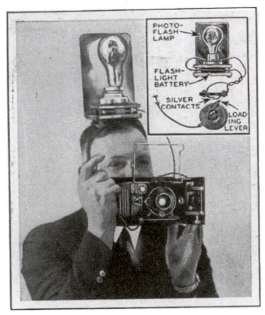

When wired up as shown in the insert, the photo flash lamp is set off at the precise instant the shutter is clicked. Silver contacts to the battery and flash lamp close the circuit.

THE difficulty of synchronizing the flare of a photo flash lamp with the click of the shutter is frequently encountered by enthusiasts of the camera art. There's a way to overcome this difficulty, however, and that is by constructing the little gadget shown in the accompanying photo.

The contrivance consists of a flat type pocket flashlight battery mounted between two pieces of wood, on the top of which is affixed a common porcelain socket to hold the photo flash lamp.

On the base of this baseboard is mounted a pair of contacts in such a position that the loading lever will push them together when the shutter clicks. The wiring is illustrated in the insert.

Synchronization is achieved by the simultaneous clicking of the shutter and the closing of the photo flashlamp circuit through the silver contacts. The duration of the flash is 1/50 of a second, which occurs when the shutter is wide open.

For convenience, the flash lamp unit is secured to the head by an elastic band, thus leaving the hands free to operate the camera. The lamp should be backed by an aluminum reflector.

TTL Exposure System

As stated before, the current digital single lens reflex (dSLR) camera has two integrated metering systems: a TTL reflected light meter for continuous existing ambient light and a TTL reflected flash meter for compatible flash units. The camera computer reads and/or balances existing light and flash based on input from the photographer and reflectance of the scene. These two metering systems provide separate, yet similar, controls for existing light and flash. In an automatic exposure mode, utilizing instant feedback from the LCD monitor and the histogram, the dSLR makes control of both simple: "Take a picture, take a look," then adjust by selecting + or − for more or less of either.

TTL Flash and Exposure: A Primer

There are two parallel metering systems in today's dSLRs.

TTL flash is based upon through-the-lens reflective flash metering and the exposure strategies are similar to reflective meter continuous light exposure strategies.

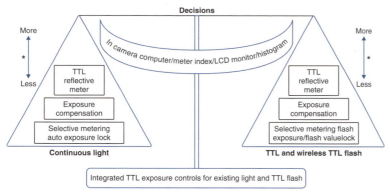

FIGURE 1.2 TTL exposure controls.
*Flash Exposure Compensation "+" may be required for light-toned subjects. Flash Exposure Compensation "−" may be required for dark-toned subjects.

A. All reflective meters provide an exposure value based on exposure for a middle tonal value.[5]
 i. If the reflective meter sees predominantly white or light tonal values, more exposure than the meter indicates may be required.
 ii. If the reflective meter sees predominantly dark tonal values, less exposure than the meter indicates may be required.
B. Exposure Compensation is used to change the metered exposure for correct recording of different tonal values.
C. Flash Exposure Compensation is used to correct the flash exposure for subject reflectance, or whenever more or less flash is desired.

TTL Flash and Aperture

The aperture value set on the camera is communicated to the TTL flash by the camera's computer. With manual flash, or non-TTL automatic flash, changing the f/stop can change the relative amount of flash illumination in the picture. But TTL flash automatically changes *flash power* in response to changes in f/stop. The camera's computer adjusts the flash duration to maintain a constant relative flash exposure even at different f/stops. When no existing light is used, making the same TTL flash picture at different f/stops will produce virtually the same histogram.

TTL Flash and Distance

Speedlights are small and compact, therefore power is limited. TTL flash displays a usable distance range on the LCD panel of the flash. The distance range shows the near and far limits of the flash's ability to provide a "standard" flash exposure and represents the minimum and maximum amounts of light

[5]This is analogous to the 18% gray that is prevalent in film photography, where the average meter reading is when 18% of the light is reflected from an object.

the TTL flash can produce. The usable distance range is dependent upon ISO, aperture, and focal length. Stay within the limits of the distance range displayed on the flash.

If you change f/stop, ISO, and/or focal length, check the distance range display on the flash.

Inverse Square Law

Why is "Distance" Important?

The **Inverse Square Law** in physics explains that all light becomes less intense over distance.

$$Intensity = \frac{1}{distance^2}$$

When the light-to-subject distance is doubled, only one-quarter of the quantity of light (two stops less) reaches the subject:

$$Intensity = \frac{1}{2^2} = \frac{1}{4}$$

When the light-to-subject distance is halved, four times the quantity of light (two stops more) reaches the subject:

$$Intensity = \frac{1}{\left(\frac{1}{2}\right)^2} = 4$$

The quantity of light illuminating a subject is always dependent on light-to-subject distance.

TTL Flash will automatically respond to changes in flash-to-subject distance, within the "usable distance range" displayed on the flash LCD panel.

PHOTO 1.6 *Brendan's Trick*

Toward the end of writing this book Nikon released the SB-900. While the SB-800 is still a great Speedlight, the SB-900 has a few advantages. For portrait work the biggest difference is the ability to choose from three illumination patterns: Standard, Center-weighted, or Even. This photo was taken with the Standard illumination. A group portrait might be better with Even illumination and the Center-weighted setting could be used to increase the light falloff at the edge of an image.

It is always fun to check out a new piece of equipment and in this case my four year old was a willing subject. He could not wait to show me his new trick with the skateboard. The trick you ask. You are looking at it.

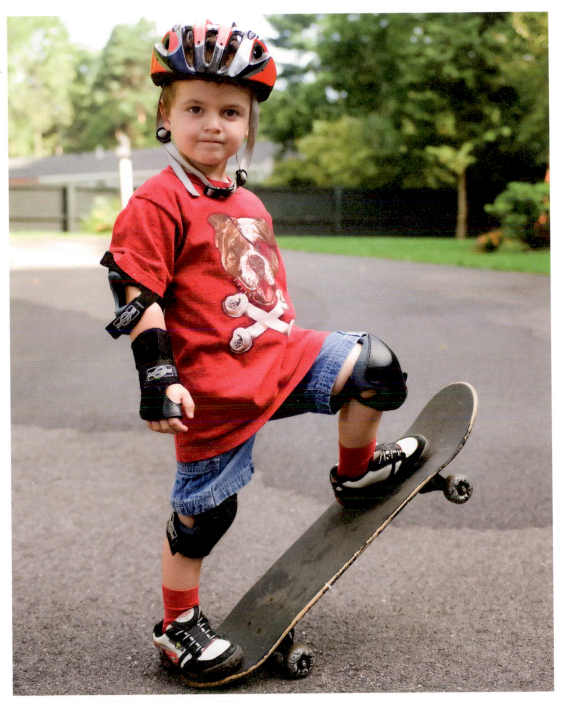

PHOTO 1.6 Brendan's trick (see lighting diagram on page 160).

TTL Flash and Subject Size

Because the metering sensors cover the entire area and are making a "best estimate" for what is most important in the frame, if the flash subject is very small in the picture, or if only a small portion of the picture is illuminated with TTL flash, the flash may overcompensate. Depending on meter pattern, the flash meter is looking to see a certain quantity of flash across the frame. It is logical for the flash to provide plenty of flash to a subject that is taking up only a small portion of the frame.

Use Flash Exposure Compensation to ensure satisfactory flash exposure.

TTL Flash and Shutter Speed: Synchronization

The flash needs to fire while the shutter is open. This is called **synchronization**. Flash synchronizes with the shutter over a wide range of shutter speeds, from the longest shutter speed up to a faster shutter speed traditionally referred to as "X". With advances in shutter materials and designs, depending on the size of the digital sensor, many dSLR cameras can now synchronize with flash as fast as 1/250 or 1/500 sec. Refer to your camera instruction manual to find X for your particular camera. If you use a shutter speed faster than X, the flash will fire while the shutter blades are closing, resulting in a partially dark image. With vertical-operating shutters, the top portion of the picture will show a flash lit image and the bottom part will be darker. Normal flash synchronization fires the flash at the beginning of the exposure. Other flash synchronization options, such as Slow Speed Synchronization, High Speed Synchronization/FP Focal Plane Flash, and Rear Curtain Sync/Second Curtain Synchronization are listed in Figure 1.3, *Speedlight Components* on page 22.

TTL Flash: Flash Anatomy and Features

The TTL flash offers many traditional functions and some unique features not found on other types of flash. These features and functions make the TTL flash a versatile problem-solving tool.

Speedlight Components

1. Pilot Lamp or Ready Light
 The Pilot Lamp, or Ready Light, illuminates when the flash is ready to fire. The Pilot Lamp/Ready Light displays on the back of the flash and in the camera viewfinder. The time it takes for the flash to be ready to fire is called the recycling time. Refer to the flash instruction manual for typical recycling times.

PHOTO 1.7 Wedding shower (see lighting diagram on page 161).

PHOTO 1.7 *Wedding Shower*

My wife and I attended this shower as guests. I brought the camera. The opening of gifts brought much excitement. The existing light has been underexposed, making my flash more visible and predominant in the picture. The window itself was allowed to burn out. It was more important to show the atmosphere of the room than hold details outside. I am crouched at the feet of the couple, getting an unusual perspective. People are hovering about, taking pictures, giving presents, clapping, and joking. The little girl is lost in her own thoughts, tired from running and the activity swirling around her. A slow shutter speed, Second Curtain Synchronization, and slight camera movement captures the blur of it all. My flash freezes some of the movement as definitive composition and gesture. The Speedlite is bounced up into the wall to my left. My wife commented it all looks like the little girl's dream.

I'm a newspaper photographer, so I always carry a flash, but use it only when absolutely necessary. In other words, I go with available light when I can — it's faster to set up, and I'm often on a very tight schedule. Shake and bake. There are those times, of course, when a Speedlight provides the power — portable, variable, soft as a kiss or hard as a hammer — without which there'd be no photo.

*Amelia Kunhardt,
Quincy Patriot Ledger
newspaper*

Nikon: Accessory battery holder SD-800 adds a fifth AA battery to the SB-800, giving 20% faster recycling times.

Canon: The 580EXMkII gives faster recycling time than the 580EX.The 580EX gives faster recycling times than the 550EX.

(See also the section *Batteries: Powering the Flash* on page 144.)

2. Flash Exposure Confirmation

 Indicates the flash meter has detected a sufficient quantity of flash entering the camera.

 Canon: Small indicator light near the pilot lamp on the flash glows green to confirm sufficient flash exposure. It does not illuminate if the flash exposure is insufficient.

 Nikon: The Ready Light glows steady to confirm the flash exposure. The Ready Light blinks rapidly to indicate insufficient flash exposure.

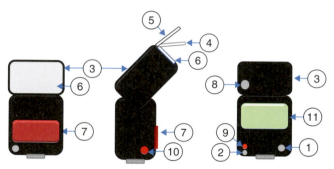

FIGURE 1.3 Speedlight components.

If insufficient flash exposure is indicated, try one of the following: use a higher ISO, use a larger aperture, or move closer.

3. Bounce and Swivel Head

 Rotates 360° and tilts up and down allowing the light to be pointed in different directions.

 A downward tilt below horizontal is used for close subjects, to avoid a dark band at the bottom of the picture. Refer to the flash instruction manual for distance recommendations regarding the down tilt.

In Remote/Slave flash operation, use the bounce and swivel feature to position the Wireless TTL Remote/Slave receiver toward the Master flash while at the same time pointing the Remote/Slave flash head toward the subject. (See *Wireless TTL Flash* on page 96.)

4. Built-in Wide Panel or Built-in Wide Flash Adapter
 This is a Fresnel plastic covering that pulls out and flips down over
 the front of the flash. The wide panel changes the angle of illumination
 to provide even flash coverage for extreme wide-angle lenses. Refer
 to the flash instruction manual for focal lengths requiring the wide
 panel.

 The wide panel is not a diffuser. It does not make the light softer.

5. Catchlight Panel or Built-in Bounce Card
 Pulls out with the wide panel. Retract the wide panel to use the bounce card.
 The primary purpose of the bounce card is to create catchlights in the eyes
 in outdoor portraits. The bounce card can also provide fill light in the eyes
 when bouncing the flash from a ceiling. Refer to the flash instruction manual
 for details of using the bounce card.
 Nikon: The bounce card has a Control Button Quick Reference guide for
 setting the flash to Remote.

 Pull out the wide panel carefully. Excessive force can damage the flash.

6. Zoom Head
 Internal mechanism that automatically changes the angle of illumination
 to match the angle of view of the lens. The zoom head can also be
 manually adjusted to change the angle of illumination as needed.

 The longer focal length settings are especially valuable to obtain a narrow
 angle of light. This creates a "spotlight" effect, useful when taking pictures
 down a hallway or aisle, or when edge falloff and vignetting are desired.
 Turn the flash head horizontally or vertically to shape the light to match
 the subject. Use the zoom head in conjunction with the bounce and
 swivel head to precisely place light.

7. AF Assist Beam Emitter or Wide Area AF Assist Illuminator
 The red panel on the front of the flash emits a striped, high-contrast
 pattern onto the subject, allowing the camera autofocus system to operate
 in low light.

Canon: On some camera models, the AF Assist Beam Emitter feature may be enabled or disabled through a camera Custom Function. Refer to the camera and the flash instruction manuals. When the flash is used as a Wireless TTL Slave, the red panel on the front of the flash blinks to indicate the flash is recycled and ready to fire.

8. Modeling Flash or Modeling Illuminator Button
 The flash fires repeatedly for approximately one second, giving a visual preview of the effect of the flash on the subject. This "modeling light" can also be activated by pressing the depth of field preview button on the camera.

Excessive use of modeling flash may cause overheating, damaging the flash. Refer to the flash instruction manual.

Nikon: Modeling Flash can also be activated by a button on the flash.

9. Flash Button
 Press to test fire the flash.
10. Light Sensor Window for Wireless Remote Flash

It is important to identify this sensor because it needs to be clear when using wireless TTL flash. The sensor is on the side of Nikon Speedlights and on the front of Canon Speedlites.

11. LCD Panel
 See *LCD description* on page 30.

Features controlled through menus displayed on LCD:

a. Flash Exposure Compensation
 Changes the quantity of flash in the picture without changing the aperture or the shutter speed. Compensates the flash exposure up to ±3 stops. Corrects the flash exposure for subject reflectance, fill flash, or whenever more or less flash exposure is desired. Flash Exposure Compensation can be set on the flash, or through the camera body. Refer to the camera and flash instruction manuals for details of setting Flash Exposure Compensation.

If flash exposure compensation of more than ±3 stops is required, change the flash mode to "M" Manual.

Nikon: If the flash is already firing at maximum or minimum power, Flash Exposure Compensation settings will be limited.

Canon: If the flash is already firing at maximum or minimum power, Flash Exposure Compensation may have no effect on the flash exposure.

b. Flash Exposure Bracketing

Canon: Allows a sequence of three pictures, each with a different quantity of preset flash. Refer to the flash instruction manual for details of flash exposure bracketing.

Nikon: Not applicable.

c. Flash Exposure Lock or Flash Value Lock

Measures and locks the flash exposure for a selected area of a scene or subject, utilizing the partial or spot metering circle in the viewfinder. Use this feature when the subject is in front of a contrasting or reflective background or to freeze the metering on a select area while moving the framing for better composition or when the flash subject is small in the picture. Refer to the camera and flash instruction manuals.

Canon: The AE Lock (*) button becomes the Flash Exposure Lock button when used with flash. Professional camera models have a separate FEL button.

Nikon: Access the Flash Value Lock through the camera menu or program the function button on some cameras.

d. Slow Speed Synchronization

Nikon: Allows the use of shutter speeds slower than 1/60 sec with flash. Refer to the camera instruction manual.

Canon: Not applicable.

e. High Speed Sync (FP Flash) or Auto FP (Focal Plane) Flash

This feature allows the use of flash with shutter speeds faster than 1/250. The flash fires repeatedly until the shutter has traveled completely across the digital sensor. The effective flash-to-subject distance range is reduced with increases in shutter speed. Primarily used for outdoor fill flash in bright sunlight, if large apertures are desired to blur the background and can be applied to other situations. Not for use in regular, general flash photography. Refer to both the camera and flash instruction manuals. This flash feature may be selected on the flash or through the camera menu, depending on camera model.

f. Rear Curtain Sync or Second Curtain Synchronization

Normal flash synchronization fires the flash immediately after the shutter opens. Rear/Second Curtain Sync fires the flash at the end of the exposure, just before the shutter closes. This technique ensures that in flash pictures of a moving subject the blurring trails behind the subject's movement, rather than in front, creating a more realistic sense of movement in still photographs. This function is unique to TTL flash and compatible cameras with electronic focal plane shutters.

Refer to both the camera and flash instruction manuals. Depending on camera model, this flash feature might be selected on the flash or through the camera menu.

Rear/Second Curtain Sync is most effective at slower shutter speeds, such as 1/15 and 1/8 sec and works best with light-toned subjects against dark-toned backgrounds. Underexpose the existing light. Holding the camera still will record motion trails behind a moving subject. Panning the camera with the moving subject will record a relatively sharp subject with the background showing motion blur.

g. Multi Stroboscopic Flash or Repeating Flash
 The flash will fire multiple times in rapid succession during a single exposure. Creates multiple images and sequence photographs of moving subjects. Best results are obtained with light-toned subjects against dark-toned backgrounds.

Excessive use of multi and repeating flash may cause overheating, damaging the flash. Refer to the flash instruction manual for operation and exposure calculations.

h. Manual Flash Mode
 Manual Flash Mode can be selected in both automatic exposure and manual exposure camera modes. Flash power is selected manually by the photographer. Satisfactory flash exposure can be obtained by referring to the LCD panel, calculation using the Guide Number, using a handheld flash meter, or by studying the histogram. Refer to the flash instruction manual and the *Manual Flash* section on page 121.
 Some Canon camera models offer in-camera metering of Manual flash.

PHOTO 1.8 *Ryan with High Speed Sync*
One of the simplest portrait techniques is to shoot with the lens wide open minimizing depth of field and rendering the background pleasantly soft. On a bright sunny day this might require shutter speeds faster than the flash sync speed of the camera, as was the case with this photo of Ryan. I wanted to add a little fill and some catchlights, but even in the shade the shutter speed was 1/500 of a second at the f/2.8 aperture of the lens. Switching the camera to the Auto FP High-Speed Sync mode allowed the camera and flash to sync at these settings.

PHOTO 1.8 Ryan with high speed sync (see lighting diagram on page 162).

PHOTO 1.9 *Julie in Blue*

Julie brought a mesh shirt to the shoot. The seams at the end of the sleeves were distracting, so I asked her to pull them down completely over her hands, solving the visual problem.

The clothing was dramatic. In response I wanted dramatic light. The main light was a Group A slave Speedlite in a 12″ × 16″ softbox. It is large enough to soften the edge of the light and give a broader specular highlight, but small enough to maintain higher contrast. It was used just outside the frame at a distance of about two feet. Using the lighting close provides softer light and smaller apertures.

The background is a blue mottled painted fabric, illuminated with a blue gelled, diffusion sleeved Group B slave Speedlite (see *diffusion sleeve background light* on page 147). The fuzzy mesh picked up the blue light, creating a form-defining glow around the subject, a wonderful surprise.

Master Flash Exposure Compensation controlled the highlights on the face. The relative brightness between Group A Main and Group B Background lights was controlled via the on-camera Master Ratio. The Master was set to transmit only.

Form Fill, contrast control for the face, was a 3′ × 6′ white reflecting panel at camera right. Placing the fill panel on the same side as the main reduces contrast on the front of the face, but the side remains darker and more moody. Form Fill retains contour.

This portrait was a collaborative effort between photographer and subject. We can capture only what the subject is willing to give. The subject projects what we evoke. Communication is key.

The evolution of technology has brought many paradigm shifts to the medium of photography, the apex of representation, the most influential medium in history.

John Paul Caponigro

PHOTO 1.9 Julie in blue (see lighting diagram on page 163).

In the "old days," on location shoots I carried: camera bag with camera, backup lenses, four large cases of monolight lamp heads, slave triggering kit, several stand cases with heavy C stands, one case with color meter and 40 LB/CC filters and lens adapters (about $1500 for this meter and filter kit alone), flash meter, spot meter, Polaroid® camera with boxes of Polaroid® print film and a trash bag for the nasty peel apart "Polagoo," three hundred and fifty feet of contractor grade bright yellow extension cord, and a tripod. It would take four or five trips with a folding push cart just to move the gear from the van into the doors of the location.

Now, I carry: camera bag with camera, backup, lenses, backpack with Speedlites, batteries, CD burner, one bag with light duty stands, softboxes, reflectors, clamps, computer bag, and tripod. One trip from the van. Grab'n'go. The color meter, color balancing filters, flash meter, and spot meter are built into the digital camera. The preview capability is built into the camera. I scrutinize my images large on the laptop monitor, view the histogram, and look at the image details magnified to 100%. The lights are small, lightweight, self-contained, and battery operated. The triggering system is all built in.

I can bring studio quality lighting anywhere. I'm never looking back.

Steve

The LCD

The liquid crystal display (LCD) is the viewing screen on the back of most digital cameras. The LCD monitor displays the results after an exposure. The LCD image is used to judge composition, framing, expression, gesture, and moment. The LCD shows basic visual elements and the relative brightness values between these elements. It is also possible to make approximations concerning color temperature and white balance as the monitor provides surprisingly good color. On some dSLRs, the LCD can be used as a live viewfinder to compose images. It can also be used for paging through and editing images, and on most models this is where the menus for camera functions can be accessed.

Regardless of what mode the camera is using to capture the information, i.e., RAW or Jpeg, what you see on the LCD is a Jpeg compressed image. The monitor is not reliable for judging exposure. The overall appearance of the image does not accurately represent visually the exposure value. In general, a satisfactory image on the monitor results is an underexposed file. Always refer to the histogram to ensure optimum exposure.

The Highlight Alert function in the menu activates the "blinkies." When viewing the image on the camera LCD, areas of overexposed pixels lacking detail will blink. Blinkies only warn of overexposed pixels.

The LCD uses a great deal of battery power. Excessive or lengthy use of the monitor can quickly drain batteries.

For proper exposure, it is important to remember the meter, the image preview on the LCD, the Highlight Alert, and the histogram provide different information. All should be utilized in the decision-making process. The LCD preview is based on the rendered gamma-corrected Jpeg, even if shooting in RAW-only mode. The feedback on the LCD is only part of the message. It displays a deceptively high level of contrast. A technically correct exposure often produces an ugly LCD image. A rich, vibrant Jpeg preview on the LCD can often result in an image file as much as 1½ stops underexposed. Therefore it is necessary for the photographer to comprehend and analyze the data from the meter, the LCD, the blinkies, and the histogram.

Measuring Light

Despite all the rhetoric differentiating digital from film, there has been a paradigm shift in technology and it has altered the way we should think about taking quality pictures. The vocabulary, as well as function, has changed. Workflow versus processing, archiving instead of editing and, because computers are making most of the decisions, even exposing an image has been affected.

On black and white film we were instructed to "expose for the shadows, develop for the highlights" to make the ideal negative. With positive color films, we would expose to hold detail in the highlights, and let the shadows fall where they may. But in digital just getting the exposure "between the uprights" of the histogram is not enough. The sea change in exposure methodology now is intended to place as much data within the RAW/NEF file as is possible. In linear digital capture, the brightest stop of highlight data contains half of all the information contained in the entire image. The next stop represents half the remaining information and so on. The issue is not about overexposure but that a file has the greatest chance to reproduce detail if the information is justified closest to the highlight side of the RAW/NEF file. Despite all the recovery that can be done in postproduction, you can make it remarkably better. The current mantra for the new ideology is *Expose to the Right*, placing the highlight point of the histogram by adjusting the camera exposure value to maximize file information. This is especially important with higher ISOs. (See the section *Histogram* on page 40.)

Understanding the Light Meter

Correct exposure in photography is a function of the incident light and the sensitivity to that light. If the light and the ISO remain the same, exposure remains the same, regardless of the color or tonal value of the subject. The only exception is with shiny reflective subjects, such as chrome and steel.

An **incident light** meter is held directly in front of the subject. It has a translucent dome over the meter cell that is pointed toward the light source to be measured. The incident meter measures the quantity of light falling on that subject. In general photography, the incident meter always indicates a correct exposure value.

The dSLR camera has two built-in light metering systems. One meter system measures the amount of continuous ambient light reflecting from the scene. A second system measures the amount of flash from a Speedlight reflecting off a subject. Both built-in meters are **reflective meters**. Reflective meters do not satisfy the correct exposure criteria, as reflective meters measure reflected light values rather than incident light levels. A change in subject reflectance will cause the reflective meter to indicate a change in exposure, even if the light falling on the subject and the ISO remain the same. Therefore, reflective light meters do not always indicate technically correct exposure values.

An example of when a reflective meter may give a rollercoaster of inconsistent exposure values is a professional soccer match at midday. If the light falling on the field remains the same, the correct exposure for all the action on the field will remain the same. The camera can be set to one correct exposure value for all pictures. The reflective meter, however, may see a rapidly changing array of reflectance values, such as a player in a light colored uniform running in front of a variety of light and dark advertisements along the edge of the field surrounded by opposing players in dark uniforms. Even though the light remains the same, the reflected meter will indicate different exposure values. Many of these will be incorrect.

The reflective meter is a simple comparative measuring instrument rather than absolute truth. Zero on the reflective meter has been a standard reference point for determining exposure for generations, whether working with older mechanical analog devices or modern backlit electronic displays. Setting the exposure compensation to zero, manually making the meter go to zero in

the viewfinder, or rotating a dial on a handheld meter to center a needle, all indicate a relative amount of light to render the scene as a middle tonal value. A wall photographed with the meter at zero will result in an underexposed image file. The white wall will be recorded as a middle tonal value. A black luggage bag against a black curtain photographed with the meter at zero will likely be overexposed. The dark tones will be exposed closer to middle tonal values. The amount of this effect will depend on the meter pattern or meter mode on the camera. Evaluative and Matrix metering allows the camera's computer to evaluate information and apply exposure compensation for subject reflectance on its own. Any change applied by the photographer is in addition to compensation by the computer. Center-weighted Averaging and Partial and Spot metering put exposure decisions purely in the hands of the photographer.

Ultimately, it is up to the photographer to tell the meter and the computer what to make the picture look like. If it contains mostly light tones, the photographer instructs the camera to correctly expose this scene by setting the meter to read at + , where light tonal values live on the scale. The more whites, the more + . If the picture is mostly dark, the photographer moves the meter to − , where the dark values exist. This remains true regardless of the intensity or dimness of the light. Correctly exposing a light scene still requires + in bright or low light conditions. In general, to consistently achieve maximized exposure values, consider the tonal values in the viewfinder, evaluate the meter setting according to the predominant tonal values, and analyze the resulting values as indicated by the histogram. All of these steps combine to ensure a maximum amount of usable information in the digital image file, i.e., correct exposure.

In summary, the reflective meter, for existing continuous ambient light and for flash, provides the following:

1. Measures the amount of light reflecting off the subject
2. Provides an exposure value to record the scene as a middle tonal value. The meter reading changes with subject reflectance.
 i. White tones may require more exposure, more light.
 ii. Dark tones may require less exposure, less light.

It's really quite simple. It starts with light. Light strikes an object, it refracts through the lens of the eye (or of the camera) and creates vibrations in the soul.
Matthew Rolston

Shoot to the histogram. Use exposure compensation to adjust the histogram and to adjust the recorded (captured) tonal values in the file.

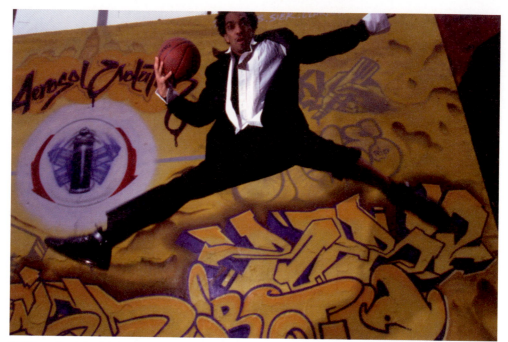

PHOTO 1.10 Tuxedo (see lighting diagram on page 164).

PHOTO 1.10 *Tuxedo*

A good friend asked me to take photographs for a magazine article. He was being interviewed about an inner city educational project and wanted art for the story. After talking to the editors about their specifications, I accepted the job. The deadline was tight but we had an idea.

I had known Wyatt for years and he was a great athlete as well as a professional dancer. I had used him as a model many times. He bought a brand new tuxedo for the shot, but was originally "from the streets." We wanted to take advantage of this dichotomy. Near my studio was a huge wall in a playground. The gangs used to "tag" the tennis court walls with wonderful graffiti. That was to be our background. I dragged my mini trampoline to the park. Wyatt could "get air" because of his athleticism and at the same time give me the aesthetic "splits" from his dancing prowess. We were after the contrast of sports, formality, and their opposites.

I had one Speedlight off-camera at the end of a 15-foot custom-made TTL cord. The camera was set on Program Mode and rear curtain sync to take advantage of any possible blur (note his feet). Timing was critical because I had to hit the shutter release at the apex of his jump. The weather was perfect. It was overcast so the light was flat and there were no contrast anomalies. I pushed the ISO a little but no other precautions were taken.

Wyatt is one of the few people I know who is resilient enough to jump over and over without losing energy and style, but we still had to finish the shot quickly.

Stops, F/Stops, Exposure Value

Photographers must learn both a visual language and a technical language. The definitions and terms in photography allow photographers to quantify light and to communicate with each other.

Open one stop. Overexpose one stop. Give one stop more flash. Three common statements using the same common term — stop. Yet each statement denotes distinctly different decisions and actions, triggering chains of events with differing end results.

Literally, the word **stop** refers to the mechanism of the iris diaphragm. A stop is a thing, a physical barrier in the lens that regulates the amount of light passing through the lens. In practice, the word stop also compares distinct changes in quantities of light entering the camera, on a subject, or emitted by a light source. When any quantity of light is doubled, that quantity of light is termed one stop more light. When the quantity of light is halved the result is one stop less.

Plus one stop or minus one stop does not automatically mean only changing the aperture. Plus one refers to doubling the quantity of light. Depending on the desired visual effect, a one stop change can be accomplished by changing shutter speed, changing f/stop number, or a combination of the two. Changing the amount of light with shutter speed will shift the histogram and alter the recording of motion. Changing with f/stop will shift the histogram and change depth of field. To say "open one stop" or "close one stop" specifically refers to changing the **f/stop** number, opening or closing the aperture diameter.

ISO is compared in stops. When ISO is doubled, the sensitivity to light is doubled. ISO 200 is one stop more sensitive than ISO 100 and only requires half the light to obtain correct exposure. Changing the ISO will shift the histogram without changing shutter speed or f/stop number.

The quantity of light falling on the subject and the quantity of light provided by a flash are also measured or expressed in stops. If the light falling on a subject is doubled, that quantity is said to have increased by one stop. With flash, if the flash duration is halved, the flash will be reduced by a stop. In both cases, by changing the quantity of light, the histogram is shifted without changing shutter speed, aperture, or ISO settings. Comprehending exposure expands the aesthetic possibilities.

The term f/stop causes much confusion and conflict. **F/stop** as set for the lens defines a specific quantity of light entering the camera. F/stop

number relates directly to the diameter of the aperture — the size of the hole, not the size of the number. F/2.8 is a larger diameter opening, so f/2.8 is a large aperture. F/22 is a small aperture. F/stop is one element of depth of field. F/stop is used as a word, is labeled by a number, and actually expresses an equation.

$$\frac{\text{Focal length}}{\text{Diameter of the aperture}} = \left\{ \begin{array}{l} 1.4 \\ 2 \\ 2.8 \\ 4 \\ 5.6 \\ 8 \\ 11 \\ 16 \\ 22 \end{array} \right.$$

This equation explains why a tiny opening on a wide angle lens lets in the same amount of light as a much larger opening on a long telephoto.

F/8 worth of light through the lens is the same for all lenses set to f/8. If the lens designer has succeeded, the photographer can trust that the f/stop number is a constant. Consumer grade zoom lenses are often variable aperture lenses, where the f/stop number changes as the focal length is changed. Actually, on these lenses, the aperture diameter remains the same as the focal length changes. These lenses may be f/3.5 at a wide focal length, yet only let in f/5.6 at a long focal length at the same maximum aperture diameter.

A constant aperture lens has a complex mechanism that precisely adjusts the aperture diameter as the focal length is changed, resulting in a constant maximum f/stop number at all focal lengths.

Since f/stop defines a specific quantity of light, f/stop is an Aperture Value worth of light entering the camera, on the subject, or emitted from a light source. Aperture Value can be used to quantify light in almost any context. A flash may provide f/5.6 worth of flash. If the flash is doubled, it now provides one stop more. The flash will now provide f/8 worth of flash.

Canon: Aperture Priority exposure mode is Av, representing the photographer selecting the aperture value of the exposure. Shutter Priority exposure mode is Tv, representing the photographer selecting the time value of the exposure.

Nikon: Aperture Priority mode is A and Shutter Priority is S.

PHOTO 1.11 Computers (see lighting diagram on page 165).

PHOTO 1.11 *Computers*

Time and time again corporate photographers are asked to perform miracles. We are wedged into ugly, cramped quarters and assigned to make companies look bigger and more important than their numbers. Often we are called on to shoot the standard computer shot, which is supposed to show off some piece of software for a "startup" or imply that an old stodgy industry has become high tech. The assignment is ultimately to make clients look good.

Faced with another boring over-the-shoulder computer screen shot, my work was cut out for me. At least the room was large but, at the same time, it was featureless. I realized I was going to get little help from the setting. So I pressed two computers together at right angles. We spent a lot of time working with programmers to get something interesting on the screens. They showed us page after page of what they were proud of but everything that would make a good picture was proprietary or a "work-in-progress." I always insist with clients that for computer shots they *have* to dedicate a computer expert to the shoot. So much time is wasted with incompatibility problems or technical glitches.

We hid a small softbox behind the "main" computer screen and angled the secondary one so there was no spill of light onto the screen. This was the only supplemental lighting in the shot. We goboed that light so it did not spill underneath the screen and reveal its placement. The illusion is that the screens were creating all the illumination. We used Shutter Priority mode so we could control the exposure off the screen. The shutter speed was relatively long. It is called "dragging the shutter." We turned off most of the lights in the room to make the scene more dramatic. I constantly prodded the programmer to face just the perfect direction to reflect the graphics in his glasses.

Exposure Value (EV), is another common photographic term requiring clarification. It denotes all combinations of shutter speed and relative aperture that give the same exposure.

Many light meters and camera systems have been calibrated to operate using the EV system. EV 0 is 1 second at f/1.0. Interpolating shutter speed and aperture values: EV 0 is also 8 seconds at f/2.8, EV 1 is 4 seconds at f/2.8, EV 2 is 2 seconds at f/2.8, EV 3 is 1 second at f/2.8, EV 4 is half a second at f/2.8, etc. Since EV indicates a specific quantity of light, different combinations of shutter speed and aperture will produce that same quantity, and are therefore the same EV. These combinations producing the same EV are called **Equivalent Exposures**. Equivalent Exposures maintain the same quantity of light while giving the photographer creative choices in the recording of motion and depth of field, and allow flexibility in responding to individual situations.

Example:

$$EV\ 12 = \begin{cases} 1/4000 \text{ second at f/1.0} \\ 1/2000 \text{ second at f/1.4} \\ 1/1000 \text{ second at f/2} \\ 1/500 \text{ second at f/2.8} \\ 1/250 \text{ second at f/4} \\ 1/125 \text{ second at f/5.6} \\ 1/60 \text{ second at f/8} \\ 1/30 \text{ second at f/11} \\ 1/15 \text{ second at f/16} \\ 1/8 \text{ second at f/22} \\ 1/4 \text{ second at f/32} \end{cases}$$

In some cases, the desired visual effect determines the need for a particular EV. The photographer may be faced with an image where stopping motion, great depth of field, and low light are all necessary. In this case, a high ISO may be required to successfully achieve an EV with a fast shutter and a small aperture that also gives a technically correct quantity of light.

A change in one EV results in a change of one stop. +1 EV is equivalent to plus one stop, −1 EV to minus one stop. Once again, this does not automatically mean to change just the f/stop number.

In review, "plus one stop" can be accomplished with shutter speed, aperture, ISO, and/or light. "Open one stop" means a larger f/stop number. "One stop more flash" requires changing the flash exposure compensation. To obtain a one stop faster shutter speed with the lens aperture wide open, double the ISO. The photographer must become more precise in comprehension and retention of vocabulary and pay close attention to context. Inaccuracies lead to unsatisfactory results. Precise photographic vocabulary results in more fluid problem solving.

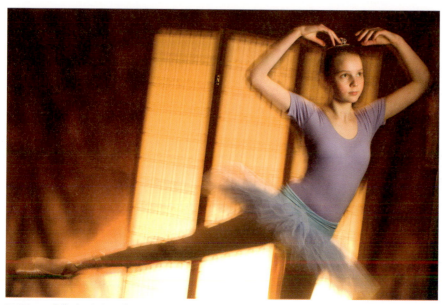

PHOTO 1.12 Ballet (see lighting diagram on page 166).

PHOTO 1.12 *Ballet*

This shot incorporates a technique I started using with film cameras years ago. Speedlights allowed me to update it.

In the studio my assistant set up a mottled background. The painted canvas was lit with two industrial incandescent work lights: one pointed at the background and the other pointed through the Japanese shoji screen placed between the cloth and the dancer. There is a Speedlight inside a small softbox off to the right side aimed at the model.

The technique works because the flash freezes the image of the girl who is in total darkness, then the camera is moved which blurs the continuous light on the background. Depending on which way you shake the camera you can get different effects on the shadow side giving the picture movement and a somewhat ethereal feeling.

The Speedlight is set on Shutter Priority for one second. It took a great deal of experimentation to arrive at that shutter speed: too long and blurring overwhelms the picture, too short and you do not have enough time to react and get the movement to show up artistically.

Shutter Priority locks the time in and the camera makes a correct exposure every time. What used to require a fair amount of trial and error to get the exposure right now happens automatically. That made this pose possible since the young girl could only hold the position for limited periods.

Histogram

The camera LCD monitor is a great place to make decisions regarding cropping, composition, expression, gesture, and sharpness and to evaluate lighting. But the appearance of the digital image on the camera LCD monitor is not an accurate depiction of the actual digital image file exposure. In most cases, if an image looks "perfectly" exposed on the camera LCD monitor, it is more than likely suffering one or more stops of underexposure. A better way to make exposure decisions is to use the histogram. The histogram is one of the most powerful exposure instruments provided to photographers. The histogram far surpasses the Polaroid as a testing tool and is instantly available for *every* image as we shoot. Resist the temptation of relying solely on the LCD for previewing.

> The Luminosity or Bright **histogram** is a true graphic representation of tonal values as recorded in the digital image file. The **histogram** is a graph: brightness on the horizontal axis (x-axis) and number of pixels at each brightness level on the vertical axis (y-axis). It is basically a mapping of the tonal values in an image and allows the photographer to see the accuracy and spread of the exposure over the camera's dynamic range. The left and right edges of the histogram represent the limits of the digital sensor's capability to hold shadow and highlight details. The extremes of the histogram display represent the dynamic range of the sensor. Pixels piled up against or touching the right edge of the histogram represent pixels overexposed with no detail. These are pixels recorded as "pure paper white," since no ink will be deposited in these areas when printed. Pixels touching the left side of the histogram represent pixels exposed as pure black with no detail. Besides the full histogram, the LCD often displays three distinct graphs representing the three color channels: red, green, and blue. The height of the spikes represents the number of pixels exposed at any one tonal value. High spikes represent large numbers of pixels exposed at that tonal value; low spikes represent few pixels exposed.

In general, there is no universal or ideal histogram. A good histogram is one that accurately represents the tonal values as existing in the scene, or more specifically, represents the photographer's vision.

The following diagram shows the correlation between the "bars" or sections of the histogram, and the tonal values these sections represent as recorded in the image file.

Canon cameras display a five-section histogram.

Nikon cameras may display a four- or five-section histogram depending on the sensor.

A to Z

banding (bānd-ēng) n. 1. posterization. 2. the appearance of visible steps or bands of color that replace subtle gradations in order to accommodate a reduced palette. 3. artifact of color gradation when graduated colors break into larger blocks of single color. 4. often the result of over-manipulation or compression in a digital image.

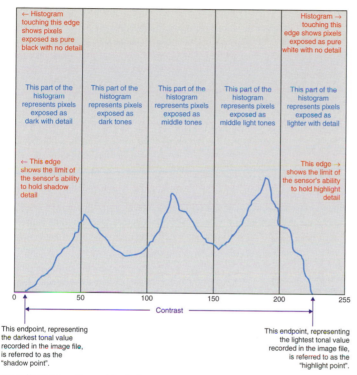

FIGURE 1.4 Histogram sections and tonal values.

Because digital is a direct positive image capture, similar to color transparency film and Polaroid prints, in most images the concern is in holding highlight detail. The brightest highlight value in the scene is represented by the **highlight point**. If the highlight point touches or piles up against the right edge of the histogram, this is an indication of overexposed highlights. The highlight point is used to judge exposure. It is the brightest tone in the picture. To shift the highlight point to the right, allow more light into the camera. To shift the highlight point to the left, allow less light. The entire histogram moves as the highlight point is moved.

Once the highlight point is placed to the photographer's satisfaction, the **shadow point** now defines the contrast level of the scene or lighting. The width of the histogram indicates the contrast range of the scene. With a satisfactory highlight point, a shadow point touching or piling up on the left indicates high contrast with loss of shadow detail. For suggestions regarding controlling contrast, see *Characteristics of Light: Analysis and Decisions; Contrast* on page 61.

Since each section of the histogram represents approximately one stop of tonal value, counting the number of sections the highlight point needs to be moved on the histogram correlates to the number of stops to change on the camera exposure.

Looking at the diagram in Figure 1.4, consider the following examples:

1. A "polar bear in a snow storm," correctly exposed, should display a histogram with the majority of the tonal values in the "white with detail" section. To ensure detail in all the white values, no pixels should touch the extreme right edge. A small "bump" may appear in the "black with detail" section, representing the bear's black nose and claws.

2. A group of groomsmen in black tuxedos against a dark-toned background, correctly exposed, should show the majority of tonal values in the "black with detail" and "dark tones" sections. Depending on skin tone, the faces may display in the "middle light" or "white with detail" sections. White shirts would also display in these sections. To ensure detail in all the white values, no pixels should touch the extreme right edge. To ensure full shadow and tuxedo details, no pixels should touch the extreme left edge.

3. A scene containing green grass, red brick, and blue sky, correctly exposed, would display the majority of tonal values in the middle, as these are all middle tonal values of these colors.

Underexposure provides no benefit.
Underexposure causes excessive noise in shadows at all ISO settings.

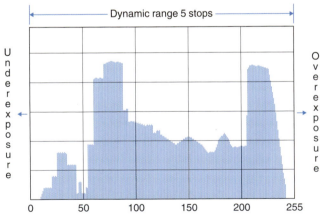

FIGURE 1.5 Histogram dynamic range.

In linear data capture a typical 12 bit image can record 4096 distinct levels of intensity for each pixel. The dynamic range of most dSLRs is about 5 stops. Half of the levels (2048) are represented by the right 1/5 of the histogram. Half of the remaining levels (1024) are contained in the next brightest stop. The third stop holds half again as much information (512). The darkest stop or the far left 1/5, has only 128 levels of capture data.

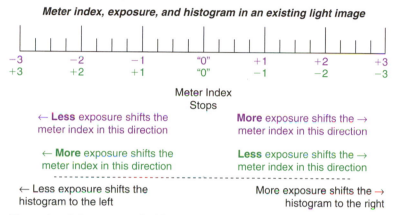

Meter index, exposure, and histogram in an existing light image

| −3 | −2 | −1 | "0" | +1 | +2 | +3 |
| +3 | +2 | +1 | "0" | −1 | −2 | −3 |

Meter Index
Stops

← **Less** exposure shifts the meter index in this direction

More exposure shifts the → meter index in this direction

← **More** exposure shifts the meter index in this direction

Less exposure shifts the → meter index in this direction

← Less exposure shifts the histogram to the left

More exposure shifts the → histogram to the right

The number of stops exposure is shifted on the Meter Index Display correlates to the number of sections the histogram is shifted on the histogram display. On most cameras, if more than 2 stops of exposure compensation is required, use manual camera exposure mode.

FIGURE 1.6 Exposure meter versus histogram.

RGB Histogram

The **RGB histogram** shows the exposure levels for each of the three color channels making up the digital image file: red, green, and blue. The RGB histogram is used to ensure visible detail in all color channels. There may be images where the Bright or Luminosity histogram shows no overexposed pixels, yet the blinkies are indicating loss of detail. This may be a case where highlight tonal value, or color, is held, but those areas contain color, and tonal value with no visible detail. For these situations, view the RGB histogram to determine if one of the color channels is touching the right edge, indicating overexposure. Reduce the camera exposure to ensure highlight detail in all channels.

With the combination of the LCD and the histogram, the modern photographer has a frame by frame accounting and metering system of unprecedented capabilities. Learning to interpret these data is essential for Speedlight usage.

Exposure Bias for Digital

As stated before with the introduction of digital capture into photography there has been a paradigm shift. All the principles of physics that have been bedrock remain the same, but with a new medium of storage, the scientist, engineers, and practitioners have found that they can achieve better results with some reevaluation. As with film, there is a finite capability. Digital may have an extended five stop range, more than E-6 or C-41 color films, but not as wide as black and white film.

Many techniques of digital photography are similar to film. And there is even software that can simulate the look and characteristics of specific films. But digital is still incapable of recording all the tones, values, and details seen by the human eye. Exposure decisions are based upon holding detail in the highlights, similar to metering and exposing color transparency film. Except for special effect, never overexpose highlights, even though in high contrast scenes, shadow values fall where they may.

Different from using a light meter, that does not inform you of as many details, you should be paying close attention to the histogram. If you comprehend the commonalities of digital versus analog, it is easier to take advantage of the differences.

Middle Tonal Value

To continue the analogy, in digital photography, EV is the combination of shutter speed and aperture that defines the quantity of light entering the camera. The reflective meter indicates what that EV should be. The "standard exposure value" is when the meter index is aligned with "0" and this, through a complicated set of algorithms, renders the predominant tones in the viewfinder as **middle tonal value** in the digital file. Examples of middle tonal value typically are green grass, red brick, i.e., the 18% gray of analog photography.

Like hidden detail in the film negative, if information is contained "between the uprights" of the histogram, we can access that detail using software to enhance the final print. This is analogous to latitude in film.

> The standard metered exposure value (EV), i.e., the meter at 0, may not be the "correct" exposure value for the picture you are making.

Exposure Compensation

Not to belabor the point by comparison to old manual film cameras, where shutter speed and aperture were the sole devices to alter exposure, digital technology has introduced a new method. Changing the EV may be biased by Aperture or Shutter Priority modes already selected.

> Aperture of f/8 and a shutter speed of 1/125 of a second at ISO 100 is 13 EV.

To maximize the amount of information in the digital file, use exposure compensation to shift the histogram, placing highlight values in the scene as high as you can on the histogram, without overexposing the highlights, i.e., expose to the right.

> If you need to shift the histogram more than Exposure Compensation allows, go to Manual Exposure Mode.

The reflected meter reading can be adversely affected by many common scenes. Use EV compensation to correct the reflected meter reading in the following scenarios.

Predominantly white or light-toned scenes such as snow, sand, or a white dress may require Exposure Compensation of +1 EV to +2 EV.

Predominantly dark-toned scenes such as tuxedoes or spot-lit theater stages might need Exposure Compensation of −1 EV to −2 EV.

Back-lit, top-lit, and side-lit subjects can use Exposure Compensation of −1 EV to −2 EV.

Shadowed subjects against brighter backgrounds such as subjects with sunny backgrounds or a subject with a window in the background might need Exposure Compensation of +1 EV to +2 EV.

Night photos with light sources in the picture such as street lights, neon signs, or headlights, or when shooting toward the sun could require Exposure Compensation of +1 EV to +2 EV.

Excessive Contrast

What if all the pixels do not fit within the graph? In some situations, contrast will exceed the ability of the digital sensor to record detail from shadows through highlights. Excessive contrast cannot be corrected through Exposure Compensation alone. The contrast can be changed via the light or by altering tonal values. The only exposure options are expose for shadow detail and let the highlights "blow out" or expose to retain highlight detail and let shadows go black. (See the section *Contrast* on page 61.)

Excessive contrast can be corrected in the following ways:

1. Use flash to add light to the subject, bringing illumination and tonal values closer together, thereby reducing contrast, i.e., fill flash.
2. Use a reflector to add fill, reduce contrast.
3. Change the contrast response of the digital sensor by accessing the following adjustments in the Menu:
 Canon: Processing Parameters or Picture Style
 Nikon: Image Adjustments
 i. This is a way to expand or compress the histogram by changing the contrast setting.

4. Change the available light on the scene.
5. Change the tonal values included in the scene.
6. Make a few identical image files varying the exposures, some exposed for the highlights, some exposed for the shadows, combine in Photoshop.
 i. This can lead to using **high dynamic range** (HDR) technique.

Mastering Distance: Near and Far

The Bounce and Swivel Head and Zoom features of the TTL flash (see also the section *Speedlight Components* on page 22) can solve some distance problems. Acquiring the skill to recognize when and how to "morph" your flash into correct position takes some practice but will reap extra benefits with experience.

Swiveling the "center" of the TTL flash toward the further subject, illuminating the near subject with the dimmer "edge" of the TTL flash.

FIGURE 1.7 Flash swivel.

The Zoom Head feature can be manually set, changing the angle of illumination of the TTL flash. Setting the flash Zoom Head to a long focal length will illuminate the further subject with the brighter "center" of the TTL flash and the near subject(s) will receive the dimmer "edge" of the TTL flash.

FIGURE 1.8 Flash zoom.

The Zoom Head can also be used to "even out" the near and far illumination for the wedding aisle shot or when making on-camera flash pictures in narrow hallways or stairwells.

The orientation of the TTL flash reflector can help shape the light. Held horizontal, the light from the flash spreads wider. With the TTL flash held with the reflector vertical, the light from the TTL flash will be taller and narrower.

FIGURE 1.9 Flash orientation.

Switching from vertical to horizontal, bounce to straight-on, or wide to narrow has so many configurations it is like solving a Rubik's Cube®. Rachet the swivel head for optimum coverage.

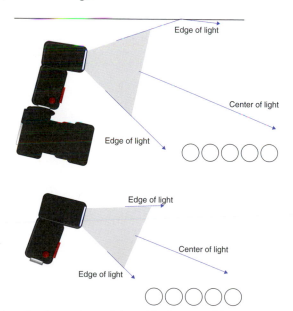

Tip the flash up for elevated crowd shots. The "center" of the TTL flash travels the furthest but illuminates the far subjects with the brighter light. The "edge" of the TTL flash illuminates the near subject with less bright light. This will help even out the flash exposure from foreground to background.

FIGURE 1.10 Flash tilt.

Sometimes you've got it, sometimes you don't. Sometimes you bring it with you. Sometimes you won't. Merging environmental Illumination with supplemental is a creative choice. It is taking charge and improving on nature. Rather than using your flash to just override the available light, you can blend the two. The ability to integrate artificial light with available is an acquired skill. Which one should dominate, which one is secondary? Sometimes it becomes a contradiction in terms.

Main Light and Fill Light: Definitions

Mixing flash with existing light is *multiple light source* photography. The following definitions will assist in the decision-making process when mixing flash and existing light, and later when using multiple flashes. These definitions do not refer to specific lights, only to the purpose and position of the light. Any light source can be considered as Main, Fill, or Accent.

Main light or **Key light** is the predominant, brightest light source on the subject. The Main light creates the direction of light, the placement of highlights, the placement and direction of the shadows, and the predominant color balance/color cast. For digital, the Main light determines the EV set on the camera. It can come from any position in the frame. To use TTL flash as a directional, off-camera Main, see the sections *Wireless TTL Flash* on page 96 and *TTL Cords* on page 135.

Fill light provides less illumination on the subject than the Main, reduces contrast, reduces shadow density, and provides more visible shadow detail. **Flat Fill** reduces contrast while maintaining the illusion of a single light source illuminating the subject. Flat Fill comes from the camera position, not from the side of the subject. Camera-mounted flash on a professional flash bracket makes an ideal Flat Fill. **Form Fill,** where the fill is placed in front of the subject's nose and may be pointing off camera, is effective and dramatic in portraits.

A poor direction of Main light is not improved by Fill. It is better to create a more suitable direction of Main.

With a directional off-camera Main and a flat on-camera Fill, the Fill light will not and cannot eliminate shadows on the subject, even if the Main and the Fill are equal in intensity. The highlights will always be made up of light from two light sources versus the shadows receiving light from one.

To eliminate shadows on a subject, illuminate the subject with a flat, frontal Main light.

PHOTO 1.13 Lobsterman (see lighting diagram on page 167).

PHOTO 1.13 *Lobsterman*

During a workshop on Cape Cod I was demonstrating lighting with the help of one of the participants. I set up a character model against a wall of lobster buoys. We had brought the clothing (red coat, yellow boots, and fedora) and the rope as props but they were for other shoots.

It was a perfect overcast day so every highlight and shadow was well within limits, but the model's dark skin was right on the edge and that was the most important element in the picture. I opted to set up a remote Speedlight on a stand, off to the right, close to my subject. The Master flash was camera-mounted and the camera was in Programmed mode. So with sufficient ambient light, the off-camera strobe defaulted to create directional fill light intended to put a reflection on the man's face and some tone in the red coat. The Master acted merely as a wireless trigger.

I worked around all the students who were also vying for position. All decisions were made looking at the LCD and histogram. No formula exists to determine a good portrait, especially while in the making. A lot of things have to happen: character, color, content, and timing. It was all done on the spur of the moment but was the best picture I took all weekend.

Accent lighting gives separation, depth, and added richness. It can be light that is not on the subject but on other surfaces or foreground or backgrounds. **Rim light** or **Edge light** comes from an angle behind the subject. It separates the subject from the background by illuminating the subject's edges. Hair light usually comes from an angle behind and above the subject and is intended to highlight or "rim" just the hair. **Background lighting** illuminates the background behind the subject. All are considered Accent lights.

A to Z

metamerism (mĭ-tām′ə-rĭz′əm) n. In color theory, it is a condition when two samples of a color appear to be the same under one light but different in another.

Philosophy
Light

Since this text is making the claim that mastery of photography is essentially mastery of light, our first chore is to recognize definitive characteristics and components of the myriad forms of illumination sculpted by time and location and climate. Outside, surveying the natural world, cameras are mirrors held up to reality. To *take* pictures that reflect our surroundings is at the foundation of photography.

The average person pokes their head outside to see if the day will be sunny and likely to be a pleasant day to take pictures. This is not an option open to the professional nor does it take into account critical timing or history. The events in question may be unique or too important to wait for more favorable conditions.

Visible light has infinite variations. It is the responsibility of photography and photographers to document them all. There is mood, character, and energy in light even when it is less than optimum. And if you have no choice about

PHOTO 1.14 *Bouquet*

The glass top coffee table spurred the idea. By directing the bounce flash further back on the ceiling, above and behind the flowers, the reflection of the illuminated white ceiling would appear on the glass. Several test files were required to fine-tune the angle of bounce and find the right spot to eliminate the reflection of the recessed lighting fixtures in the ceiling. This technique re-creates the look of a studio product photograph shot on plexiglass, where a large softbox is suspended on a boom arm above and behind the object. The reflection of the softbox on the plexiglass is on purpose. The brown squares in the background are the pattern of the rug under the table.

PHOTO 1.14 Bouquet (see lighting diagram on page 168).

conditions you may have to take a quantum leap and import your own "sun." No worry. Everything you learn about natural light applies for artificial too. Conversely, all the techniques you acquire substituting for sunlight — hot lights, fluorescent, flash, etc. — come into play under any circumstance.

For the sake of convenience, small flashes have become the standard for a lot of today's photography. Buy an expensive camera then attach a flash to the top. It has become such a ubiquitous solution that many manufactures are building the flash right into the camera. With a little extra effort, in the digital world, these flash-on-camera devices are a tremendous asset to making better, printable pictures.

However, the distinctive omnipresent frontal light is a "signature" of our inability to rearrange the position of the light. Unwarranted shadows are often the by–product of necessity and ease. But in much commercial work, the telltale evidence of a photographer's intervention is unacceptable. (The one exception: when skillfully used as fill light to just open up shadows, where on-camera lighting does not look like flash and can be quite advantageous.)

Dedicated photographers have developed elaborate formulas, charts, and tricks to calculate and match the output of flashes with the cameras, lenses, and films of choice. Because it is so complicated, equipment manufacturers have conspired to make this task quicker, easier, even automatic — with mixed results. Traditionally photographers, for whom flash is their stock-in-trade, use antiquated methods, standardize their technique, or manually calculate output to guarantee results.

Devices that measure the light output of flashes make it possible to increase acceptable results from on-camera flashes, but they are slow. And as soon as you attempt to take that one light off camera things get even more complicated. Not only is it harder to predict the quantity of light but also the quality of the final outcome.

The direction of light has the greatest influence on the veracity of the photography. Heavy-handed lighting looks deceptive … obvious … artificial. But a little practice goes a long way. And it always helps in predicting the results.

If you engage in the kind of photography that demands flexibility — photojournalism, event, wedding, sports — you may not want to transport a lot of extraneous equipment. Granted, with one light you can illuminate what you need and remain mobile but you are limited creatively.

However, you can exploit those very limitations. *On-camera* flash is most often coming from the same direction — the same axis as the lens. But you can augment flash appearance by bouncing that one light off the ceiling or off the walls or diffusing and enlarging its apparent size with light modifiers for different results. Throw a reflector into the mix and you give the scene a much more casual appearance.

When you move the light *off camera* you are no longer merely "throwing light." Off camera the light is coming from *somewhere*. Off camera, one light is a force to be reckoned with. Now you misdirect the eyes off center for drama and mood, illuminate those parts of the picture you want everyone to see, and obscure those segments you may want them to ignore. Unfortunately, the larger the separation between flash and camera the harder it is to predict. Even though the light obeys the same laws of physics, it is harder to anticipate all the additional perturbations as it becomes more removed from camera proximity and all the obstacles it will encounter on its way back through the lens.

Enter the digital SLR and Speedlight. For the first time we can put the light anywhere in the vicinity and not only will the integrated camera and light combination make its best effort to calculate the proper amounts automatically, but it will do so without any physical link between the two. Wireless firing and exposure. Then we view the results immediately on the back of the camera. The LCD confirms whether our placements are achieving the effects we want and whether it is doing it correctly. We no longer have to return to where we put the light to adjust everything.

Light can be gentle, dangerous, dreamlike, bare, living, dead, misty, clear, hot, dark, violet, spring-like, falling, straight, limited, poisonous, calm, and soft.

Sven Nykvist

War Stories

High School

Often money dictates your approach to an assignment. Two years in a row a very unique charter public high school asked me to do a black and white brochure to publicize their academic successes. Their ambitions were bigger than their budget. We had to document the different departments — Math, Language, Science, etc. — and emphasize the diversity of their student body.

I solved the logistics by shooting the whole project with one Speedlight and a tripod. I instructed interns to hold and aim the TTL lights so I could move faster and not have to do so much setup and breakdown. We worked with each featured student/model for an hour or so and were able to expedite the extensive "shot list." The technique allowed us to compress the whole job each year into one or two days, maintain my style, and still collect a reasonable wage.

LAJ

A to Z

photography (fə-tŏg′rə-fē) n. Literally from the Greek and means writing with light.

Characteristics of Light: Analysis and Decisions

To make more effective lighting decisions, it is important to understand as much as possible about the behavior of light. The first step to learning lighting, i.e., duplicating or controlling or modifying light, is to be able to describe it. Throughout history cultures have developed subjective ways of doing this. Those who needed to talk about it for practical reasons applied unscientific nomenclature. Artists used poetic terms and metaphors, but photographers need their own useful language.

All light exhibits five distinctive characteristics that can be utilized and/or changed without inherently altering the others. The five characteristics of light are factors that distinguish one kind of light from another as well as the effect of the light on a subject. The **Five Characteristics of Light** are as follows:

Quantity
Contrast
Quality
Color
Direction

Quantity, Intensity, or Brightness

To photographers the most important characteristic of light is its quantity, alternately called intensity or brightness. Photographers may need to define many different variations of the same light: the quantity of light falling on a subject, the quantity of light reflecting from the subject, the quantity of light illuminating the highlights, the quantity of light in the shadows, and the quantity of light entering the camera.

Before TTL, incident light meters were placed in the path of the source to measure the quantity of light falling on a subject. All things equal, the

PHOTO 1.15 *Anya in White*

This image was made with one direct, unmodified, Speedlite mounted on a professional flash bracket on a handheld camera. The center of the Speedlite is located close above the center of the lens, producing a front light. The full length is shot with a 110 mm focal length at a distance of 25 feet with the model against the white back wall of the studio. The longer distance creates a narrow angle between the center of the lens and the center of the flash, providing a nearly shadowless light. The shadow is projected almost straight behind the subject. The flash compensation is +1⅔ because of the predominance of white and light tones in the scene, adjusted according to the histogram. The overhead lights in the studio were left on to keep the ambient level bright and the pupils closed down, preventing red eye. The shutter speed was high to eliminate the effect of the ambient light 1/250 at f/4.5, ISO 100. Simple and effective.

PHOTO 1.15 Anya in white (see lighting diagram on page 169).

incident meter indicated the correct exposure regardless of scene or subject reflectance. As a general rule in photography, if the light remains the same, the correct exposure remains the same. In most dSLRs reflective light meters measure the quantity of light reflecting from a subject. Reflective meters are sensitive to changes in exposure when subject reflectance changes, even when the light remains the same. Reflected meters require the photographer to compensate for subject reflectance.

The quantity of light determines many factors involved in the outcome. ISO, noise,[6] image quality, usable shutter speed and aperture combinations that affect movement, the need for a tripod, and the depth of field are all decisions based upon the light available. In an image combining both flash and existing light, varying the quantities of existing light and of flash will result in vastly different images.

Quantities of light entering the camera can be altered by selecting a different camera setting, using neutral density filters on the lens, and by changing the light source(s).

Quantity can be reduced by lowering the power or wattage of the source, using filters over the source, increasing the light-to-subject distance, bouncing the light, and using diffusion material between the light and the subject.

The quantity of light can be increased by raising the power or wattage of a light, decreasing the light-to-subject distance, using a more efficient lamp reflector, or adding additional sources.

In general, the eye is drawn to the brightest area of an image first.

Quality

As said before, scientists and engineers speak of light in very theoretical terms: wavelengths and frequencies. Artists use more abstract words: painterly, vivid, sharp, pungent, and muted. But photographers insist on "qualifying" light. However, the terminology remains elusive. For example, many photographers that are inexperienced use lights from very far away, claiming they do not want the light to be too "harsh." What does that mean in concrete photographic terms? This discussion of quality of light will provide a more specific and suitable vocabulary.

The **quality** of light is referred to as **specularity**. A specular light is a "hard" light and a non-specular light is a "soft" light. The quality of light is analyzed by observing specifically the edges of shadow, the density of shadow, and the size and appearance of the reflection from the light source on the subject, called the specular highlight.

[6]Noise consists of any imperfections or undesirable flecks of random color in an image. Digital images produced in low light or at high ISO often exhibit this undesirable effect. Noise is the digital equivalent of film grain.

Visualize a vintage car parked at the beach. It is noon on a clear blue sky day. The edges of the shadows under the car are distinct and clearly defined. The density of the shadow is deep, the difference between highlight and shadow density is great, the scene is considered to be high contrast. The big chrome bumpers of the vintage car reflect the light source, the sun in the sky. The specular reflection is small and intense. This is called hard light.

The weather changes, clouds roll in, the sky becomes overcast. The edges of the shadows under the car become feathered and indistinct. The density of the shadow is reduced. Shadow and highlight values move closer together. The contrast is low. Those big chrome bumpers show a reflection of the light source, now the entire sky. The specular reflection is large and broad and lustrous. This is soft light.

The difference between hard and soft light is the difference in light sources. In the example hard light is produced by the direct sun. The sun is a huge star, yet appears as a small pinpoint light source in the sky. Soft light is produced by overcast, when the light source is the entire sky from horizon to horizon. This illustrates that quality is related to the relative size of the light source.

The larger the light source, the softer the light. The smaller the light, the harder the light.

Quality of light helps shape the emotional response to an image. Soft light often evokes a gentler, romantic effect. Hard light tends to be more theatrical, dramatic, and "edgy." Hard light can emphasize and define texture, while soft light smoothes and flattens.

A simple way to change the quality of a light source is with distance. Rule-of-thumb: The closer the light, the softer it is. Moving any light source closer to a subject will make it larger in relation to the subject. If you desire the softest light from any source, use it as physically close to the subject as possible. Removing any source further from the subject will reduce its size relatively. If the light source is not movable, move the subject in relation to the light.

Therefore bouncing a light softens its quality by increasing the size of its spread. A single TTL flash can easily be converted effectively into a 20 square foot source by bouncing from a wall or ceiling.

Diffusion softens quality when the diffusion screen is larger than the light source. Light banks, umbrellas, diffusion discs, and reflector panels are popular photographer's lighting accessories.

PHOTO 1.16 Emily (see lighting diagram on page 170).

PHOTO 1.16 *Emily*

Emily is a fashion designer and is wearing one of her own creations. I decided on a high key look, based on her light skin tone and pastel dress. By blending dress and background, more attention goes to eyes, face, and hair. The background is the freshly painted white wall of the studio. The ambient light level in the studio was low, opening her pupils and contributing to the dreamy expression.

For an overall soft, even light, "stack lighting" was used. One slave Speedlite was bounced onto a 3′ × 6′ white reflective panel positioned above the lens, one slave Speedlite was bounced onto a 3′ × 6′ white reflective panel positioned below the lens. Slave Group IDs were changed for top and bottom lights depending on if I wanted the relative brightness values the same or different for the two lights. I experimented with equal, top brighter, and bottom brighter and achieved a variety of effects. The Ratio is top light Group A:bottom light Group B … 3:1 here.

Lights placed on either side of the lens produce two sets of highlights and two sets of shadows cast to both sides. Lights placed above and below the center axis of the lens cast shadows directly behind the subject and allow the edge contours to fall off into shadow. Look carefully at the image. A subtle line of shadow separates each edge of the subject from the white background. There is an illusion of a single, predominant, more natural direction of light. The soft light and large aperture help create the more romanticized, painterly appearance of the image.

When only a single light source illuminates the scene, quality of light also determines the contrast of the light. (See the section *Contrast* on page 61 for more discussion on this topic.)

Quality and quantity are separate characteristics of light. A single candle flame is a dim hard light. A photographer's 8 foot softbox with 5000 watt seconds is a bright soft light. Quality of light is not a function of quantity or brightness.

> To produce harder light, use a smaller light source, a more direct light source, or increase the lamp-to-subject distance.
>
> To produce softer light, use a larger light source, diffuse or bounce (reflect) the light source, or decrease the lamp-to-subject distance.

PHOTO 1.17 Jazz Bassist (see lighting diagram on page 171).

PHOTO 1.17 *Jazz Bassist*

I love jazz. Over the years I have listened to everyone. That has resulted in a huge collection of photographs of musicians dating from Miles Davis, Charlie Mingus, and Carmen McRae leading up to today's young turks local to my area. After learning Brian McCree and his band were playing at a club in town, I approached him between sets. He agreed to come to my studio. We did several flattering setups but then I wanted something a little more abstract. Hard light. Straight flash from an unusual angle. Duplicating stage lighting. I saw this shot in my head in black and white before I even started shooting. We shot in RAW and converted it to black and white in postproduction.

Brian ended up using the shots on his band's CD.

War Stories

Holocaust

The first thing you want to decide when using Speedlights is what is the look you want. Most often I want a "not-lit-look." A Speedlight is capable of putting out a very small amount of light and putting it exactly where you want it. I made a portrait of a Holocaust victim in the dormitory where he had been held prisoner 50 years before. What little light there was came from a skylight directly above him. I needed a way to light the prison number tattooed on his forearm, which was in darkness. I wrapped an off-camera Speedlight with black Cinefoil® and dialed it down so the light on the arm would be a bit less intense than that hitting his face. The effect is that there is no artificial lighting at all.

Cary Wolinsky, *National Geographic*

Contrast

Photography is a two-dimensional medium. So everything is a matter of edges: the edge of the prints, the edge of the picture, the edge between two subjects. You visually differentiate one object from another because of its edges. In black and white it is one shade of gray separating another that defines depth of field. In color it is an edge between a red and a green. Edges are contrast delineations. It is how our eyes and brains recognize shapes.

Contrast is defined as the measured difference between the quantity of light in the highlights compared to the quantity of light in the shadows. When comparing the difference in shadow and highlight illumination in units of light, contrast can be expressed as **lighting ratio**.

Contrast determines the difference between highlight and shadow detail in the digital image file (see Figure 1.4). Most digital sensors can record detail over a

five-stop range. A contrast range exceeding five stops will render shadows as pure black or highlights as pure white, depending on exposure. Contrast also affects the emotional response of the viewer to an image and helps to express mood.

Excessive contrast is indicated by a histogram with highlight point or shadow limit off the scale, or one showing loss of both highlight and shadow details. If less exposure is applied, the histogram can be shifted to the left, holding detail in the highlights, but resulting in the loss of shadow detail. If more exposure is given to the image file, the histogram will shift to the right, preserving more shadow detail, but at the loss of highlights. Excessive contrast is not fixable by exposure. There is nothing we can do to exposure that will change contrast. Exposure only determines what areas hold detail.

However, there are ways to compromise contrast. One way to change contrast is to reconfigure the scene itself. A black hat on white snow is a high contrast situation. Remove the hat and the contrast of the scene is now low.

Contrast is obviously determined by the light falling on a scene. When it is illuminated by a single light, the contrast is related to the quality of the light source. Hard light is inherently high contrast, soft light produces lower contrast. The addition of a second light, a soft flat fill light, can reduce contrast while maintaining the quality of a harder main light. The edges of the shadow and the specular highlight will remain the same, only the shadow density will be affected.

Contrast can be enhanced by several methods too. Introducing a brighter, directional light will increase contrast, highlight and shadow, and light direction. The new main light can be actually brighter than the existing light or the existing light can be underexposed to make the main light virtually brighter. That way the existing light can be used as fill for the new main light. Using "subtractive lighting" and eliminating unwanted light from a subject also elevates contrast and provides a more dominant direction of light.

In general, the eye is drawn to an area of greatest contrast first.

In multiple light source photography, **Contrast** can be independently adjusted without changing the **Quality** of the **Main light**. A hard Main light can produce sharp-edged shadows for dramatic effect and **Fill light** can produce open, low-contrast shadow density in the same image. The characteristics of the edges of the shadows and the density of the shadows are analyzed and controlled independently when using both Main and Fill lights.

Color is a matter of taste and of sensitivity.
Edouard Manet

Color

There is no such thing as white light in nature. White light is the result of equal amounts of all the wavelengths in the spectrum. Varying those quantities

gives light its color. Different lights give off different colors and affect the recording medium uniquely. Tungsten, fluorescent, halogen, sunrise, and sunset may seem similar to our eyes because the human brain equalizes and adjusts for the differences, but each has its own "palette."

The color of a light source is expressed in a variety of terms. Mostly we compare one thing to another, i.e., it looks like some common "standard." "That dress looks like a rose." The color of light sources determines many factors in the way color is recorded in an image. With today's technology, a dSLR's white balance can be adjusted for the prevalent color of those light sources. Color gels can be used over a light source to match color, to convert to a color for effect, or to change to another specific color balance. (See the section *Balancing TTL Flash and Available Light: Colors of Light* on page 73.) Though often not required for digital, colored filters can also be used over the lens. Mixing light sources can skew the predominant color balance. Between camera controls and filtration, virtually any color can be mimicked.

The study and use of color in photography is an extensive topic. Color affects the composition, sense of contrast, and emotional response to an image. Color creates mood. Color may be described alternately as warm, cool, pastel, vivid, painterly, and otherworldly. Clients may object to an unnatural color cast or the tint may be applied for aesthetic purpose.

Changing the color of a light source does not change the quality or contrast of the light source. Changing color electronically with the digital camera does not affect the quantity of light or the exposure. Color is an independent characteristic of light.

Auto White Balance neutralizes only daylight light sources and may provide acceptable white balance under some fluorescent light sources. Auto White Balance will not correct for artificial light sources. For existing light photography under any light source, Custom White Balance/White Balance Preset will provide the most accurate color correction.

Canon: White Balance Shift provides manual color shift/color correction in both blue-to-amber and magenta-to-green color scales. Any combination of Light Balancing and/or Color Correction filtration can be dialed in electronically to the camera. White Balance Shift is calibrated in mireds, not the usual protocol used by most photographers. Refer to the Eastman Kodak® Web site to access information regarding the conversion of LB and CC filter designations to mireds. The modification of color using White Balance Shift can be done visually or in conjunction with a hand-held color meter.

PHOTO 1.18 Lucia at sunset (see lighting diagram on page 172).

PHOTO 1.18 *Lucia at Sunset*

Shot on a Massachusetts beach in December in freezing cold. I am all bundled up in a parka.

3:45 p.m.: The sun had already set behind a 30-foot high concrete sea wall, behind the camera position, to the west. The background is the afterglow in the eastern sky. There is no direct sunlight on Lucia.

The exposure value was set on the camera to provide the desired amount of glow and color in the sky. Lucia is lit with a Slave Speedlite in a vertical softbox on a light stand just outside the frame, camera left. The TTL receiver on the Slave has been rotated to face the camera position. A Wireless Transmitter STE-2 on the camera fired the Slave. Distance from Transmitter to Slave was about twenty-five feet. A long 100 mm lens was used to compress the perspective between model and sky.

Color Spaces and the Color Triangle

Mixing any two primary colors will produce a secondary color. The color triangle below simplifies the conversions between RGB (red, green, blue) and CMY (cyan, magenta, yellow). Adding the colors of any two sides will yield the color of the angle between the two colors. For example, red + blue = magenta. Adding the colors of any two angles will yield the color of the side between the two angles. For Instance, cyan + magenta = blue. Adding all three primary colors yields white, which is the center of the triangle. So adding a magenta (which equals red + blue) filter to the green tint of fluorescent light is equal to adding red, blue, and green and will be equivalent to white light.

PHOTO 1.19 Lucia Glowing (see lighting diagram on page 173).

PHOTO 1.19 *Lucia Glowing*

"What are we doing now, Stephen?"

"Lucia, in this picture I want to make you glow."

Two Slave Group B Speedlites were mounted with vertical 7" × 5" softboxes and were positioned at 45 degree angles behind Lucia, one on each side at her eye level. A lens shade prevented lens flare from these hair/rim lights firing toward the camera.

The Main light was the Master Group A Speedlite fitted with a 16" × 12" horizontal softbox, suspended above the model and the lens on a mini boom arm. This softbox was literally inches away from the model. Notice the large catchlight reflection in Lucia's eyes. The Master Speedlite was connected to the camera with a TTL cord. A 32" silver disc reflector on a stand was angled upward under the lens and under Lucia's chin (she was actually standing against it). Using the lights close to the subject makes them big in relation to the subject. I wanted the large, broad, lustrous specular reflections on the skin here.

The exposure value was adjusted to take advantage of an incandescent wall lamp behind Lucia and to provide a desired amount of selective focus. Slave

Speedlites used as rim or hair lights may need to be set lower in Ratio even though they may be brighter in the picture. Work visually as well as to the Histogram. The recipe says "season to taste."

Direction

Sun, moon, lamps, headlights, television, candles. Illumination can come from anywhere. For practical purposes some directions are more useful or flattering than others. We may choose to control direction or accept what is provided. The **direction** of light is defined as the angle that light falls upon the subject. The direction of light determines the placement of highlights and angle of shadows.

Flat light, coming from the camera position, also referred to as **front light**, smooths things out. Flat light minimizes texture and depth. Light that skims across a surface at a narrow angle accentuates texture. Light coming from behind a subject creates shadows that stretch toward the camera, giving the illusion of depth in a two-dimensional photograph.

Side light promotes a sense of contour and shape. The directions or patterns of light in traditional portraiture complement and define the human facial structure. **Broad** and **short** directions of portrait light, where a side of the face visible from the camera is illuminated or is in shadow, respectively, increases or thins the apparent facial width.

Many photographers working with controlled lighting for the first time try to eliminate all shadows. This is easy but rarely interesting. The purposeful placement of shadows for effect is one of the great joys of working with light. Light direction is critical to the success of an image. The change of a few degrees can mean the difference between a stunning image or an unsuccessful one.

Inexperienced photographers also believe that poor placement of shadows is improved by fill. Poor placement of shadows is a problem of light direction, not contrast. Analyze the issue. If the image would be improved by a better direction of light, change the direction. (See the section *Main Light and Fill Light: Definitions* on page 48.)

Changing the direction of light is simple: move the light source in relation to the subject or move the subject and camera in relation to the light.

> Make lighting decisions based upon analysis of Quantity, Quality, Contrast, Color, and Direction. Look at the effect of each light in the image. Realize the control you have to make changes to each light source and previsualize the results. Explore and experiment. Study the details and nuances of light. Learn the physics of light. Practice. Utilize light intelligently and effectively to obtain the results you desire.

> The shadow points directly to the light source.

I'm a run and gun, speed type of shooter, chasing all kinds of mixed light. Some days it's heavy strobe for the first shot, pure available light for the second and then flash fill (shutter drag) for the third. That goes on all day long for as many as twenty or more locations a day. Whatever my clients needs I can do. I always keep a couple of those little Speedlights stashed in my kit. I can't tell you how many times they have saved my life.

George Disario

Mixing TTL Flash with Available Light: Quantities of Light

It is often said "there can never be enough light." So working with only one Speedlight … there are limits. Available light may be beautiful and appropriate or ghastly and discolored. Deciding to work with existing light or making your own is taking advantage of every possibility. All light can be combined and mixed for interesting effects. The ability to alternate exposure compensations for existing light and TTL flash makes each light source interchangeable as Main, Fill, Accent, and/or Background lights and play to the strengths of modern Speedlights.

Available Light as Main

When the direction or quality of available light is satisfactory, it is logical for use as the Main light. **Aperture Priority**, **Shutter Priority**, and **Manual** camera exposure modes are programmed to tell the camera's computer to "correctly expose the available light." These camera exposure modes instruct the computer to make the available light the Main light. Compensate the metered exposure to correct for subject reflectance and to optimize the highlight placement on the histogram.

> If the quantity, quality, direction, and color of the available light is satisfactory, but the contrast is high, consider using fill light. (See the section *TTL Flash as Fill* below.)
>
> In low-light conditions, Program camera exposure mode used with flash will likely produce exposures of 1/60 sec with the aperture wide open.

TTL Flash as Fill

Flash Fill reduces the contrast of available light Main. Fill flash was once considered a skill understood by only professional photographers. TTL flash makes flash Fill easy and convenient.

PHOTO 1.20 *Dylan's Birthday*

Getting the Speedlight off of the camera might be preferable, but it does not always seem practical. "How silly do you want to look at your kid's birthday party?" I keep a small softbox mounted on a small light stand with a flash mounted and set up as a remote. I have used this setup around the house and at birthday parties. It is relatively easy to move the whole rig in place, take the picture, and then set it aside. This photo was made using a pop-up flash in commander mode to fire the remote Speedlight. Many cameras with pop-up flashes offer this feature. For my camera without a pop-up flash I use the SU-800 wireless transmitter to trigger the same remote flash. The SU-800 is more compact and less expensive than a full flash.

PHOTO 1.20 Dylan's Birthday (see lighting diagram on page 174).

DSLRs have computerized fill flash programs that balance available light Main and flash Fill. It must be noted that when the camera detects sufficient available light for a "standard" existing light exposure, the TTL flash is automatically reduced to act as Fill. The computer applies Flash Exposure Compensation, reducing the quantity of flash to avoid overexposure of the existing light highlights. The amount of Flash Exposure Compensation applied by the computer is not indicated to the photographer. To change the amount of flash Fill, to change the contrast, adjust the Flash Exposure Compensation. The amount of FEC applied by the photographer is in addition to that of the computer.

To set your camera and flash to provide automatic flash Fill:

Nikon: Access the flash metering system on the flash. Set the flash to "TTL BL."

Canon: Access the flash metering system through the camera Custom Function Menu. Set the ETTL II flash metering system to "Evaluative."

It cannot be emphasized often enough that the standard protocols that apply with manual camera operation undergo a sea change when you add *two* computers, i.e., one for the camera and one for the Speedlight. They work together but the decision-making hierarchy is no longer linear.

Making flash work in the old fashioned way the computers can be instructed to provide a "standard" flash exposure without applying Flash Exposure Compensation on its own. Changing the flash setting will change how it calculates flash exposure. The computer now is programmed to provide a "standard" flash exposure without making "fill" reduction. If you choose to override the automatic function it often results in a more prominent effect of flash in the image. View your LCD monitor and histogram to determine the amount of flash you want in any given situation.

To set your camera and flash to provide "standard" flash exposure:

Canon: Access the ETTL II flash metering system through the camera Custom Function Menu. Set the flash metering system to "Average."

Nikon: Access the flash metering system on the flash. Set the flash Mode to "TTL."

TTL Flash as Main

When the direction of available light is not sufficient or appropriate for the subject, TTL flash can substitute lighting of the photographer's choosing. On-camera, flat, flash-as-Main can eliminate unwanted shadows from available light. Flash-as-Main may be a preferred strategy for event and candid photography.

To make the TTL flash the Main light, underexpose the existing light on the subject. In **Program**, **Aperture Priority**, or **Shutter Priority** camera exposure mode, underexpose existing light by existing light Exposure Compensation " − ". **Manual** camera exposure mode at higher shutter speeds (not exceeding 1/250 sec) and/or smaller apertures can make the TTL flash appear as the

only light source. Depending on the camera model, Manual camera exposure mode may be required if, for desired visual effect, the existing light needs to be underexposed by more than two stops.

> For general flash photography, such as indoor event coverage, try Manual camera exposure mode, ISO 400, 1/60 sec, and f/4.5. This allows a good amount of available light in the image, makes the TTL flash the main light source, provides a moderate amount of depth of field, and maintains good image quality.

A back-lit subject, a shaded subject with a sun-lit background, or a subject in front of bright windows may require the TTL flash as Main light, not Fill.

> Adjust the available light exposure to obtain the desired look of the brighter background. Adjust the Flash Exposure Compensation to provide the desired amount of flash on the shaded subject.

In all cases of flash-as-Main, adjust the Flash Exposure Compensation as needed for subject reflectance and to obtain a satisfactory highlight value.

Available Light as Fill

When the TTL flash is used as the Main light, available light can be utilized as Fill. Once a satisfactory highlight value for the flash subject has been achieved with Flash Exposure Compensation, varying amounts of available light can be "burned in" to help control contrast.

> In **Program, Aperture Priority, or Shutter Priority** camera exposure mode, try available light exposure compensation " −1," " −1 ⅔," or " −2." In Manual camera exposure mode, use shutter speed (not exceeding "X") and/or aperture to underexpose the available light by −1 to −3 stops.

Keep in mind, "correct" available light exposure may be Exposure Compensation −2 to +2 due to subject reflectance. More than two stops may be required to lower the available light sufficiently for the flash to eliminate shadows and become the Main light.

PHOTO 1.21 Sparkle (see lighting diagram on page 175).

PHOTO 1.21 *Sparkle*

The parade came to a halt. The majorettes were stopped in a shadow cast across the street. I see the picture. My Speedlite will provide a complementary directional Main light on the subject, the sunlight illuminates the background. I know the existing light meter will see the scene as a silhouetted subject against a bright background. I run out into the street in front of her, say hi, stretch the TTL cord, aim the flash with my left hand, and put camera to eye with my right. The reaction to a stranger placing camera and flash in her face is a beaming smile of recognition and pride. The shutter clicks, and the LCD proves the moment. Her reaction to having her picture made was more than expected, and crowns the image. The whistles blows, I return to the sidewalk, the parade moves on. Boy, this stuff allows fast work. By adding my own light, I have put my own mark on the image. My light is softer and in a better direction than the sunlight. My light brings out the sparkles: the sequins, that smile, the eyes. My subject is clear to the viewer. I have put attention to where I want it in the image. The image, as shown, existed for only 1/250 sec. No one else saw this image of the scene except me. This is the image the scene triggered in my head. I told the computer what I wanted the image to look like. Now I get to share my vision. In the hard, bright sunlight, I was able to apply a direction and quality of light of my own choosing. With Speedlites and TTL, the entire world becomes our studio.

Balance of light is the problem, not the amount. Balance between shadows and highlights determines where the emphasis goes in the picture...make sure the major light in a picture falls at right angles to the camera.

Elliott Erwitt

A to Z

chiaroscuro (kē-är′ə-skŏŏr′ō, or -skyŏŏr′ō) n. From Italian: chiaro = light + oscuro = dark. 1. light and shade effect 2. in art, the manner of indicating transition from one tone into the other or of contact between them 3. a style of painting, photography using only light and dark to achieve the illusion of a third dimension.

General Guidelines

Take time to review and study the image on the LCD monitor and analyze the histogram. Carefully identify and evaluate the effect in the image of each light source. Make decisions on the relative quantities and directions of available light and TTL flash and adjust each accordingly.

The guidelines in Figure 1.11 on the next page will assist in achieving the desired balance of existing light and flash.

Balancing TTL Flash and Available Light: Colors of Light

TTL electronic flash approximates daylight in color. Available light comes in many forms. The color of TTL flash can be altered to more seamlessly integrate with the colors of existing light. Color filters for the flash may be obtained from several manufacturers, such as Lee® Filters and Rosco®. Filters may be attached with tape, rubber bands, or Velcro®. (See the section *Filters/Gels* in *Equipment Accessories* on page 150.)

Mixing TTL flash with available light: quantities of light	
Camera exposure mode	General guidelines
Program, P and Program, P Aperture priority, A Aperture priority, Av	A. check usable flash distance range on the flash LCD panel for the aperture and ISO set on the camera B. change the quantity of existing light by available light exposure compensation C. change the quantity of flash by flash exposure compensation Nikon: set "Slow Sync Mode" for shutter speeds slower than 1/60 sec.
Shutter Priority, S Shutter priority, Tv	A. check usable flash distance range on the flash LCD panel for the aperture and ISO set on the camera B. change the quantity of existing light by available light exposure compensation C. change the quantity of flash by flash exposure compensation D. use a shutter speed that does not exceed "X" * Nikon: set "Slow Sync Mode" for shutter speeds slower than 1/60 sec.
Manual, M Manual, M	A. check usable flash distance range on the flash LCD panel for the aperture and ISO set on the camera C. change the quantity of flash by flash exposure compensation D. use a shutter speed that does not exceed "X" * E. change the quantity of available light by changing shutter speed and/or aperture Nikon: set "Slow Sync Mode" for shutter speeds slower than 1/60 sec.

FIGURE 1.11 Guidelines for Mixing Flash with available light.

* = unless using "High Speed Sync"/"FP Flash", see *Speedlight Components* on page 20.

Nikon: several color-correction/color balancing filters are bundled with the SB-900 and SB-800 flashes.

Although gels manufactured for this purpose are heat resistant, it is recommended to cut the filters slightly oversized and leave air space between the filter and the front of the flash reflector. Filters in direct contact with the front of the flash surface may melt due to heat generated by the flash, damaging the plastic surface.

TABLE 1 Filters and Gels.

Balancing TTL Flash and Existing Light: Colors of Light			
Existing Light Source	**Lee Filter®**	**Rosco® Filter**	**Camera White Balance**
Tungsten	Full C.T. Orange	Roscosun CTO	Tungsten
Incandescent	Full C.T. Orange + 1/8 to ½ C.T. Orange	Roscosun CTO + 1/8 to ½ CTO	Custom White Balance
Fluorescent	Plus Green	Tough 1/8, 1/4, 1/2 Plusgreen, Tough Plusgreen	Canon : Daylight + "15 mired Magenta" White Balance Shift or Custom White Balance Nikon : Custom White Balance
Fluorescent (cool white)	CC30M (30 magenta)	CC 30 M	Daylight

Review results on the LCD monitor to determine color suitability. Additional filters may be used to fine-tune the color of the flash as needed. Colors achieved are dependent upon the exact color of the existing light sources, the relative amounts of flash and existing light making up the total exposure and the correctness of the color balance.

A Custom White Balance/Color Preset can be made for the mix of existing light and flash.

Bounce Flash: Direction and Quality of Light

Accomplished photographers are always striving to do unique things with light. Not without a special reason do they employ direct flash to illuminate pictures. It is a clumsy use of such sophisticated tools. One of the most skillful accomplishments is lighting that looks "natural." Natural light comes from the sky, a window, overhead, anywhere but from directly in front of the viewer.

Bounce flash is a technique where the main light is redirected at a wall, ceiling, or some other surface to broaden and diffuse the light falling on your main subject. It is an easy and effective method used to produce soft but directional light with a TTL flash. Bounce flash makes small camera-mounted flash look like large directional off-camera light.

You bring a straight flash picture back to National Geographic and they have a gallows out back.

Joe McNally

Bounce surfaces will absorb some light and some light may be reflected in directions away from the subject. It is not so much an efficient use of light as an aesthetic one. Bounce flash also increases the distance of light travel, effectively reducing the light quantity because of the Inverse Square Law. (See the section *Inverse Square Law* on page 18).

PHOTO 1.22 Wedding cake (see lighting diagram on page 176).

PHOTO 1.22 *Wedding Cake*

Pictures of the wedding cake are an event standard. This detail was made immediately after the cutting ceremony. I had to work quickly as the wait staff wanted to remove the cake from the dance floor.

A light-colored wall near the cake table provided a convenient bounce surface. The cake table was rotated to accommodate the desired camera and lighting angles. The flash was bounced to create a skim light across the surface of the cake, accentuating texture. Shadows are cast toward the camera, enhancing the illusion of depth and dimension in the photograph.

You may need to use a higher ISO and/or larger apertures. Check the flash Exposure Confirmation and the histogram when using bounce flash.

The usable flash distance range display on the TTL flash is disabled when the flash head is in a bounce or swivel position.

White or light-toned walls and ceilings are ideal for bounce, since they do not taint the color of light. Lower, residential ceilings provide a more natural direction of bounce, high ceilings may produce a "top light" similar to noontime. With on-camera flash, close camera-to-subject distances can produce an undesirable top light appearance too.

The direction of the flash head in relation to the bounce surface will determine direction of light on the subject. Bouncing flash is analogous to "shooting billiards" with light.

Moving Light

Aiming a flash at someone is a very aggressive act. It is invasive and can be scary. It certainly announces your presence and may alter an interesting activity. But to ensure readable pictures it may be necessary. Since a flash is nearly a point source of light, with all of its resulting immediacy, direction, and harshness, a little finesse may be called for to get the most of its capabilities. The most recent generation of Speedlights is very malleable. Even locked on camera its light head has "swings and tilts" like a large format field camera. You can point it anywhere. Point it to be efficient. Point it to be subtle. Point it to be bigger or to be small. Point it to hide or shed light on the world. You can effectively "fold the light around corners," kind of exceeding the design specifications. You can even defy the Laws of Physics.

Light is my inspiration, my paint and brush. It is as vital as the model herself. Profoundly significant, it caresses the essential superlative curves and lines. Light I acknowledge as the energy upon which all life on this planet depends.
Ruth Bernhard

Comprehending Directions of Bounce Flash

In Newtonian Physics all light travels in straight lines. Light reflects off of a surface at an angle opposite to the angle at which it strikes that surface. Where **I** is the angle of incidence and **R** is the angle of reflection, then: **I** = **R**.

This is illustrated below:

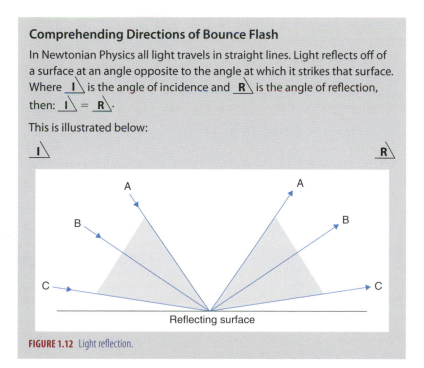

FIGURE 1.12 Light reflection.

Visualize the "straight lines" of light leaving the flash head, striking the bounce surface and reflecting toward the subject. Study the image on the LCD monitor to determine the direction and visual effect of the bounced light on the subject.

Turn or tip the flash head sufficiently. Avoid hitting the subject with direct flash from the edge of the flash reflector (spill).

The compound articulation of the Speedlight swivel head means you can twist and turn the flash in almost any direction, i.e., up, down, behind you, to the side, regardless of the orientation of the camera. In switching from horizontal to vertical, to keep the light bounced off an appropriate reflector, you may have to ratchet the head like a Rubik's Cube®.

A to Z

carte-de-visite (F. c̲ȧrt de vï-sïté) n. 1. portrait photograph on a mount about the size of a postcard, introduced in 1854 that became a social craze in many countries 2. a formal mass-produced calling card popular in the 1850s printed on card stock with a photograph, usually albumen prints from wet collodion negatives.

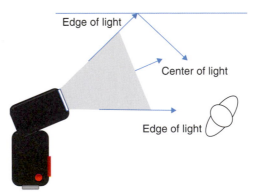

Flash head tipped too low. "Spill" from the edge of the flash reflector strikes the subject as direct light, causing hard-edged shadows and uneven illumination.

FIGURE 1.13 Flash spill.

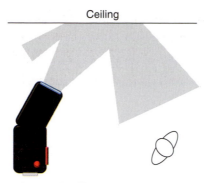

Ceiling

The flash head is tipped upward sufficiently to illuminate the subject with only soft, reflected light. No direct "spill." Lower, residential ceilings provide natural looking, 45 degree light.

FIGURE 1.14 Tilt to avoid spill.

Turn and tip the flash head up when the camera is tipped down.

FIGURE 1.15 Adjusting flash tilt for camera angle.

PHOTO 1.23 Wedding gown (see lighting diagram on page 177).

PHOTO 1.23 *Wedding Gown*

This lovely gown detail was created with bounce flash at the house, before the ceremony. I had the bride turn her back at a 45 degree angle to a light-colored wall, and directed the flash to the wall above and behind her. The bounce flash is coming back toward the camera, creating a short skim light that brings out every detail of the elaborate train. A lens hood prevents unwanted lens flare.

Bounce flash does not have to be flat, dull, or uninteresting. Look for every opportunity to do the unexpected or the dramatic. Take more risk with your lighting. Use light for effect, not just exposure. Use light with imagination.

The bounce card directs "spill" from the flash reflector forward, providing Fill. The built-in bounce card is small, creating a harder Fill. A larger white card attached to the flash with a rubber band or Velcro® can provide softer Fill.

FIGURE 1.16 Bounce card.

Create "window light" by turning the flash head sufficiently toward the wall. Avoid direct spill from the edge of the flash reflector striking the subject. Turn the subject slightly toward the wall, toward the direction of light. A custom white balance/ white balance preset can be used for off-white walls.

FIGURE 1.17 Creating window light.

81

Turning and tipping the flash into a light-toned wall or walls behind the camera creates a broad, soft, light that can be used as a front-lit Main or a Fill.

FIGURE 1.18 Back wall bounce.

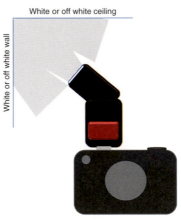

Directing the flash up at a 45 degree angle to the side creates a directional 45 degree light on the subject.

FIGURE 1.19 Corner bounce.

PHOTO 1.24 Jazz pianist (see lighting diagram on page 178).

PHOTO 1.24 *Jazz Pianist*

Over the years I have had various involvements with music and record companies. I have photographed Donal Fox, a very talented musician/composer numerous times for his promotional materials. He was still using some black and white studio pictures I had taken but he needed updated photographs.

Through contacts at a dealer that rents pianos for his concert tours we found the ideal location. We had quite a choice. The instruments were grand but the space was small.

I had a preconceived idea of how I wanted to pose him. We moved one of his favorite, huge Steinways closer to the wall to take advantage of the right angle corner of the room. I moved the single Speedlight around until the circle of glare on the side of the piano did not obliterate the logo on the side.

We were tethered to a laptop computer so I could review the images between exposures. The camera was on a low tripod with me sitting on the floor.

Beforehand I helped Donal with wardrobe and eyewear, but because of the simplicity of the lighting, my crew and I were in and out in record time.

PHOTO 1.25 Arianna and Grandpa (see lighting diagram on page 179).

PHOTO 1.25 *Arayana and Grandpa*

The photo room featured nice blue curtains and light-toned walls and ceiling. I selected a shooting angle that placed the corner of the room over my left shoulder. The Speedlite, on a flash bracket, was swiveled and tilted to direct the light backwards to my left, creating the traditional pattern of portrait light seen here. The receding perspective on the curtains creates visual interest and depth in the background. The subjects provided the genuine emotion.

It looks like I was using a light stand, softbox, and a whole bunch of equipment, but I was not. Event shooter on the run. Handheld camera, on-camera flash, studio quality results.

Straight ceiling bounce is a marginal technique because it often creates shadowed eyes. Creating a direction of bounce for each situation becomes art. Manual Exposure Mode was at a 35 mm focal length, adjusted to the highlight point of the Histogram.

Two Lights

One Two Three…Infinity.[5] This concept from the famous book title ironically alludes to the anthropological construct that in some cultures anything over the number *three* becomes too many to count. It is similar in photographic lighting too. After you figure out how to coordinate *two* lights, more are basically academic.

You don't take a photograph, you make it.
Ansel Adams

Doctor For many years I have photographed health care assignments: hospitals, pharmaceutical companies, medical schools, insurance companies. Getting good photographs in these places is all about access. And once in operating rooms, research facilities, and nursing homes, speed is a big issue. The situations can change quickly because of vacillating health conditions, privacy issues, or patient's whims. We used only three Speedlights for this photograph, all outfitted with softboxes: small, medium, and large. We added light gels to two of the flashes, green to the lightbox used to illuminate the CAT scans and chemical beakers in the background. I was trying to duplicate the fluorescent color it normally emitted and light blue on the flash and small softbox directly behind the foreground CT scan. We were directed to emphasize the doctor in an environmental portrait. Strategic placement of Speedlights can be very directional and increase the drama of a potentially mundane scene. (See lighting diagram on page 200.)

[5]*One Two Three…Infinity: Facts & Speculations of Science* by George Gamow.

Many neophytes to photography mistakenly fantasize that as soon as you acquire the right equipment, — if you cobble together a digital camera, the software to run it, and a portable flash — you qualify for the appellation "photographer," when indeed your journey is just beginning.

It is deceptively simple to wed image to film. How hard can it be to push a button? But just like any craft it takes time, effort, patience, and talent to become proficient taking pictures. Even though translating the world that we see with our eyes into a more permanent medium has been made so much easier with the advent of more ergonomically designed and technically proficient equipment, doing it well remains just as elusive as when alchemists coated their own collodion wetplates behind large wooden bellows cameras. Rather than just recording what happens in front of them, real artists are exposing silver or charging electronics to communicate ideas. So interjecting the perfect volume of illumination upon just the right target can advance that quest enormously. In capable hands light can dazzle the senses. To successfully intermingle the light you have, with what you bring, is the charge of a seasoned craftsman.

Prevailing wisdom is that in most multiple lighting arrangements one light is the primary source and all others are ancillary. The first light sets the tone and the second adds dimension. So learning how to position just one extra light influences your vision exponentially. It is a skill that will revolutionize your photography. Second lights can be diffused or bounced or spotted or gelled … just about anything. They "elevate" a scene. You may need dozens of "second lights" of varying kinds but each serves as a building block toward the final outcome. Whether you are meticulous and use formulas and calculations or you are capricious and fly by the seat of your pants, entrance into the digital world accommodates all personalities and makes the journey more herculeon.

The capacity to nuance lighting using the technology built into the new Speedlight empowers you with unprecedented ability to shoot, get immediate feedback, and rebuild any idea your imagination can conjure. Relinquish control and let the camera and Speedlight dance a *pas de deux* together so you can spontaneously chase the evolving action or weather condition. Or micromanage how each influences the picture right in front of you and adjust virtually every frame. The ease of changing from one scheme to another as you add a second, third … infinite number of lights, all manipulated by whim, magnifies your capacity. You do not have to be a "techie." Speedlights are not about equipment. They are about intuition.

All the Laws of Physics you have committed to memory still apply but using Speedlights suggests a new way of thinking, as stated before, a paradigm shift. This book proposes to teach you something you thought you already knew. Reacquainting yourself with a time-honored technique stimulates rapid progress to become comfortable with every aspect and more proficient with all its facets. We cannot stop thinking and advancing.

Embrace change. Shed your fears. Acquiring a dSLR and two Speedlights is *potential* energy. What you do with them, all *kinetic*.

With color transparency film and Polaroid tests, we used to work so hard on ensuring just basic exposure. Carefully metering each light multiple times, writing f/stop values on paper, poring over those still sticky instant pictures, learning to translate Polacontrast to film contrast, exposure bracketing, clip testing… and you were never absolutely sure until you saw the processed film, in hand, on an industry standard light box a minimum of four hours later. I would often bracket exposure. Exposure bracketing would turn a 12-exposure roll into four usable frames. Too bad if the best expression was a 1/2-stop underexposed.

Exposure is a no-worry issue now. With digital, I confirm exposure as I shoot. Use the histogram. Exposure is technical. Maximize the usable information in the file. Exposure is literal, and digital lets me nail it then and there. It's easy.

Now I bracket contrast instead of exposure. It's contrast that is subjective. With Wireless TTL, I can adjust the contrast in the image at any time without worrying about changing the exposure. I discover more variety, and have more choices about emotional responses to the images. I can respond to my own feelings about an image as I shoot. I can make it softer and more open, or edgier with more drama and punch, or just see the difference, at any time, without interrupting the flow of the shoot. I take more risk now, knowing it is fluid. It's not nailed down and inflexible anymore. It's easy.

Steve

Light

Gaining enough facility with light so as not to be dependent on prevailing conditions is one of photography's rites of passage. Transporting your very own light to a location is a major style breakthrough. The next step, with Speedlights, is to realize you can use more than one with very little extra "muscle." Technology has made many of the complications moot. It enables us to be more spontaneous, change our ideas, attempt more variations, and have peace of mind with each successive exposure. Without introducing a stack of manuals, formulas, or calculations, we can intuitively juggle more than one light. And each one can be programmed to perform separate functions. Theoretically we could throw a handful of Speedlights in any direction, manipulate each individually, and without taking a step make them all work independently … together … wirelessly.

PHOTO 2.1 Construction worker (see lighting diagram on page 180).

PHOTO 2.1 *Construction worker*

We had our choice of dozens of culverts on the job site. But that was the easiest decision we had to make putting this photograph together. Working on deadline I needed this shot to go smoothly. My crew and I moved from concrete pipe to concrete pipe rejecting several different lighting schemes. Finally we mounted one Speedlight hidden just behind the rim on the left side of the cylinder. The second light was set up to backlight the worker, separate him from the background, cast a light inside the tube, and highlight the gravel mound behind him.

The "balancing act" was to put the dramatic rim light directly on the construction worker's face and have him maintain his uncomfortable position while pointing the flashlight directly into the camera lens. The overhead sun kept shifting and changing the background shadow. So it became a race against time and nature. We integrated the light in the sky with the output of the strobes but that was fairly easy. There was a bit of postproduction to punch a little more color into the man's shirt.

These kinds of shots require a lot of preproduction and timing. We had to coordinate the date and time with the foreman and conform to many safety regulations. The whole site was cleared two days after we did the shot and all the pipes disappeared.

Utilizing only one light is overcoming inadequate light. But when you introduce a second artificial light source you are imitating, supplementing, or improving the environment. As a result, you have entered the nebulous realm of *lighting*. Going on location with multiple lights is constructing your own reality.

Lighting

Lighting is the physical act of "sculpting" your visual environment — reshaping a three-dimensional space. This is done by elevating selected surfaces toward the "sun" and shading others from it. With lighting we decide whether objects of interest will be perceived as static or in motion. Lighting can lead the viewer into or out of the frame. We may not have the power to control what goes on in the world but, with lighting, we can control exactly what our audience sees of it. We can delineate between drama and melodrama. We can surprise and obfuscate. Lighting gives credence to what otherwise would not even exist. Unfortunately, most of the time, if the methods are obvious, we have failed.

But if it was easy, everybody would do it. Speedlights simply make it *easier*. With a smaller, lighter kit and with the new methods of checks and balances, the dedicated photographer has a head start.

Whether in the fields of commercial or fine art, because we are the sole architects, when we build with light, we reside in the netherworld of fantasy and dreams. When shedding darkness anything is possible. We can investigate inside our minds as well as the interiors of our monuments.

As photographers we can safely accept the *light* that nature provides us or we can take on the task of *lighting*. Everyone approaches it differently but there are stages that end up in most everyone's agenda:

Design
Execute
Review
Postproduction

Design

Lighting starts in the mind. Rather than trial and error, when you walk into a scene you should first survey and assess your surroundings. Then determine whether the light is sufficient or whether you have to supplement it. Imagine how you would like it to look. Previsualize what you eventually want your audience to see. This is the **Design** phase. You estimate what equipment you will need, the problem areas, and where you will position each light and its contribution to the final output. Take time to theorize the overall mood you want to create, whether bright and clear or dark and mysterious. You may have requirements to be formal or stylized. Even check where all the electrical outlets are before you have to drag equipment around. As you become more adept, much of the work is done in your head first. In elaborate productions you can sketch placement of camera and lights on graph paper to see if it will work. This phase can take place days or weeks before the actual shoot.

PHOTO 2.2 *Evelyn's headdress*

Doing beauty shots is one of the great traditions of having a studio. It is quid pro quo. Attractive models need to work with different photographers for experience. We get to work out new ideas and techniques.

I had worked with Evelyn often, so we already had a rapport. The whole shot depended on the talents of the makeup/stylist with whom I have collaborated for years. I drew a diagram of what I had in mind, but Audrey embellished, using her imagination and experience to make the headdress come to life.

Evelyn is such a natural beauty the makeup needed only to be fairly traditional and simple. But her exotic nature was strong enough to enhance the over-the-top flotsam and jetsam in her hair.

Lighting was simple — classic portrait lighting with a softbox and reflector with a light on the painted backdrop to separate the model from the background.

Execute

Next comes the **Execute** stage. You move your equipment, then your subjects, into place — models, products, props, etc. — after having rearranged furniture or built sets. It may be time-consuming but it can be the most exciting part. Shooting often becomes anticlimactic because it is the very last part of *execution*. If you have designed well enough in advance there may be very little alteration. But if not, you redesign and re-execute. You can "bracket" for high dynamic range (HDR) applications in postproduction. This is the step where you have the greatest creative freedom. But *shooting* is what photography is all about. It is where all the elements come together. When you "pull the trigger" all conditions, models' wardrobe, and timing are in synchronization. Excitement crescendos. In photography this is synergy. It is where the magic happens.

Review

Because of the newest technical advances you can "test" the design and **Review** your execution as you progress utilizing the LCD and histogram built into your camera or by tethering to a computer right on set. You and your clients have a ringside seat. You can review the influence of mixed lighting and override the bias of unwarranted *color temperatures*. The tandem of LCD to judge aesthetics of the shot and histogram to monitor the technical contributions makes execution seamless. Since you are recording the pictures and sampling them simultaneously, there is no time lost and there is no anxiety as to whether you have succeeded. This overlap is the safety net that digital affords you.

Postproduction

Anytime after you have completed the assignment you can go back and manipulate any image that you deem worthy. This is considered **Postproduction**. Reminiscent of the darkroom, with software, you can alter, brighten/darken, change contrast, correct color, and eliminate defects that might have been overlooked during execution. In addition, we can improve

PHOTO 2.2 Evelyn's headdress (see lighting diagram on page 181).

such things as sharpness and lens correction and we can do it selectively to any portion of the image. If you shoot in RAW, everything but exposure is a "tag." Besides "retouching" any single image, computer programs have been designed for extensive image compositing and special effects. The objective is to optimize the images for archiving, reproduction, or publication.

Speedlights are not intended as substitutes for larger strobes but they provide a less expensive, small, portable, convenient, quick, flexible, and predictable alternative. Commercial, advertising, architectural, still life, and large format photography may require more power, modeling lights, or other attributes. The permutations increase exponentially with each new light added. But there is no limit. To shine light on any subject we choose is monumental. To change the way the world looks is supernatural because "only gods can move the sun."

A to Z

Scheimpflug rule (shim'-floog rool)1. a useful rule when using camera movements is that when the planes of the subject, the lens panel, and the image are made to coincide at a single line, everything will be in focus. 2. (named after an Austrian Army officer who patented it in 1904) states that the film plane, the subject plane (plane of sharp focus), and lens plane (the plane through the optical center and perpendicular to the lens axis) must converge along a single line.

PHOTO 2.3 Watch with macro techniques (see lighting diagram on page 182).

War Stories

Jail

Over the span of a dozen years I have taken cameras and lighting into many of the most infamous maximum security prisons and draconian death rows in the United States. To the constant astonishment and distress of security guards, I have humped 35 mm and 2 1/4" cameras and large studio strobes, Polaroid, black and white and color films, and every length of extension cord into these "black holes of Calcutta" only to be poked and prodded, checked, and bullied about every piece of lint I possessed. We've had to document and itemize each piece of equipment with make, model, and serial numbers and the list has been previously authenticated by Notary Publics.

The efficient prisons pat us down, peruse the documentation, spot check it, and ask us to retrieve random paraphernalia on the list. The dumb ones make me reveal every nut and bolt and cross it off both as I enter and then as I exit. This tedious exercise has been vastly streamlined with the advent of Speedlights. Without loss of creative control or quality, I have sped up the process and gained flexibility in the cramped quarters of the cells and visiting rooms with increased assurance like never before possible.

LAJ

PHOTO 2.3 *Watch with macro techniques*

As commercial photographers, assignments can test our mettle. I have had jobs where I photographed objects too small for the naked eye to see and things too big to see. I have been hired for pictures of events that moved too fast to observe and, of course, those too slow.

Macro photography is a specialty unto itself, often requiring particular equipment: lenses, bellows, extension tubes, etc. With products needing to be shot close-up, the size of the lighting needs to be comparable and a fair amount of technical expertise applied.

We meticulously positioned, taped, and glued this watch on a mirror to show off the sinuous but mechanical complexity of the wristband. The lighting elements of the Speedlights match the size of the watch making it easier to position them close to such a small item. But once the main lights are positioned most of the work goes into carefully placing "show cards," i.e., pieces of cardboard or Foamcore®, white to reflect light back in the metal surfaces and black to add contrast.

For a traveling photographer it always comes down to, "the art of the possible. "With just a couple of Speedlights, you extend the possible."

Cary Wolinsky, National Geographic

Wireless

The second attribute that distinguishes Speedlights is the fact that they operate cordlessly. The units are unfettered by long, cumbersome, unreliable cords or external devices that traditionally have been needed to "hardwire" multiple lights together. The freedom this affords today's shooter, with communication between each unit, is the breakthrough that drives this book.

Wireless TTL: Remote/Slave Flash

Wireless TTL is a proprietary, closed-loop system with the capacity to transmit firing and flash exposure information to single or multiple compatible Remote/Slave TTL flash units. Exposure for the TTL Remote/Slave(s) is metered in-camera, through-the-lens (TTL). Flash Exposure Compensation for the TTL Remote/Slave(s) is controlled from a master flash, which needs to be connected to the camera through the hot shoe. The master flash may be mounted directly on the camera, or connected with a TTL cord (see the section *TTL Cords* on page 135). Exposure strategies for mixing available light and flash remain the same as with single, on-camera TTL flash. Many flash features remain operational: Flash Exposure Lock/Flash Value Lock, Modeling Flash, Flash Exposure Bracketing, Manual Flash, and FP Flash/High Speed Sync.

In effect, the modern photographer can set up compatible Speedlights in every corner of a location and just as quickly command each one to emit a specific, individual output without moving.

Wireless TTL: Additional Trigger Devices Need Not Apply!

Radio slave, infrared, and photo eye slave are remote flash triggering devices that fire a remote flash; however, they do not transmit flash exposure information. These devices are not Wireless TTL, nor are they compatible with or required for Wireless TTL.[6]

> All Wireless TTL transmitter and receiver equipment is built into the 550EX, 580EX, 580EXMkII, and SB-900 and SB-800 flashes. No additional or accessory devices are required to utilize Wireless TTL with these flashes.

The 580EXMkII and the SB-900 and SB-800 have built-in, non-TTL photoelectric eye triggers allowing these flashes to be used with and fired by manual non-proprietary flashes in non-TTL flash modes.

[6]The exception is with combinations of specific Quantum® flashes with Quantum® radio slaves that together provide a version of Wireless TTL.

Nikon SU-4 Mode

The SB-900 and SB-800 can be used as slaves to any strobe in the SU-4 mode. This wireless flash mode can be accessed through the custom settings menu. SU-4 type wireless multiple flash can be performed in two ways: (1) in the auto mode, in which the wireless remote flash units start and stop firing in sync with the master flash unit, and (2) in the M (Manual) mode in which the wireless remote flash units only start firing in sync with the master flash unit. The mode button will toggle between these states when the flash is set to SU-4. You will want to rotate the flash body so that the light sensor on the lower left corner of the front of the flash faces the Master flash.

A to Z

parallax, (par-uh-laks) n. 1. the apparent change of angular position of two observations of an object relative to each other caused by the viewpoint of the observer. 2. in photography, there is a displacement between the viewfinder and the optical lens in twin lens reflex or rangefinder cameras that causes a difference in what is recorded from what is observed.

War Stories

Mansion

While teaching a workshop in Newport, Rhode Island, we gained entry to one of the magnificent, famous mansions. We moved about the tailored gardens and shot with the ornate architecture as a background. But eventually we ended up in the cavernous ballroom. The opulence was so overwhelming that I wanted to do something befitting the setting. With the help of a dozen participants we moved tons of priceless furniture and props around. I had the workshop students push a grand piano into the corner. The stylist made up and dressed two models in period costumes. I showed everyone how to use the different sections of the football field-sized room. As a final effort, because I wanted to show off the entire space, I placed one model near the piano lit by the sunlight streaming through the floor-to-ceiling windows and the other model in the much darker interior. With one Speedlight inserted into a medium softbox, I was quickly able to balance the two light sources before we had to pack up and leave.

LAJ

Every time I put a strobe unit on the camera, my wife giggles because, she says, "You don't have a clue as to what you're doing with that thing." In point of fact, she's mostly right. Flash units have always intimidated me and the only time I use them (and I use them effectively if erratically) is on Halloween with pretty much direct flash, outdoors. The other time I use it is at home, a habit I picked up when I realized that my daughter Amanda was not always going to do amazing things in great light. What I did and do is to try not to change the quality of the light which was coming from overhead. I shoot with bounce off the white ceiling.

Jay Maisel

PHOTO 2.4 Motorcycle (see lighting diagram on page 183).

PHOTO 2.4 *Motorcycle*

Advances in technology have improved so much that small Speedlights emit power that belies their size. Batteries continue to be the weak link but they have advanced enormously over the last few years. Therefore Speedlights can be considered for large jobs that were never possible before. Used in groups they can affect digital sensors like much bigger strobes.

Seven lights were employed for this "beauty" shot of a vintage Honda. Motorcycles are big, shiny, highly reflective objects and require precise lighting. Employing several different methods of diffusion in this case eliminates the point source characteristics of the Speedlights and gave them a "broader" appearance. Modified with diffusion materials, they presented a very large rake of light that "fell off" gently around the edges to the left side of the motorcycle and on other surfaces they could be employed to highlight smaller sections of the vehicle as well as the background.

A single Speedlight is hardly enough to illuminate such a large object professionally … successfully, but the cumulative effect of placing a sufficient quantity on contrasting surfaces is another strength of the portable lights.

Wireless TTL Transmitters: Master

The Nikon SB-900 and SB-800, Canon 550EX, 580EX, and 580EXMkII have built-in Wireless TTL transmitters. The Wireless TTL firing and exposure signals are encoded into the light burst of these flash units. Attached to the camera hot shoe, directly mounted on a TTL cord and through the menu on the Speedlight set to Master, these flash units can control up to three groups of Remote/Slave(s). Multiple Remote/Slave(s) can be included in each group.

The Master flash can be used as flash and transmitter or as transmitter only if no light from the camera position is desired. Used as transmitter only, the Master will still appear to fire. This is a low-powered Wireless TTL pre-flash signal and will have no adverse effect on the photograph. The most common effect is a secondary central catchlight (reflection of the Master flash) in a subject's eye or a reflective surface. The Wireless TTL transmitter signal works when fired through diffusion panels, softboxes, and other light modifiers, allowing all sorts of choices in light quality (see the section *Modifying Flash: Quality of Light* on page 132). Plastic bags can be used for lighting effects and/or weather protection (see the section *Accessories* on page 147).

Refer to the manufacturer's flash instruction manual for specific information on operating the flash as a Master.

Nikon: Some cameras have a built-in Wireless TTL transmitter system, providing Wireless TTL for a single or multiple Remote Nikon flashes. Activate the transmitter by setting the camera to Commander Mode. The SB-900 and SB-800 operate as either Master or Remote. The SU-800 Commander device operates as a Master only.

Canon: The 550EX, 580EX, and 580EXMkII are interchangeable as Master and Slave. The optional STE-2 transmitter, used in place of a flash as a Master, can control up to two groups of Slave flashes.

Wireless TTL Receivers: Remote/Slave

The Nikon SB-900, SB-800, SB-600, Canon 550EX, 580EX, 580EXMkII, and 420EX have built-in Wireless TTL receivers. Any of these flash units can serve as a Remote/Slave with a compatible Master.

Refer to the manufacturer's flash instruction manual for specific information on operating the flash as a Remote/Slave.

> Exposure Compensation on the Remote/Slave(s) should be set to "0".

In every photograph the subject is always the same: light. Learning how to see light is the first step to a good photograph. Learning how to control light is the second. With one or more Speedlights, photographers can mold light into various forms — transforming a flat scene into one with depth and dimension. Bounce a Speedlite off a reflector, and you increase the light source; diffuse a Speedlight with a diffuser, and you soften the light. The creative possibilities are endless — when you take control of the light.

Rick Sammon

PHOTO 2.5 Eye chart (see lighting diagram on page 184).

PHOTO 2.5 *Eye chart*

Sometimes it takes years for a photograph to evolve. An image can germinate for a long time before it is fully realized. I haunt flea markets, antique stores, and souvenir shops to find odd and interesting props. I store them away until I can incorporate one into the perfect shot. I owned the optometrist's lens kit for two or three years before the right project came along.

In the studio we were not working from a layout or predetermined sketch. The whole idea sprang from an original concept we developed. The different elements got pushed around a lot before this still life came together. I was going for a feeling of randomness, but every piece is placed precisely for maximum effect. We had to "distress" some of the props to make them look old.

The designer used it vertically in a book. I preferred the horizontal.

PHOTO 2.6 Trombones (see lighting diagram on page 185).

PHOTO 2.6 *Trombones*

When photographing highly reflective objects the size of the light source is essential. Because the shape and kind of light can be seen in the reflection, great care should go into its application. For metal, mirrors, glass, etc., both the light source and any reflectors often become part of the "design."

A very large custom-made light bank was positioned on the right side of the set. Then an 8′ × 8′ Foamcore® reflector was placed on the left so it started well behind the trombones. That way their curved surfaces would be "wrapped" by the Foamcore® highlight all the way around. We had to erect another 4′ × 8′ sheet of Foamcore horizontally directly above the set to show highlight on the 180 degree curve of the instruments.

A second Speedlight was goboed on the painted background with a blue gel to connote concert lighting.

The client made large posters from this shot. It is always good to see your effort big.

Canon: Activate the receiver by setting any flash to Slave. Any EX flash can be operated as a Slave.

Nikon: Activate the receiver by setting any flash to Remote.

The SB-900, SB-800, and the SB-600 can be operated as Remotes.

A to Z

pigeon, (pǐj'ən), n. 1. grip equipment for photography, film and video. 2. metal plate with a mounting stud used to position a light low to the ground, much lower than a stand can go. 3. small, low light stand.

The advent of cordless, TTL-controlled flash is an amazing development of the digital age that is often overlooked. For my money, the ability to get professional-looking results from multiple flash setups with point and shoot simplicity is one of the major appeals of digital photography.

Bob Krist

Wireless TTL Communication: Line of Sight

Different from the accessory triggers for most strobes, the signal for Wireless TTL is not infrared or radio activated. They are coded pre-flashes. For multiple Remote/Slave(s) to work they must "see" the light pulses from the Master. This direct path is called **Line of Sight**. Obstacles or barriers that block the light signal can prevent Wireless TTL from working or give unreliable results. In small, light-colored interiors, the Wireless TTL signal from the Master may sufficiently bounce off s urfaces to fire all Remote/Slave flashes even if the receivers are not facing the transmitter. But for most situations, and especially outdoors, anywhere the signal does not bounce, line of sight is required between the Master transmitter and the Remote/Slave receiver(s).

PHOTO 2.7 *Water pour—freezing motion*

Flash duration is the mechanism that Speedlights use to control the amount of light they project into any photograph. The more power you need the longer it emits light, and when you want a lesser amount the thyristor shortens the period of output.

As a consequence, for small strobes that need to send out small increments, the flash durations can be very short (approximately 25 microseconds). The inventive photographer can exploit those quick emissions. In this case we wanted to freeze liquid motion. Defy gravity.

All the light for this picture is coming from behind the measuring cups. It was designed to give edge light on the Pyrex®. The Master Speedlight was below the table and was only needed to trigger the other strobes. Stacking up the glassware was the initial problem. We actually had to superglue them together to withstand the buffeting of water pouring. We erased the logos and cleaned up errant bubbles in postproduction.

PHOTO 2.7 Water pour — freezing motion (see lighting diagram on page 186).

When set to Master, the flash will automatically zoom to the 24mm lens setting to provide the widest spread of the Wireless TTL signal. In general, the Wireless TTL signal from the Master radiates in an 80 degree wide "cone" in front of the Master, and is effective to over 30 feet outdoors and over 40 feet indoors. The Manual Zoom feature is still operable on the Master, but changing the angle of illumination from the Master also changes the spread of the TTL transmitter signal.

The Speedlights' bounce and swivel head can point the Master at a Remote/Slave behind or beside the camera. A TTL cord connected between camera and Master enables use of the Master off the hot shoe.

In some lighting scenarios, no direct line of sight between Master and Remote Slave is possible. Examples are a background light or veil light behind a subject or in a bank-light pointed toward the camera. The electronics are sensitive enough that reflector discs, reflector panels, and mirrors can be used to bounce the Wireless TTL transmitter signal around corners and at angles to the Remote/Slave. Because of the interchangeability of Master and Remote/Slave, you can place flashes to receive the signals in clever arrangements to ensure that they all get the message.

> The Wireless TTL receiver is located on the side of the Remote/Slave flash.

> Use the bounce and swivel head of the Remote/Slave to point the receiver toward the Master, while pointing the flash reflector at the subject.

Release yourself of the idea that Master/Slave or Master/Remote connotes any pecking order. The Main light may be quite removed from the camera. The Master should be thought of as 1—a controller, 2—a trigger, etc.

War Stories

Texas Prison

After weeks of communication with the Department of Corrections and warden to get permission to photograph inside maximum security, I was refused by the guard on duty my contact visit with an inmate in a Texas prison. We were separated by bulletproof plexiglass. After long negotiation, I convinced the guard to let me pass a Speedlight mounted on a stand through the small security opening. He begrudgingly accommodated my request by precisely placing and aiming the light inside. I then put the Master Speedlight on low output on my side of the glass and used the remote as the main light in the picture. It wasn't the ideal, but the setting and circumstances overrode the aesthetics.

LAJ

Wireless TTL: Remote/Slave ID Groups

Remote/Slave flashes can be identified as Group A, B, or C. All Groups fire at the same time. Flash power for each Group is adjusted by changing Flash Exposure Compensation settings on the Master. More than one flash can be assigned to the same Group. Multiple flashes assigned to the same Group will provide approximately the same flash output. The camera's computer views all flashes within the same Group as a unit.

Nikon: Master is identified and controlled separately as an M.

Canon: Master is always part of group A.

Wireless TTL exposure control for multiple Groups is illustrated by the following flow chart:

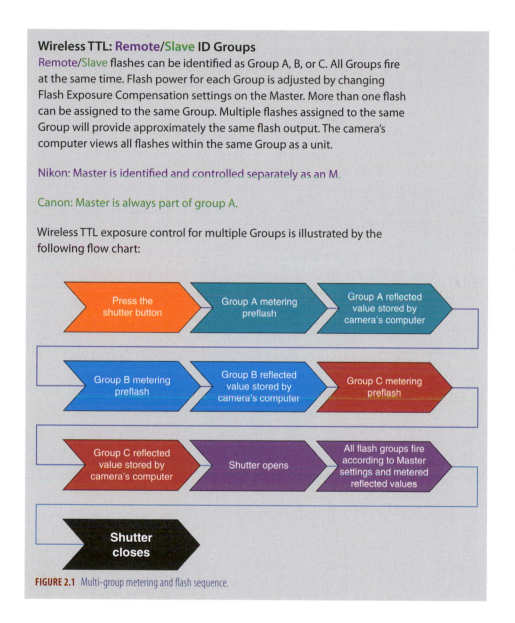

FIGURE 2.1 Multi-group metering and flash sequence.

Finite

A Master Speedlight can activate three groups and, according to Nikon, there is no limit to the number of Speedlights in each group. But is there eventually some limit to the number of Speedlights that can be used in a shot? Does the pre-flash process take longer if we add lights? Since light actually travels one foot in about a nanosecond, the distance between the Speedlights is insignificant. Each of the groups makes a separate light measurement, in sequence, but this time delay does not depend on how many Speedlights are in the group. The camera's computer makes the final exposure calculation

based on the light measurements from the Master Speedlight and up to three Remote/Slave groups. Theoretically the calculation is only based on a maximum of four light measurements and does not take any longer if more than one flash is in a group. The final data transmission to each of the remote groups and the firing of the flashes is also independent of how many Speedlights are in any one group.

The answer is ultimately one of practicality. How much light do you need? Is AC power available? For a location shot, packing several Speedlights might be a little easier, assuming you own several Speedlights. Finally, there is a cost trade-off that really depends on your ambitions as a photographer.

Wireless TTL: Channels

Four proprietary Wireless TTL operating Channels are available from each manufacturer. The Master will ignite all the Remote/Slave(s) set to the same Channel (and only those set to that channel) at the same time. Multiple operating Channels avoid interference from other photographers using same-brand Wireless TTL in the same location (see the section *Wireless TTL: Privacy* on page 108).

PHOTO 2.8 *Toys*

It is easy to think of Speedlights as portable — for use on location. But they should be considered just as well for still life photography. However, the philosophy for lighting still lifes is very different from lighting people or interiors. Speedlights are especially suited to direct small beams of light and can be arranged in tandem to selectively illuminate individual products. For small objects you are often highlighting particular shapes or surfaces. In that case directing small lights is ideal. Pinpointing the important features is easy for Speedlights.

In this shot the set was relatively small so space was limited, but several flashes were positioned in close proximity. Each one had a different kind of modifier — softbox, grid spot, gobo, or gel — to get a specific effect, shadow, sidelight, or color. Because they are compact enough, they can be placed close, aimed precisely, and dialed up or down so side by side two lights output very different levels of power.

I had a huge selection of antique toys from a friend's collection. I labored for days drawing a preliminary layout. All the other props I had stored away in my studio. I was up on a ladder. The camera was rigged to shoot straight down onto the set, which made it easy to arrange the reflectors and mirrors around the legs of the tripod.

Shooting still life is very painstaking work. You make very intricate adjustments and shoot often just to see how it looks.

PHOTO 2.8 Toys (see lighting diagram on page 187).

With sufficient numbers of flashes, the Channels feature can provide flexibility and speed on location or in studio. Pre-set lights in different parts of a room or lights set for different visual effects on a subject can be accessed instantly. For example, a "hard light" setup can be placed on Channel 1, and a "soft light" setup can be placed on Channel 2. The photographer can switch back and forth from one lighting effect to the other interchangeably simply by changing the Channel setting on the Master.

Wireless TTL: Privacy

Only the same manufacturer's flashes set to Master and set to the same Channel will fire Wireless TTL Remote/Slave(s). The light of "point and shoot" flashes will not trigger Wireless TTL Remote/Slave(s) nor are they fired by the same manufacturer's flashes not set to Master.

Both Nikon and Canon are proprietary systems with four interflash communication Channels. Four Nikon photographers can utilize Nikon Channels 1 through 4. Four Canon photographers can utilize Canon Channels 1 through 4. All can have a flash set to Master. Eight different Wireless TTL lighting setups can fire in the same room with no interference.

Travel

At the beginning of my career I convinced the second largest computer company that I was an experienced traveler. They immediately put me out on the road. Out of my league I went downtown and purchased a couple of cheap cardboard steamer trunks from Woolworth's Five and Dime, stuffed old newspapers around the twenty-plus pound studio power packs and boarded coach class, flying out of my local airport toward a new way of life.

Not knowing any better, somehow my equipment survived this treatment for months. Until I could afford more elaborate methods to better protect valuable, delicate electronics, my entire arsenal was at risk.

Soon after an entire industry caught on and caught up and designed high tech luggage for photographers along with lightweight stands, carbon fiber tripods, and pint-sized zoom lenses. Entire companies emerged around the necessity to make it easier for "road warriors": photographers who turned the factories, boardrooms, and extreme locations around the world into their personal "studios." At the same time the cameras and lights got smaller, the packaging got better.

Now I take the bulk of my lighting kit on board as carry-on.

LAJ

PHOTO 2.9 Luthier (see lighting diagram on page 188).

PHOTO 2.9 *Luthier*

There are few things that genuinely inspire you. I do not know why but music has always held great fascination for me—both the sounds such as classical, jazz, rock and roll, folk, and gospel as well as the implements: pianos, guitars, horns, woodwinds, etc. It is as if the instruments and what they produce are magic. Boston has dozens of companies and craftspeople who manufacture and repair every conceivable kind.

My assistants and I scouted a few potential sites before we chose the violin/cello shop. The choice was obvious once I saw the array of violins and violas against the green wall. We made a date to come back later when the store was not busy. Then we tiptoed around the expensive merchandise and gingerly erected a boom to hold the main light and set up all the background lighting.

Working with non-professionals can be tricky. They may have their own preconceived ideas of how they want to appear in pictures. As photographer/director you have to control this. Holding the delicate violin overhead was unexpected, but I had seen the movement while observing craftsmen before the shoot. My contribution was to have the face of the violin pointing downward and have a reflector on the repairmen's lap to kick light back into the surface. I brought several polishing cloths for extra color and chose the yellow.

The repetition of shapes is a classic compositional gambit. The colors make their own statement and the connotation of craft and music is a metaphor for sophistication, culture, and quality.

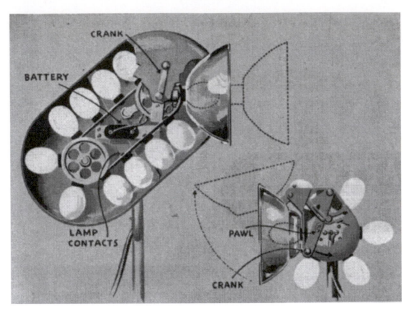

Repeating Flash Systems. Time-savers for photographers are the two lamps above, in which manually operated cranks replace spent bulbs with new ones, moving the reflectors out of the way as they do so. Once the fresh bulbs are in place, the reflectors return to position. The top lamp was invented by E. B. Nobel and A. W. Seitz, the lower one by John J. Malloy. Both devices use a series of bulbs with bayonet-type bases, and their discharge switches can be operated either by hand or by synchronizing apparatus.

Wireless TTL: Basic Settings for Master and Slave

The following lists provide the basic settings for preparing a Wireless TTL multiple flash setup.

Nikon SB-900 or SB-800 as transmitter only with one or more Remote Groups

On-camera flash Mode to "-----"
On-camera flash to Master
Remote(s) set to A, B, or C as needed
Master and Remote(s) set to the same channel: 1, 2, 3, or 4

Nikon SB-900 or SB-800 as flash and transmitter with one or more Remote Groups

On-camera flash Mode to TTL
On-camera flash to Master
Remote(s) set to A, B, or C as needed
Master and Remote(s) set to the same channel: 1, 2, 3, or 4

Canon 550EX, 580EX, or 580EXMkII as transmitter only with one Slave Group:

On-camera flash switch to Master
On-camera flash Master Unit Flash off
Ratio off
Slave(s) set to A
Master and Slave(s) set to the same channel: 1, 2, 3, or 4

Canon 550EX, 580EX, or 580EXMkII as transmitter only with two Slave Groups:

On-camera flash switch to Master
On-camera flash Master Unit Flash off
Ratio on
Ratio A:B
Slaves set to A and B as needed
Master and Slaves set to the same channel: 1, 2, 3, or 4

Canon 550EX, 580EX, or 580EXMkII as transmitter only with three Slave Groups:

On-camera flash switch to Master
On-camera flash Master Unit Flash off
Ratio On
Ratio A:B:C
Slaves set to A, B, and C as needed
Master and Slaves set to the same channel: 1, 2, 3, or 4

Canon 550EX, 580EX, or 580EXMkII as flash and transmitter with one Slave Group:

On-camera flash switch to Master
On-camera flash Master Unit Flash on
Master is always part of group A
For Master and Slave at the same flash exposure value: Ratio off, Slave ID set to A
For Master and Slave at the different flash exposure values: Ratio on, Ratio A:B, Slave ID set to B
Master and Slaves set to the same channel: 1, 2, 3, or 4

Canon 550EX, 580EX, or 580EXMkII as flash and transmitter with two Slave Groups:

On-camera flash switch to Master
On-camera flash Master Unit Flash on

Master is always part of group A
Ratio on
Ratio A:B or A:B:C as needed
Slaves set to ID A, B, C as needed
Master and Slaves set to the same channel: 1, 2, 3, or 4

Canon 550EX, 580EX, or 580EXMkII as flash and transmitter with three Slave Group:
On-camera flash switch to Master
On-camera flash Master Unit Flash on
Master is always part of group A
Ratio On
Ratio A:B:C.
Slaves set to ID A, B, C as needed
Master and Slaves set to the same channel: 1, 2, 3, or 4

Wireless TTL: Controlling Exposure and Contrast

To continually emphasize this paradigm shift in digital/Speedlight technology, we no longer rely on the old habits of controlling flashes with aperture and shutter speed and manually raising and lowering flash power. Now all decisions go through two independent computers, one in the flash and one in the camera, and they insist on giving you "correctly" exposed images every time despite any misguided choices. But everything in TTL flash is relative. Any adjustment you make in an automatic mode tends to make all the lights re-level themselves to get the proper exposure. If you come to understand this interdependency the rest is easy. Exposure strategies for Wireless TTL multiple flash photography and mixing these flashes with existing light remain basically the same as for on-camera TTL flash. Flash exposure for *each* Remote/Slave group is controlled by Flash Exposure Compensation and/or Ratio settings on the Master.

Using multiple TTL flashes is analogous to swimming pool lane buoys. They are all held together by a single cord. When you pull one buoy down underwater, they are all partially displaced by different but predictable amounts to hold the one submerged afloat. Likewise, each Speedlight contributes more or less light to balance the overall shot.

Group, Flash Exposure Compensation, and/or Ratio settings in Wireless TTL may seem confusing, at first, to those accustomed to manual flash and incident metering, or those unaccustomed to working with controlled lighting. Adjustments in Flash Exposure Compensation and/or Ratio settings should be judged both visually on the LCD monitor and graphically on the histogram. Review the highlight point of the histogram to determine exposure and the shadow point to determine contrast (see the section *Contrast* on page 61). Believe your eyes. Wireless TTL operates by comprehension, intent, and observation, not by linear formula.

PHOTO 2.10 Rolled rugs (see lighting diagram on page 189).

PHOTO 2.10 *Rolled rugs*

The client wanted a variety of detail images from the rug showroom to include in advertising materials. A Slave Speedlite in a 20" × 30" softbox, ratioed to provide the main light, was positioned to give a dramatic skim light, accenting texture and casting shadows forward to enhance the sense of depth. The Master Speedlite on the camera, fitted with a 5" × 7" softbox, was set to fire as a fill. The angle of the main, with the Slave at the rear of the softbox, did not allow line of sight between Master transmitter and Slave receiver, and the large dark interior of the showroom did not bounce the signal. The Main would not fire. The client was watching. In a moment of problem-solving inspiration, I popped open a silver disc reflector and put it by the slave, eyeballing the angles between Master and Slave. Test shot…Main fired. Image accomplished.

In review, Wireless TTL flash exposure is based upon reflected meter values. The Exposure Compensation for each Remote/Slave Group is set according to the brightness value desired in the image and the reflectance of the area illuminated. Wireless TTL flash Groups are adjusted in relation to each other, rather than a hypothetical baseline. In most cases, all other flashes are adjusted in accordance to the brightest flash. As more existing or continuous

light is incorporated in the exposure, the overall effect of the Speedlight will be reduced. It is recommended to have a preconceived idea for each flash Group used: Main, Fill, Accent, etc. In general, satisfactory highlight exposure should be obtained before attempting to judge contrast.

Group A is used as a Fill light.

Group B is used as a Main Light.

No available or continuous light is relevant in the image.

The brightness of the Main light determines the highlight exposure and its value. In this example, adjusting the value of Group B will change the highlight exposure in the image file.

Once a satisfactory highlight exposure value for Main light Group B has been established contrast can then be analyzed. The relationship between the Main light and the Fill light determines the density of the shadow areas and the amount of detail visible in those shadows.

To compress highlight and shadow, to lighten the shadows, and to reduce contrast, the exposure values for the two Groups must be brought closer together.

To increase contrast the exposure values for the two Groups must be pushed further apart.

Increasing or decreasing the Main light, Group B, will adversely affect the highlights, so the contrast in this example is controlled by changing the value of the Fill light, Group A.

Fill light Group A "−" will increase the difference between Main and Fill, increasing shadow density and increasing contrast. Fill light Group A "+" will do the opposite.

If Fill light Group A is set to "−2", it will fire at a reflected value two stops less than the Main light Group B, regardless of whether the Main light Group B is adjusted up or down.

Wireless TTL exposure for multiple flashes is also based on the total amount of flash entering the camera. As one flash Group is made brighter, other flash Groups may become darker. With manual flash each change is independent. But with multiple lights, as in the buoy analogy on page 49, any change in any of the lighting, available or flash, affects all the others. Adjust flash Groups accordingly.

A to Z

gamma (gam-uh) n. 1. measure of contrast in photographic materials. 2. in digital photography, the measure of the contrast of an image or imaging device.

Since multiple wireless TTL Speedlights work in unison, adjusting any one may automatically change others and the overall look of the picture. To illustrate the need for a visual and flexible approach to setting Wireless TTL, consider these examples:

1. If a Background light is made brighter or darker, the Main light may also need to be adjusted. The total amount of flash entering the camera is changed, therefore the TTL flash settings may need to be changed.
2. When a TTL flash Group illuminates a small portion of the subject or the frame, it will have a tendency to overexpose. A Rim light, Edge light, or Hair light may need to be set to a low value even if it is the brightest light in the image.
3. If a subject changes from a dark shirt to a light shirt, the TTL settings may need to be adjusted for the change in subject reflectance.

Once an exposure relationship is established between multiple TTL flashes, the camera computer works to maintain that relationship even if the lighting setup changes. Consider these examples:

4. Main: The Main light may be moved to create a different direction without adjusting the TTL flash settings.
5. Main and Fill: Once a satisfactory highlight point (exposure) and shadow point (contrast) are established, the Main light may be moved closer to, or farther from, the subject to change the quality of light without further adjusting the TTL flash settings.
6. Main and on-camera Fill: Once a satisfactory highlight point (exposure) and shadow point (contrast) are established, an on-camera Fill light may be moved closer to, or farther from, the subject to change the composition without further adjusting the TTL flash settings.
7. Main and Fill: Once a satisfactory highlight point (exposure) is established, the Fill light exposure compensation/ratio may be changed to adjust the contrast without affecting the highlight point.

In review, if the amount of existing light in the image file changes, by either exposure or actual brightness, the camera computer will adjust the flash values accordingly. The quantity of existing light in the image is changed by adjusting a camera setting: existing light Exposure Compensation, shutter speed, aperture, and/or ISO. To change the brightness value of any or all of the Wireless TTL flash Groups, adjust the Flash Exposure Compensation and/or the Ratio settings for those Groups. The amount of TTL flash in the image is altered with the brightness of the TTL flash(es).

The number of settings, choices, and decisions may be the most intimidating aspect of Wireless TTL photography with multiple flash Groups. But the system really is almost foolproof. If you succeed in getting the Speedlights to fire, the LCD will give you instant feedback as to whether they are doing what you want. Just be sure you keep in mind they are rarely making the mistake. They are simply doing what you tell them…perfectly. It is always helpful to have a previsualized purpose for each flash Group, as this gives a good starting point for Flash Exposure Compensation and/or Ratio settings (see the section *Main Light and Fill Light: Definitions* on page 48).

PHOTO 2.11 Julie in green (see lighting diagram on page 190).

PHOTO 2.11 *Julie in green*

The background is black seamless colorized with a green-filtered Speedlite. The green was selected to complement the clothing and eye color, and to add mood. Firing a filtered flash into the black background produces intense, saturated color and quick falloff for a dramatic haloed vignette effect.

The combination background/hair light effect is produced with one Speedlite behind the subject. The Speedlite is on a low stand, tilted straight up, covered with a green gel, and is fitted with a diffusion material "sleeve" (see the section *Diffusion Sleeve* on page 147). The sleeve effectively turns the Speedlite into a soft, diffused flash that fires in predominantly two directions. Light striking the background gradates beautifully and light going forward illuminates the edges of the subject producing a rim light. If I wanted to illuminate only one side, I would place a black report cover over the opposite side of the sleeve as a gobo.

The Main light is a Speedlite in a 12" × 16" white-lined softbox. I move my lighting in close, looking for the edge of the softbox in the viewfinder, then backing it up only an inch or two so it is out of the picture. The physical closeness of the light results in the glowing skin tones. It also produces large bright catchlights to add life and bring attention to the eyes. Classic Rembrandt lighting was created by using the light at 45 degrees to Julie's face, accentuating and complementing the facial structure. A 3' × 6' white reflector was positioned to camera left as fill. It picked up some of the background light resulting in the green cast in the shadows.

Nikon and Canon use distinctively different control protocols for adjusting the relationship between multiple Remote/Slave Groups. The following sections for each manufacturer's Wireless TTL control system will apply a logical aesthetic and technical process to make multiple Wireless TTL more intuitive, fluid, and creative.

Canon:

The LCD panel on the Master flash features Flash Exposure Compensation and Ratio controls for Slave Groups A, B, and C. The Master is always part of Group A. All flash Groups fire at brightness values relative to each other as dictated by the photographer. The flash brightness values are also affected by the quantity of existing or continuous light. The controls for all of these light sources can soon become intuitive if time is taken to analyze the effect of each one. If the Master and all the Slaves are in the same flash Group, they might fire at different powers but will all provide approximately the same brightness value.

Use the key words to regulate the flash control to the effect desired in the image: **Flash Exposure Compensation** is used to adjust the flash highlights, i.e., the highlight exposure value, **Ratio**, is used to change contrast, often referred to as lighting ratio.

Ratio A:B establishes the brightness value relationship between Groups A and B. The Ratio is shown as units of light. The dots in between the numbers represent intermediate ratios. An A:B Ratio of 1:4 translates into one unit of light emitted from Group A for every four units emitted from Group B, resulting in Group B being two stops brighter than Group A. An A:B Ratio of 4:1 translates into four units of light from Group A for every one unit from Group B. The Ratio feature can be set to any Ratio shown on the flash LCD.

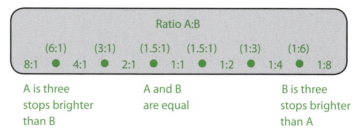

Ratio A:B:C provides the same A:B Ratio control as above, with Group C controlled by a separate Flash Exposure Compensation of "−3" to "+3" relative to the total brightness values provided by Groups A and B.

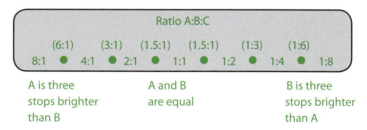

C "−3" to "+3" Flash Exposure Compensation relative to the total brightness of A:B

Flash Exposure Compensation on the Master changes the quantity of flash provided by the Master and all Group A Slaves. Since the other flash Groups respond to changes in any one flash Group, the Flash Exposure Compensation on the Master effectively raises or lowers all flash Groups equally.

Consider a two Group lighting setup providing a Main and a Fill. The Main light is often used close to the subject. But let us suppose that the Main light is an off-camera Slave. Identify the Slave as Main and Group B. The on-camera Master is ideal for use as a flat, frontal Fill light. Used with a TTL cord, the same Master can also become a Form Fill (see the section *Main Light and Fill Light: Definitions* on page 48). With Canon, the Master is always part of Group A.

The difference in brightness between the Main light and the Fill will determine contrast. To make the Slave Group B Main light two stops

brighter than the Master Group A Fill, set the A:B Ratio at 1:4. This will provide four units of light from Group B for every one unit from Group A. Group B as Main will be two stops brighter than Master Group A as Fill.

When needed, adjust the Group C Flash Exposure Compensation to make Group C brighter or darker relative to Groups A and B.

Use these guidelines as a starting point to obtain a traditional 3:1 Main:Fill contrast range:

> If the Main is A and the Fill is B, start with the A:B Ratio at 3:1.
> If the Fill is A and the Main is B; use 1:3.
> View the contrast range on the histogram.
> Adjust the Flash Exposure Compensation for C (if used) to obtain satisfactory results.

A to Z

camera obscura, (cam'-er-ah ob-scoo'-rah) n. 1. light-tight box with a small pinhole on one side, through which rays of light pass and form an inverted image of the external view projected in their natural colors onto the opposite surface 2. from the Latin meaning "dark room". 3. device leading to the origin of the present day camera.

Nikon

The LCD panel on the Master flash features Flash Exposure Compensation for Remote Groups M, A, B, and C. On some camera models, these controls are accessed through the camera LCD when the camera is set to Commander Mode. The Master is always Group M. All flash Groups fire at brightness values relative to each other as dictated by the photographer. The flash brightness values are also affected by the quantity of existing or continuous light. The controls for all of these light sources can soon become intuitive if time is taken to carefully analyze the effect of each one. All Remote flashes in the same Group will provide approximately the same brightness value.

The flash Group compensations are adjusted to create a brightness relationship between the Groups, rather than an intrinsic individual base.

Consider a two Group lighting setup providing a Main and a Fill. The Main light is often used close to the subject. It is likely that the Main light will be an off-camera Remote. The on-camera Master is ideal for use as a flat, frontal Fill light. Used with a TTL cord, the Master can also become a Form

Fill (see the section *Main Light and Fill Light: Definitions* on page 48). To control the brightness values of the Remote Main and the Master Group M Fill relative to each other, identify the Remote to be used as Main as your choice of Group A, Group B, or Group C.

The Remote Group used as Main will provide the highlight brightness. Set the Flash Exposure Compensation for the Remote Group used as Main to "0", to provide a standard flash exposure.

The difference in brightness between the Main light and the Fill will determine contrast. To make the Master Group M Fill two stops less than the Remote Group used as the Main, set the Flash Exposure Compensation for Group M to -2 EV. Group M will now remain at two stops less than the Group used as Main, even if the Flash Exposure Compensation for the Group used as Main is raised or lowered.

If additional Remote flash Groups are added, adjust the Flash Exposure Compensation for these additional Groups in relation to the Main and Fill to achieve the desired brightness values.

Use these guidelines as a starting point to obtain a traditional 3:1 Main:Fill contrast range:

Start with the Main at "0" and the Fill at -1.7 EV. For more dramatic contrast, set the Fill at -2.3 EV to -3 EV. For less contrast, set the Fill at -1 EV.

View the contrast range on the histogram.

Adjust the Flash Exposure Compensation for any Remote Group to obtain satisfactory results.

Test

With one or more Remote(s)/Slaves you can press the Flash button on the back of the Speedlight Master and each Group will ignite in sequence to demonstrate that the Wireless feature and the entire system is working. It is quite an impressive display. You can activate the Master and have dozens of Speedlights firing one after another. It is a veritable stroboscopic light show.

As with traditional manual flash and Polaroids, it may take several test images and adjustments to successfully place tonal values where desired. Experimentation and experience with the Wireless TTL system will make efforts easier.

War Stories

CEOs are an acquired taste. Fortune 500 ones can be for photographers with trust funds and blue blood. The rest of us fly coach to shoot VPs and managers for their annual reports. A special language is spoken in the boardrooms of large corporations. It's different from down on the assembly lines of automobile manufacturers and roustabouts on desert oil patches.

Years ago, my first bank executive was done with trunks of rental studio strobes and my recently purchased sports jacket and tie. I think he appreciated my sartorial effort. Soon I owned enough of my own lighting equipment. Name brand stuff in custom made cases but still it cost dearly as excess and overweight baggage and took a cadre of assistants to transport.

Over time I've had to bully some execs but many have become friends. The last CEO I did was with two Speedlights on automatic as I chased him around four floors of a new acquisition. He was "too busy" to stop for fifteen minutes and have a proper portrait taken.

At 38 billion dollars S&P worth he was a ten with everything and I was still a six in a new pair of slacks.

LAJ

Manual Flash

Canon Speedlites and Nikon Speedlights can be operated on Manual. The Manual mode changes the fundamental operation of the flash system, disconnecting the flash from the in-camera reflective meters and computer, returning to "old school" flash photography. In Manual flash mode, the camera's computer will no longer change the quantity of flash automatically. The photographer regulates flash power, distance, and aperture. Each flash group will now provide a fixed, unchanging quantity of flash. Flash brightness values are changed by flash power rather than Flash Exposure Compensation.

How It Works

Manual flash is a combination of the basic physics of light and photographic mechanics. Exposure for Manual flash is determined by a combination of ISO, flash power set by the photographer, flash-to-subject distance, zoom head position, and aperture. The following explains the significance of each component of a Manual flash exposure value.

ISO is the relative sensitivity to light. ISO determines the quantity of flash sufficient to properly expose capture medium.

If the range of flash power settings cannot provide the desired aperture and/or span the flash-to-subject distance, change the ISO.

PHOTO 2.12 Fish (see lighting diagram on page 191).

PHOTO 2.12 *Fish*

A large segment of my work over the years has been what used to be called *photoillustration* where I have had to "illustrate an idea" with a conceptual photograph. A client once asked for a series of photographs to highlight a story concerning different aspects of ecology — some were negative and some positive. This one represented something like "preserving clean water."

With the help of the shop owner, my assistant and I spent a long time, at a pet store, scouting and researching fish that could withstand the treatment of being enclosed in such confined quarters. I wanted as much color as possible but I was told the prettiest fish were also the most delicate. We had to acclimate our "model" by slowly adjusting the water temperature.

For each exposure we had to position a mirror just right for the fighting fish to see his reflection, get excited, and flair his fins. We made the idyllic blue sky with puffy clouds by spray painting seamless background paper and lighting it.

Since I spent so much time thinking about concepts that were eventually turned into photographs, I have had to develop systems that resulted in abstract but legible ideas. My theory for good photoillustration is that the more ambiguity the more successful the idea. After the shot one of the authors took the fish home to his children.

Flash power changes the amount of flash. Flash power does not make the flash tube brighter or dimmer. It controls flash duration or the amount of time the flash tube is lit. Maximum flash power, also called full power, is represented on the flash LCD display as "1/1". Maximum power is the longest duration, and the greatest amount the Speedlight can produce. Full power may be needed at small apertures, low ISO, or if the subject is far away from the flash. Minimum power produces the shortest duration. Because of the short flash duration, low flash power can freeze very fast action. Low flash power is for large apertures, physically close subjects, or high ISO settings. Flash in Manual mode is adjustable in 1/3 stop increments. The actual amount of flash is expressed as Guide Number (see *Guide Number* on page 10). See manufacturers' instructions for specific steps of setting Flash Power in Manual flash mode.

The Nikon SB-900 and SB-800 are adjustable in full stop increments from 1/1 to 1/2 power, then 1/3 stop increments from 1/2 power to a minimum power at 1/128.

Reducing Flash Power: If 1/1 Full Power were to provide f/8 worth of flash at a certain distance, 1/2 Power would provide half that, requiring an aperture of f/5.6 for the same distance. Quarter power would provide 1/4 the amount, for an aperture of f/4 at the same distance and so on.

PHOTO 2.13 Thanksgiving family portraits (see lighting diagram on page 192).

PHOTO 2.13 *Thankgiving family portraits*

This Thanksgiving my mother and father's families gathered together, 26 people in all, to cook and devour enormous amounts of food and drink plenty of wine. A rare occasion, I needed to document the three generations.

I had three speedlights and my camera, but nothing else. Searching through my family's basement we found cardboard boxes, stands and linens. Good enough. We cut a hole in the back of each cardboard box for the Speedlight swivel head, making sure not to block the sensor. We attached pillowcases to the front opening of the boxes. The "softboxes" were attached to stands.

One "softbox" lit the subject while the other was positioned behind a white bed sheet background. The sheet acted as a diffuser, giving a soft halo effect around the subject.

With the white background and consistent lighting I was able to focus on the individual characteristics that make each person unique.

> If 1/1 Full Power at an ISO were to provide f/11 for a subject 10 feet from the flash, 1/4 power at the same ISO would provide f/11 worth of flash for a subject 5 feet from the flash (see the section *Inverse Square Law* on page 18).
>
> If 1/1 Full Power at ISO 100 were to provide f/16 for a certain distance, 1/2 power at ISO 200 would provide f/16 at the same distance and 1/4 power at ISO 400.

The flash-to-subject distance, at any power setting, affects the amount of flash reaching the subject.

Adjust the flash power, aperture, and/or the ISO to provide a correct flash exposure for a subject at any given distance from the flash.

Adjust the flash power and/or the ISO to achieve a desired aperture value.

Different combinations of flash power and aperture can all result in a correct flash exposure value.

> Off-camera flash can maintain a constant flash-to-subject distance for constant exposure values while allowing the photographer to move, changing the camera position without changing aperture or flash power.

The zoom head position controls the angle of illumination, spreading the light to cover a larger area for wide angle lenses or concentrating the light for greater range and efficient use with longer focal lengths. The zoom head position affects the Guide Number and intensity at any given distance.

Flash power and/or aperture may need to be adjusted for each change in focal length when the flash zoom is set to Auto.

Setting the zoom head manually will allow a constant aperture at different focal lengths at the same distance and same power. Set the flash zoom head manually to cover the widest focal length being used. Aperture will not have to be changed when zooming the lens to a longer focal length at the same distance.

Flash LCD

ISO, flash power, flash-to-subject distance, zoom head position, and aperture can all be used as starting points for a Manual flash picture. When a single Speedlight set to Manual flash mode is used on the camera hot shoe, or used with a TTL cord, the LCD on the back of the Speedlight provides a guide to obtaining correct Manual exposure settings. Even in Manual flash mode the computer will continue to display information to aid the photographer.

Attach a Speedlight to the hot shoe of a camera with a zoom lens. The flash should not be in Master or Remote/Slave modes. The flash head should be in the straight ahead, not bounce, position. Turn on the camera and flash, and set the flash mode to Manual. A single usable distance will be indicated on the flash LCD. Canon displays this distance as a bar under a single distance number on the bottom of the LCD. Nikon displays this single distance numerically. This displayed distance will change with changes to the ISO setting on the camera, changing flash power, changing focal length, and/or changing the f/stop setting on the camera. To obtain a correct Manual flash exposure, make adjustments to flash power, aperture, and/or ISO until the distance displayed on the flash LCD matches the actual distance between the flash and the subject.

Set an aperture on the camera for depth of field. Determine the flash-to-subject distance. Referring to the flash LCD, adjust the flash power until the LCD indicates the correct distance.

Select a flash power. Determine the flash-to-subject distance. Referring to the LCD, adjust the aperture on the camera until the LCD indicates the correct distance.

Canon Speedlite LCD Display

The line over the distance indicates a correct flash power and aperture for a correct exposure at the indicated flash-to-subject distance.

Nikon Speedlight LCD Display

6.6 Ft

The displayed distance indicates a correct flash power and aperture for a correct exposure at the displayed flash-to-subject distance.

A handheld flash meter can be used to determine exposure when a single Speedlight is set to Manual flash mode and is connected to the camera hot shoe. The use of a flash meter is recommended when a Speedlight, set to Manual, is bounced or used with a softbox or diffuser. A handheld flash meter may not be effective with Wireless Manual flash (see the section on *Wireless Manual Flash* page 128).

The flash LCD displays usable distance when the Speedlight is connected to the hot shoe of the camera and the flash head is pointed straight ahead. It is disabled when the Speedlight flash head is tilted or swiveled, and when the Speedlight is set to Master and/or Remote/Slave functions. Use Guide Number, histogram/blinkies, trial and error, or a handheld flash meter in these configurations.

- If the correct flash-to-subject distance cannot be obtained by adjusting the aperture and/or the flash power, change the ISO.
- If the subject is underexposed, increase the flash power, use a larger aperture, or use a higher ISO.
- If the subject is overexposed, decrease the flash power, use a smaller aperture, or use a lower ISO.

Manual flash mode can provide the solution to situations where the various TTL flash modes may not seem satisfactory.

TTL flash modes can be problematic in certain fast-moving situations, such as a wedding processional where people are rapidly moving toward the camera and dressed in various light- or dark-colored clothing. In a TTL flash mode, each tonal value change in the subject requires a change in Flash Exposure Compensation to obtain a satisfactory exposure. The photographer working in a TTL flash mode may not have time or the experience to adjust to the correct compensation for

each new subject hurrying down the aisle. Manual flash can provide reliable and consistent flash exposure in this situation. With Manual mode, if all people are photographed at the same distance, the same power, and the same correct f/stop, exposure values for all subjects will be correct. This is the principle of **scale focusing**, a simple solution for pictures of moving subjects with Manual flash.

An average full-length portrait with a normal focal length lens[7] will place the subject about 12 feet away from the camera. Shut off the autofocus and pre-focus the lens at 12 feet. Set the aperture on the camera to f/8. This will provide sufficient depth of field to get from approximately 10 to 15 feet in focus. If the flash power is adjusted manually to provide f/8, all subjects at 12 feet will be correctly exposed regardless of light or dark clothing or skin tones. As each subject steps into the 12-foot distance from the camera, providing a pleasing full-length image, the photographer makes the picture. Focus and exposure are virtually guaranteed for each image.

Continuous autofocus can also be used if the photographer can judge the distance by the size of the subject in the viewfinder, or by noting when a subject passes a particular feature in the scene used as a "marker" to indicate correct distance, such as a bow on a pew at 12 feet away from the camera.

Manual flash mode can be advantageous in static situations where a variety of subjects must be photographed using the same lighting setup. A good example is a location setup in a conference room, where the job calls for individual portraits of a number of employees, and all exposures and images must be uniform.

Another example where Manual flash mode may be appropriate is in volume prom couple photography. Manual allows the photographer to make pictures of the dark suit, the white shirt, the light blouse, the dark sweater, and the lab coat subject all the same.

Wireless Manual Flash

The Wireless transmitter and receiver built into the Speedlight remain usable when the Speedlights are set to Manual flash mode. Master, Remote/Slave, Group, and Channel settings remain the same (see the sections on *Wireless TTL* on page 96). Wireless TTL flash modes control flash group brightness values by flash exposure compensation and/or ratio settings. It also controls flash group brightness values by changing power settings for each group. The power for each group can be selected on the Master, or each Remote/Slave flash can be set individually. Setting the Master to Manual Flash Mode will set all Remote/Slaves to Manual. Then power for each Remote/Slave group can be set through

[7]Normal focal length is approximately 30 mm for a 1.6× sensor, 35 mm for a 1.4× sensor, and 50 mm for a 35 mm full frame sensor camera.

the Master. Manual flash is not metered in-camera (some Canon camera models meter Manual flash). In Wireless Manual flash, changing the power for one group will not change the power and brightness of other groups.

Exposure and flash power settings for multiple groups of Wireless Manual Speedlights may have to be determined by measuring flash-to-subject distances and calculating with Guide Number, or by trial and error adjustment of each group's flash power and observation using the LCD, the histogram, and blinkies. Handheld flash meters may not be effective with Wireless Manual flash, as the Speedlight's Wireless transmitter emits a pre-flash that will give a false meter reading, often resulting in extreme overexposure. See manufacturer's instructions regarding specific Wireless Slave/Remote operations and functions.

In summary, in a manual flash setup:

- To make the light from one particular flash brighter or darker, change flash power for that flash unit only.
- To make all flash equally brighter or darker without changing f/stop and ISO, equally increase or decrease the flash power on all flashes; for example, if flash power is doubled on each flash, the overall flash brightness value would increase by one stop.
- When no existing light is in the picture, to make all flashes equally brighter or darker without changing depth of field, change the ISO.
- If no existing light is in the picture, to make all flashes equally brighter or darker and change the depth of field, change the f/stop.
- To make only existing, ambient light brighter or darker, change shutter speed.
- To make both existing light and flash equally brighter or darker, change f/stop or change ISO. As the amount of existing light increases, flash power may have to be reduced to avoid overexposed highlights.

Mixing Speedlights with Studio Flashes

Manual flash mode allows the use of the Speedlights in conjunction with other, traditional flash units, such as studio strobes or older, non-TTL flashes.

The Nikon SB-900s and SB-800s have a built-in photoelectric eye trigger that will fire these units when it sees a light Impulse (see the section *Nikon SU-4 Mode* on page 97). The SB-900 and SB-800 also have traditional PC flash cord terminals, allowing triggering by wired connection to the PC[8] outlet on a camera, infrared triggering device, or radio slave receiver.

[8]A **PC cord** is a simple wired connection between the flash and camera or the flash and a triggering device. The PC cord carries only a firing signal. It does not transmit exposure information. A PC connection terminal is found on many cameras and remote triggering devices. It is a round connection terminal with a single pin protruding in the middle. PC cords are available in a variety of styles, lengths, and from many manufacturers. The "PC" refers to Prontor® and Compur®, the two shutter manufacturers that collaborated to standardize this connector.

PHOTO 2.14 Architectural shot (see lighting diagram on page 193).

PHOTO 2.14 *Architectural shot*

Interiors are designed around light. So when scouting this residential location with the property owner light was streaming into the front foyer and illuminated it beautifully. I thought the available light would do most of the work. Of course on shoot day the weather turned ominous and there was little help from the sun.

Shooting architectural photographs with a 35 mm camera has been transformed with the advent of digital. The ability to employ very wide angle lenses means you can work in more restricted spaces and maintain good depth of field. Camera movements can be managed even though there are no swings or tilts. Keeping lines parallel is a decision that can be made while shooting or afterwards, with software.

To best illustrate the space, I almost always strategically position the camera first, then arrange everything else around it. I then find the architectural elements first, then solve the logistics problems second. We had planned on bringing many of the props with us — neon sculpture, flowers and plants, diptych painting — but the rest was impromptu. My assistants moved a lot of heavy furniture out of the picture and replaced them with preferred pieces. Then we slowly "built with light," adding another Speedlight wherever necessary.

Step by step we substituted Speedlights for nonexistent sunlight then accented different areas to control the contrast. A large blue seamless background paper was moved just out of frame on the extreme left to be reflected in the glass doors on the right. We lit the paper with a blue gel and you can see the intentional glare in the glass pane and on the black chair. Eventually seven flashes were needed to make the scene appear "natural."

The hot shoe on the Canon Speedlites can be fitted with a variety of devices for remote triggering when the Speedlites are used with non-TTL flashes. Hot shoe photoelectric eye triggers and PC-to-hot shoe adapters allow the Canon Speedlights to be triggered by the light from another flash, or by wired connection to a PC terminal on a camera, infrared triggering device, or radio slave receiver.

A to Z

rotogravure (rō′te-gre-vyōōr′) n. 1. photographic intaglio printing process in which type, illustrations, or pictures are transferred from an etched (recessed) design in a copper plate onto a web of paper, plastic, or similar material on a rotary press. 2. printed publication, such as newspaper section, produced by this system. 3. using photography to produce a plate for printing. 4. the opposite of letterpress printing.

War Stories

Necessity Is the Mother of Invention

Recently, I received a call from a prestigious, national magazine: follow and photograph a jazz musician for several days. Dream assignment. Only caveat, he was a nine-year-old prodigy AND autistic. That meant if he wasn't interested in what was going on, his attention span was nonexistent. I surmised that it would be difficult to set up lights and have him pose or repeat movements.

The magazine has a very specific look and we needed a great deal of ingenuity to maintain that look. I was stymied as to how to accomplish my very deliberate lighting methods without alienating the boy.

Speedlights to the rescue. I jerryrigged a small, cheap 12″ × 12″ softbox to one Speedlight and connected it to the camera with a 15-foot TTL cord. My able assistant was saddled with chasing the budding genius throughout our sessions inside, outside, during rehearsals, etc., as he "bounced off the walls" with his relentless hyperactivity. Through hand signals she kept the light just outside the frame, so that I could get the maximum effect from the diffused light.

With the camera on Programmed mode, I paid no attention to exposure or shutter speed. Virtually every image was usable and using rear curtain sync we were able to balance to all the ambient lights on the fly.

LAJ

Modifying Flash: Quality of Light

The Wireless TTL signal from the Master remains effective if bounced or passed through a diffusion screen. In-camera flash metering and automatic flash exposure remain operational. Exposure strategies remain unchanged. Master and Remote/Slaves can be used with reflector panels or discs, diffusion panels, and softboxes. Several brands of 5″ × 8″ softboxes attach directly to the flash with Velcro®. Speedlights can be attached to much larger bank lights too. A variety of manufacturers produce brackets and rings to mount a TTL flash to extra small, small, medium, and large softboxes.

Various softboxes mount the flash at the rear, ideal for maintaining line of sight between Wireless TTL transmitter and receiver.

Softboxes: Notes

When used with Speedlights, the softbox acts as an enclosed diffuser. Figure 2.2 shows how the Speedlight fires directly toward the front panel of the softbox, which creates a larger light source and somewhat scatters the direct light. By the increase in size and the slight scattering, the softbox turns the Speedlight into a softer light source.

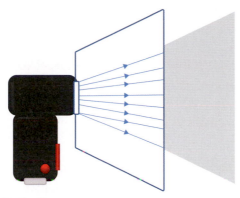

FIGURE 2.2 Speedlight with softbox.

When used with "studio" strobe heads that have removable reflectors, the softbox becomes a mixing chamber as well as a diffuser. When the bare flash tube of the studio strobe is in the softbox, light is directed not only at the front panel, but at the internal reflecting panels of the softbox. This mixing can produce a more homogeneous, softer light from the same softbox, as shown in Figure 2.3.

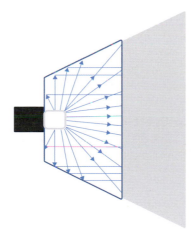

FIGURE 2.3 Studio flash with softbox.

The Speedlight can be made to mimic the bare tube head. The Nikon Speedlight comes bundled with a snap-on dome diffuser. A similar diffuser is available from independent manufacturers for the Canon Speedlite. Used alone, this diffuser does not soften the light. The size of the light source remains the same. Study the edge of the shadow on the subject with and without it. The dome diffuser does bounce light in all directions. When used indoors, overall contrast is reduced and more light is provided in the background of the picture. The dome diffuser used on a Speedlight inside a softbox turns the Speedlight into the equivalent of a bare tube flash, as

depicted in Figure 2.4. The quality of light from the dome diffuser Speedlight in a softbox may be softer than a "straight" Speedlight.

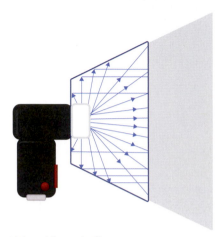

FIGURE 2.4 Speedlight with dome diffuser and softbox.

Softboxes are available in a variety of sizes and specifications. The larger the softbox, the softer the light. The greater the softbox-to-subject working distance, the larger the softbox needed to maintain a soft light. Silver-lined softboxes will have more contrast and specular highlight than white-lined softboxes. Several brands have interchangeable interior fabrics and secondary, removable internal diffusion baffles. Recessed front softboxes provide a more narrow angle of illumination than flush front. Recessed fronts allow more control over the spread and feathering of the light. Flat, flush fronts may be better if there is extensive use of reflectors as fill. Recessed front softboxes often can be fitted with fabric egg-crate grids, providing a soft, specific spotlight effect. Barn doors, purchased or fashioned, may be available to further control the spread, spill, and placement of the light. Circular masks change the shape of the catchlight in the eyes.

Strip boxes are long narrow softboxes designed for full length portraits and fashion, for use as edge or hair lights, or any time long, slender highlights are desired, such as in photographing bottles or glassware. Small Speedlights can be used with a large softbox. Set the zoom head to the widest to evenly illuminate the front diffusion screen.

The horizontal or vertical orientation of the softbox can change the look of the image. A vertical subject may be best with a vertical light. Group pictures may call for horizontal. Shape the light to better match the subject. Using a large softbox horizontally for a portrait may yield less contrast and more of a "wrap around" look, as the wider softbox is illuminating the subject from more angles. A very large horizontal softbox may successfully take the place of separate Main and Form Fill lights for portraiture.

PHOTO 2.15 Bottles (see lighting diagram on page 194).

PHOTO 2.15 *Bottles*

Photography is well suited to illustrate abstract concepts. One of the first things you learn with glassware is to illuminate it from behind. This works with clear, transparent glassware, translucent, or containers holding liquids.

We had to light this setup from both front and back to get the best qualities. The problem arose from trying to keep the front strip light from "contaminating" the saturated color coming from behind through blue gels.

Softboxes mount Speedlights on the rear of the light modifier. When the Speedlight/softbox combination is used in front of the camera, closer to the subject, it is easy to maintain line of sight between Master transmitter and Slave/Remote TTL receiver. Make sure the softbox mounting bracket flash shoe rotates to allow facing the receiver toward the transmitter while placing the flash head into the softbox.

> Set the zoom head of the flash to a wide setting to provide even coverage across the diffusion screen. Multiple TTL flash units, set to the same Remote/Slave ID, can be rigged or mounted firing into the same bank for increased light output.

Certain configurations, such as bounce umbrellas, may block the Wireless TTL signal and may not work well in many situations. White shoot-through diffusion umbrellas may be usable, as the umbrella does not come between Master and Remote/Slave.

> *A* paper towel tube, rolled black seamless paper, or Cinefoil® can be used as a snoot to limit the spread of the flash or create special effects. (See the section *Accessories* on page 147.)

Wireless TTL flashes can be modified to duplicate the same quality of light as studio flash units.

Equipment, Accessories, Products

Photographers love gadgets. In an effort to capitalize on this insatiable appetite, new products are being introduced all the time. Magazines and conventions are filled with companies hawking their wares. The Internet flourishes with Web sites whose sole purpose is trade. Everyone feels they can "build a better mousetrap."

It is unfortunate but far too many reduce taking pictures to the quality and quantity of equipment and paraphernalia. Whereas the right tool can solve a myriad of problems, a little common sense is necessary to discover just those accessories that will substantially contribute to making better images. Some are tools you need to succeed and some are merely toys. Personal style dictates what kind of equipment photographers need, that and maybe their pocketbooks.

After gathering together the basic equipment to take pictures, generations of great photographers have proven that little else is needed to make brilliant photographs. Although we could all use the proverbial compass to point toward true North, a magic carpet to raise us high above it and a "perpetual motion machine" to power it all, while we are waiting for that we all know "necessity is the mother of invention."

The best photographers in the field display an amazing *MacGyver*[9] instinct whereby they enlist one tool to do the work of another and make complicated devices out of ordinary objects. That gift sometimes can prove

[9]Angus MacGyver was an American TV character known for his inventive use of common household items to improvise complex devices to extricate himself from life-or-death situations.

counterproductive, because too many of us try to reinvent the wheel when we could better spend time incorporating someone else's invention to do the job. But getting equipment to do double duty is important.

You don't need the latest gadget. But this chapter is intended to highlight a few things that may help and a few things that show how others have already "paved the way."

Equipment
Stands

A mini stand is provided with each flash. The mini stand will hold a Remote/Slave flash upright on any flat surface. The mini-stand has a standard 1/4"-20 screw thread on the bottom to mount on various light stand adapters and tripod heads. A "swivel adapter" or small ball head on the top of a light stand allows the flash to be aimed in different directions and angles.

A variety of light-to-medium duty light stands sufficient to hold a TTL Remote/Slave flash and a diffusion device are available at reasonable prices. Most come in 6-, 8-, and 12-foot heights.

> If, for durability, a metal flash shoe is preferred, use a flash shoe that has a plastic insert or a cut-out space. Avoid metal flash shoes that make contact with the pins on the bottom of the TTL flash. This may cause the pins to short and the flash may not fire properly.

TTL Cords

A TTL Cord allows tethered use of TTL flash removed from the camera hot shoe. The TTL Cord maintains the flash-to-camera TTL flash connections and all TTL flash features. The TTL cord allows the flash to be handheld or attached to a light stand or secured on a flash bracket. The extra distance of the flash from the camera permits more options and a more directed light. TTL cords are available from the original camera manufacturers and from several independent brand names.[10]

> Aiming the flash accurately, while hand-holding it with one hand and the camera with the other, takes a little practice. Point the center of the flash at the subject. Holding the flash with the flash head horizontal or vertical will match the shape of the Speedlight to the subject. The zoom head can also be adjusted manually to alter the light. Review your images on the LCD monitor to ensure satisfactory direction and coverage. Review the histogram for satisfactory flash exposure.

[10]Paramount Cords (www.paramountcords.com) custom-manufactures Nikon TTL cords in any length, and can provide Nikon TTL cord for consumer modification. Michael Bass (www.michaelbassdesigns.com).

PHOTO 2.16 Dance (see lighting diagram on page 195).

PHOTO 2.16 *Dance*

Historically dancing has been linked to culture and sophistication. Recently its television popularity has made it even more accessible. Using amateur competition ballroom dancers and a rented studio, my assistants and I moved false walls into position to create a three-sided room-within-a-room. This allowed us to hide the Speedlights so they would not show in the mirrors. Positioning the lights and camera was very critical because everything was reflected.

With the music blaring to set the mood and give the dancers the appropriate impetus, the choreographer suggested several genres. We tried them all. Eventually the Latin dancers "filled the space" with stylized rumba. We only had a modest lighting kit. Therefore I had to "fill the space" with only three flashes, which was a tall order. That is why I chose to use the SC-29 TTL cord. I wanted directional lighting and needed to spread what little lighting I had around and emphatically off camera.

It is always hard to do justice to dance using still photography. I shot from below mid-level to make the models seem more majestic. Even though the camera can record the delicate "line" and beauty, it has trouble serving the music. In the final picture I substituted the reflection for movement.

Canon: Canon OC-E3 off Camera Shoe Cord 3 maintains all on-camera flash functions up to two feet from the camera.

Nikon: Various TTL cords are available from Nikon. SC-17 is a simple TTL cord. SC-29 has an auxiliary Wide Area AF Assist Illuminator and is for use with a professional flash bracket.

War Stories

On assignment making pictures of the president of an international corporation, the art director wanted something candid, relaxed, journalistic. "The look" called for bright, lively, natural looking light that complimented the subject: long lens for that intimate, voyeuristic, flattened perspective and blurred backgrounds. Time was strictly limited. I was able to set up two EX Speedlites almost opposite each other and on a 45 degree axis to a bank of windows. Each Speedlight was fitted with a softbox.

By placing the subject in the center of the three lights, Main, Fill, and Accent lighting was available for every camera angle around the subject. Right on the camera I could control the brightness and, therefore, the intended purpose of each light—Shutter Priority for the window light and Manual exposure mode when I wanted the window light to go away. Flash Compensation controlled flash highlights, Ratio controlled contrast, making one part of the picture brighter or darker with the push of a button. On-camera flash used as a transmitter. Instant visual feedback. Fingers dancing over the camera, like playing an instrument, pushing the keys that will produce the image you want in that moment. This is fun.

Steve

Flash Brackets

Horizontal pictures, with the flash mounted on the hot shoe, show almost no shadows. The center of the flash is above the center of the lens. When the camera is vertical with the flash on the shoe, the light comes from the side and produces asymmetric shadows. Holding the camera with the flash on the left, or on the right, can change the direction of the shadow but not eliminate it.

Red eye is flash reflecting off blood vessels in the back of the eye. Flash close to the lens axis causes red eye. Telephoto lens pictures are more prone to show red eye due to the narrow angle of reflection as a result of the increased flash-to-subject distance.

A professional flash bracket can alleviate these problems. Flash brackets that position the flash above the lens for both horizontal and vertical compositions maintain shadowless lighting. A professional flash bracket increases the distance between the flash and the lens. This creates light that is directional and reduces red eye.

Flash brackets come in two designs: flash-rotating or camera-rotating. The flash-rotating bracket matches the orientation of the rectangular flash with the rectangular format of the camera. The camera-rotating bracket keeps the flash horizontal regardless of camera orientation. A camera-rotating bracket may result in flash pictures that are dark on the top and bottom unless the wide panel is used on the flash.

A proprietary TTL Cord is required to maintain communication between the camera and the flash when using a flash bracket.

What Causes Red Eye?

Flash used close to the lens reflects from the back of the eye, into the lens.

FIGURE 2.5 Red eye.

Flash separated from the lens, such as on a flash bracket, changes the angle of reflection. Red eye is reduced or eliminated.

FIGURE 2.6 Red eye reduction with flash bracket.

Using a long lens increases the flash-to-subject distance, changing the angle of reflection. Red eye increases, even with a flash bracket.

FIGURE 2.7 Red eye with long lens.

With the flash on the hot shoe, vertical composition creates side light with strong side shadows. Holding the camera with flash on right or left changes the direction of light provided by the TTL flash.

FIGURE 2.8 Flash direction with vertical camera shots.

Flash-rotating brackets maintain the orientation of the TTL flash and the camera for even flash coverage. Keeping the flash centered over the lens eliminates side shadows. Increased lens-to-flash distance reduces red eye.

FIGURE 2.9 Flash-rotating brackets.

141

Camera-rotating brackets turn the camera vertical while the flash remains oriented for horizontal coverage. The tops and bottoms of the flash pictures may be dark. Use the Built-In Wide Panel/Built-In Wide Flash Adapter *to widen the angle of illumination from the TTL Flash.*

FIGURE 2.10 Camera-rotating brackets.

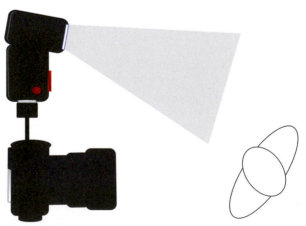

Tip the flash head down to evenly illuminate subjects that are close to the camera, especially when using a flash bracket.

FIGURE 2.11 Tipping the flash head down when using brackets.

PHOTO 2.17 Mountain bike — rear curtain sync (see lighting diagram on page 196).

PHOTO 2.17 *Mountain bike*

All I remember is that the day was cold. We needed an extreme sports action shot and the client liked my idea because we did not have to rely on luck. "Let's set it up? I do it all the time." A garden hose and a ladder substituted for a rainstorm.

After finding the right location, we selected the appropriate clothing. I wanted color. To make this shot work my concept was always that the falling water was to be the "star." For the water to show up it had to be backlit. The first practice shots had the water streaks going in the wrong direction. Then I changed to Rear Curtain Sync. That way the droplets were correctly followed by the blur. The model was moving and straining by running in place and was very uncomfortable because of the weather.

The Speedlights were all protected with clear gallon-sized refrigerator bags, even though my assistants got soaked. I used a long lens to throw the background out of focus. We set up in late afternoon, then waited for the sun to do down.

Batteries: Powering the Flash

Suffice it to say modern Speedlights have been engineered to emit every "ounce" of power. These small flashes are incredible improvements over their predecessors and exceed all expectations. They are ideal for big and little jobs. However, batteries remain the weak link. Compact strobes "eat batteries for breakfast." For your lights to work and work well you have to keep up with their voracious appetite for energy. Even partially exhausted batteries drastically slow recycling times and may not recharge fast enough to provide a full charge.

Batteries are energy storage devices and the heart of the flash. Proper battery maintenance is essential to satisfactory flash operation. Attention to batteries is important.

1. Unsuitable or exhausted batteries can overheat and damage a TTL electronic flash. Old or damaged batteries can leak corrosive chemicals, ruining the flash.
2. Use only fresh batteries of the same brand and purchased at the same time. Do not mix.
3. If the recycle time exceeds 10–12 seconds immediately change to fresh ones.

Flash recycling times are dependent upon the flash power required for each picture, type of batteries used, and their condition.

4. Do not leave batteries in the flash for extended storage. If the flash will not be used for several weeks, remove them. Even with the flash turned off, the batteries are making a connection with metal contacts causing battery drain. Over time they can become exhausted and leak if left in a device.
5. Do not use carbon-zinc batteries in the electronic flash, even if they are labeled "heavy duty." Carbon-zinc batteries do not satisfy the power requirements of the TTL flash, and will damage it.
6. Carry spare sets of fresh batteries.

Do not carry "AA" batteries loose. Loose batteries can short out and discharge against one another and are prone to leakage.

Make bundles of four (or five) AA batteries with rubber bands and place each bundle in separate plastic bags. Purchase and use commercially available battery cases or battery boxes.

Avoid touching battery contacts with your fingers as body acids and oils can damage the contacts.

Regularly inspect your batteries for contact condition, case damage, and leakage.

Battery contacts can be cleaned and polished with a pencil eraser. Corrosion can be removed with a swab moistened with rubbing alcohol.

Battery Types: Power Decisions

Alkaline batteries are readily available, reasonable in price, provide good performance in TTL flash units and can only be used once. Alkaline batteries may lose power quickly in temperatures below freezing.

Lithium batteries are readily available, more expensive, provide more flashes than alkalines, and can only be used once. Lithium batteries are excellent back-up batteries. They have extended shelf-life and can hold full power for up to three years of storage. Lithium batteries may provide better cold weather performance.

New rules limit how many spare lithium (rechargeable) batteries you can take on an airplane. No lithium battery spares are allowed in your checked baggage. Up to two spares are allowed in carry-on bags. Batteries that are installed in their devices are not spares and are not affected by the new rule.

Nickel-Cadmium (NiCd) batteries are rechargeable, readily available, and reasonable in price. NiCds require a compatible charging device, hold charge over extended storage, and can be used for up to 200+ charging cycles. Some NiCd batteries are prone to "memory" problems, where continued partial discharge/full charging cycles can lead to a dramatic reduction in capacity. Fully discharge NiCds before charging to avoid decreased performance. NiCds will provide faster recycling but fewer flashes than alkaline batteries.

Nickel Metal Hydride (NiMH) batteries are rechargeable, readily available, and reasonable in price. NiMH batteries require a compatible charging device, and may provide up to 1,000 charging cycles. Quick-chargers may decrease battery life due to heat damage. These batteries gradually lose power with storage. "Top off" the charge immediately before use. They occasionally should be fully discharged before charging to maintain battery performance. This is called *refreshing* the battery. They can provide faster recycling and more flashes than alkaline, lithium, or NiCd. The higher the current rating, in milliamp hours (mAh), the greater the number of flashes. Look for NiMH batteries of 2,000 mAh or higher. They also provide good cold weather performance.

External battery packs can provide extremely fast recycling and high numbers of flashes for extended shooting sessions. These may use multiple expendable batteries or feature high-voltage rechargeable battery cells. External battery packs are available from a wide variety of manufacturers. They are a staple for professional shooters.

145

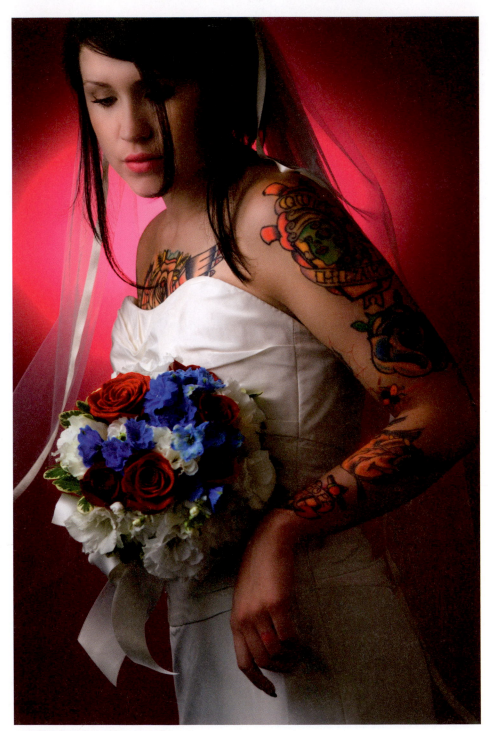

PHOTO 2.18 Wedding (see lighting diagram on page 197).

PHOTO 2.18 *Wedding*

Major changes in wedding etiquette mean there is less time between "Yes!" and "I do." Couples also expect less time between capture and delivery of the wedding album. More pressure is being put on the typical wedding photographer to be a "Jack-of-all-trades."

Speedlights no longer need to be relegated to just the ceremony and reception. Now we can expect them to document the studio images too. They are perfect for the formals as well as the "getting ready" candids that are so popular now. The compact nature of Speedlights permits them to do double duty filling a large church with illumination or for those wedding "photojournalists" who want to fly under the radar of "Bridezilla."

I used a large flattering softbox for the bride and another remote strobe for the background. We brought in a magenta seamless background paper, set up, and then just waited for the make-up artist to work her magic. Photographers learn very quickly their position in the pecking order for these types of situations.

Canon : The Compact Battery Pack CP-E3 takes eight AA alkaline, lithium, or NiMH batteries. The 580EX and 580EXMkII can be set, through the flash Custom Function menu, to be powered by a combination of internal and external batteries or by the external power supply only.

Accessories

Typing Paper

On location you may have to use almost anything to get the shot, especially when traveling fast and light. The most mundane household items may be pressed into service. Ordinary 8 1/2" × 11" white typing paper makes a great reflector, diffuser, or gobo. But if you tape two sheets together along three edges you create a versatile mini diffuser. Slide the Speedlight between the two sheets on the open side and you have a handy backlight. If you put it

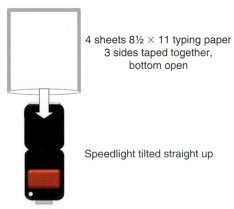

4 sheets 8½ × 11 typing paper
3 sides taped together,
bottom open

Speedlight tilted straight up

FIGURE 2.12 Speedlight diffusion sleeve.

PHOTO 2.19 *Spiral staircase*

We knew it was very ambitious to try and take advantage of this architectural detail. It was chosen for its visual impact rather than historical significance. In addition, running up and down the staircase was exhausting. To get dramatic spread from the Speedlights without them showing in the frame was a lot more complicated than I first thought.

Each level was a physical obstacle to line of sight. So the light banks containing the Speedlights were just outside the frame hidden by the floor above. It was like assembling a puzzle. Distance was also a problem. From top level to the first floor was pushing the limits of wireless range. Since the softboxes were placed various distances from the models we controlled their different powers all from the Master.

between the subject and the background and point it straight up, it lights both with soft light and falls off around the edges quickly. (See Figure 2.12.)

Ask the closest secretary if they have a couple of sheets and some tape. You can also make more durable versions with plastic or other diffusion materials. Works wonders.

A Clamps

To survive in photography you have to be resourceful. No need to run out and buy the latest and most expensive equipment. Often custom or makeshift methods are just as good or better. The mechanisms for attaching Speedlights to stands or softboxes or umbrellas are rarely very universal. Many companies make merchandise but most are single use items. Often they utilize the hot shoe attachment on the bottom of the Speedlight, which is a very weak connection. It is susceptible to cracking or breaking when any weight or leverage is applied to the structure.

With a lot of ridicule I started using large A clamps a long time ago to good effect. A Speedlight fits between the jaws perfectly and the two handles serve as outriggers that can be clamped, taped, or tied to almost anything. I use another clamp to attach the assemblage to softboxes. It is secure and solid. It may look kludgy but it works.

In lieu of the little stands that come with each Speedlight, you can always use an A clamp to stand it up on a table or shelf. The small stands hold the lights well, but as soon you add any type of accessory (i.e., softbox, snoot, etc.) they tip over. The A clamp has enough ballast to support most attachments.

Glad Bags

There are all kinds of diffusers. Many projects demand custom-made applications. Years ago I discovered one of the most versatile, ubiquitous, and inexpensive materials — white **Glad**® trash bags. In a pinch I have used a

PHOTO 2.19 Spiral staircase (see lighting diagram on page 198).

couple of the "off brands" and they worked fine, but I stick with the same brand because I know their physical properties. I always carry a box of trash bags with any lighting kit. I have jerryrigged quick light boxes, taped the bags to walls and under computers, even stretched them across picture frames to substitute for the real thing. You can cut them along a seam and double the size in single ply or keep them uncut as two-ply. They are color balanced (even cut out excess UV from flash) and can be cut to any shape. I have even used Glad bags as the actual background for backlit subjects. Use them and throw them away.

Filters/Gels

A cheap trick that professionals have been using for years is to get the free sample books of gels from Lee® or Roscoe® filters. You can send away for the booklets or pick them up as "swag" at tradeshows or conventions. The gel sizes are small but they are perfectly shaped to attach to the front of a Speedlight. The variety of colors can enrich your photography immensely. The companies have caught on to this "misuse" of the "giveaway" packages, so cherish them when you find them.

Grid Spot

One of the cleverest DIY accessories is a grid spot for Speedlights. I found the original prototype online. The grid spot is made from a corrugated lightweight plastic called Coroplast®. Buy it in black. For the SB-800 Speedlight cut the pieces according to the table below and assemble with gaffers tape. For other Speedlights, make minor adjustments to the widths depending on the size of the Speedlight head. (See Figures 2.13 and 2.14.) You can also try various lengths to vary the effect.

Coroplast Grid Spot for SB-800

	W (inches)	L (inches)	Quantity
Top	2.5	5.5	1
Bottom	2.5	4.5	1
Sides	1.5	4.5	2
Center	2.5	3	8

FIGURE 2.13 Coroplast grid spot pieces.

Coroplast Grid Spot

FIGURE 2.14 Coroplast grid spot, assembled.

War Stories

Babies

One of my favorite assignments was the "job from hell." Several modeling agencies sent over dozens of 3- to 6-month-old babies with their accompanying "stage mothers." It was a Pandora's Box.

Many photographers claim the need to light these "handfuls" with soft, high key because they're so cute and cuddly but, in fact, it's to make it easier because they are so squiggly and unpredictable that we have to flood the studio so broadly so as to anticipate any movements they make. At that age they don't take orders from anybody. We had to have three infant models available for every setup while shooting baby accessories. If one acted up, my studio manager just yelled "next!" to parents in the waiting room.

We built appropriate room sets in the studio — living room, kitchen, bathroom — and cinched each infant into a bassinet, carriage, or car seat. An assistant would chase every spastic movement with a big banklight mounted on a Speedlight just outside the frame. On the other side we surrounded the tyke with reflectors. There were several other lights illuminating the rest of the set. This gave us directional lighting with a high ratio of good exposure.

I hate photographing babies. But they make great stories.

LAJ

Summary

1. There are separate controls for existing light and flash. Change the amount of existing light in the picture by changing a camera setting: shutter speed, aperture, and/or ISO if in manual camera exposure mode; change exposure compensation and/or ISO if in an automatic camera exposure mode. With all camera exposure modes, change the amount of flash in the picture by changing the flash exposure compensation.
2. TTL flash is based on reflective flash metering. Use flash exposure compensation " + " for light-toned scenes and " − " for dark-toned scenes as needed.
3. In any camera exposure mode, when correctly exposing for existing light, the camera computer will automatically reduce TTL flash to a fill light.
4. To make TTL flash the predominant main light on the subject, underexpose the existing light on the subject.
5. The flash metering settings will affect the flash exposures. Explore TTL and TTL BL settings on the Nikon flash, and the Evaluative and Averaging flash meter settings in the Canon camera custom function menu.
6. Stay within the minimum and maximum effective distance ranges displayed on the LCD panel of the TTL flash. To change the effective distance range, change the aperture and/or the ISO.
7. Tilt the flash head down when making flash pictures of subjects closer than six feet to the camera.
8. When TTL flash illuminates only a small portion of the picture, the TTL flash will have a tendency to overexpose. Adjust the flash exposure compensation as needed.
9. When making flash pictures that include both near and far subjects, try manually zooming the flash head to the longest telephoto setting, narrowing the angle of illumination. This takes flash off near subjects at the edges of the frame, and sends more flash to the center of the picture. The bounce and swivel head features allow further fine-tuning of the placement of flash illumination in the picture.
10. If the flash takes longer than 10–12 seconds to recycle, immediately change to fresh batteries.

Lighting Diagrams

Albert's dunk

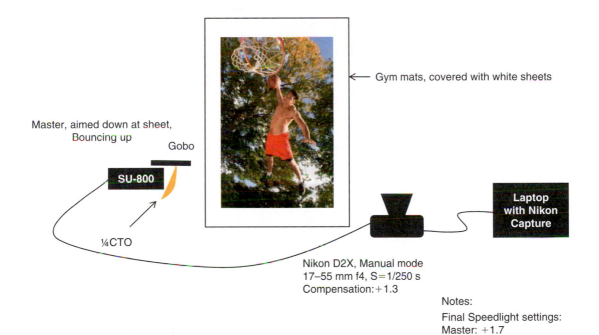

Gym mats, covered with white sheets

Master, aimed down at sheet, Bouncing up

Gobo

SU-800

¼CTO

Laptop with Nikon Capture

Nikon D2X, Manual mode
17–55 mm f4, S=1/250 s
Compensation:+1.3

Notes:
Final Speedlight settings:
Master: +1.7

PHOTO 1.1 Albert's dunk lighting diagram (see photo on page 4).

Flower girl

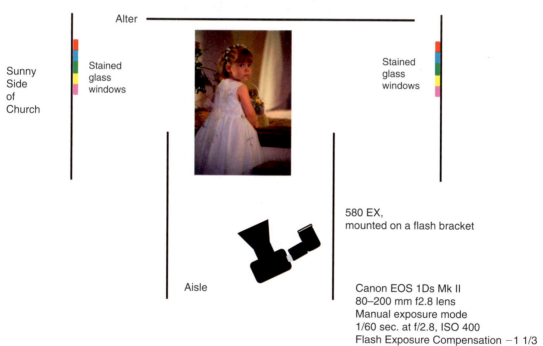

Alter

Sunny
Side
of
Church

Stained
glass
windows

Stained
glass
windows

580 EX,
mounted on a flash bracket

Aisle

Canon EOS 1Ds Mk II
80–200 mm f2.8 lens
Manual exposure mode
1/60 sec. at f/2.8, ISO 400
Flash Exposure Compensation −1 1/3

PHOTO 1.2 Flower girl lighting diagram (see photo on page 6).

Operating room

Soft box

SB-800

VAL-Voice activated
Lightstand

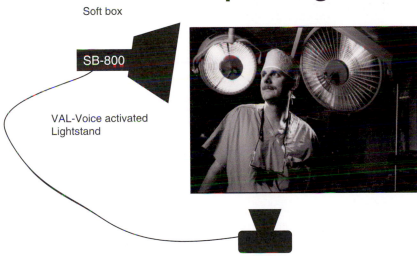

Nikon D2X, Programmed Mode

Notes:
Final Speedlight settings:
Master:

PHOTO 1.3 Operating room lighting diagram (see photo on page 8).

Sunset bride

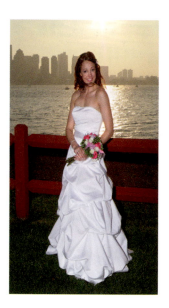

Lens shade

580 EX

Canon EOS 1Ds Mk II
50 mm f1.8 lens
Manual exposure mode
1/250 sec. at f/20, ISO 400
Flash Exposure Compensation +2

PHOTO 1.4 Sunset bride lighting diagram (see photo on page 13).

Tanzi with veil

12″×16″ softbox

580 EX

Steve

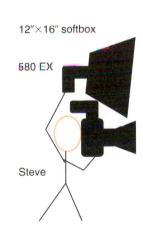

Wall

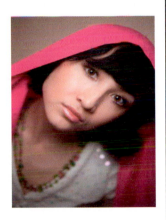

Canon EOS 1Ds Mk II
50 mm f1.8 lens
Manual Exposure Mode
1/100 sec. at f/2
Flash Exposure Compensation + 2/3

Notes:
Master 580 EX Speedlite, set to transmit only,
camera mounted and bounced off of back wall.

PHOTO 1.5 Tanzi with veil lighting diagram (see photo on page 15).

Brendan's trick

(Group A)

Voice activated
Light stand named Ryan

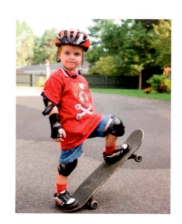

Final Speedlight settings:
Group A: −2

Nikon D3, 28–70 mm f2.8 @ 45 mm
Aperture priority, f3.5, S=1/250 s, ISO 400
Exposure comp. = −1

PHOTO 1.6 Brendan's trick lighting diagram (see photo on page 19).

Wedding shower

window

Canon 580 EX on camera
Swiveled/tilted up left to bounce off
Wall and ceiling

Canon EOS 1Ds Mk II
24 mm f2.8 lens
Aperture Priority exposure mode
1/6 sec. at f/5, ISO 400
Flash Exposure Compensation + 2/3
Rear Curtain Syncronization

PHOTO 1.7 Wedding shower lighting diagram (see photo on page 21).

Ryan with Auto FP High-Speed Sync

Master, with diffusion dome

SB-800

Voice activated
Light stand named Dylan

SC-17 TTL cord

Nikon D2Xs, Auto FP mode
105 mm f2.8, S=1/500 s

Notes:
Final Speedlight settings:
Master: −1

PHOTO 1.8 Ryan with high speed sync lighting diagram (see photo on page 27).

Julie with blue

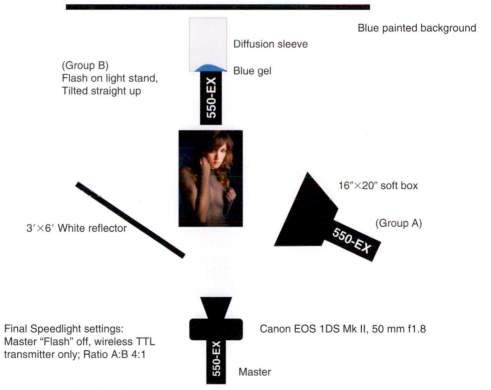

Blue painted background

Diffusion sleeve

(Group B)
Flash on light stand,
Tilted straight up

Blue gel

550-EX

16″×20″ soft box

(Group A)

550-EX

3′×6′ White reflector

Final Speedlight settings:
Master "Flash" off, wireless TTL
transmitter only; Ratio A:B 4:1

Canon EOS 1DS Mk II, 50 mm f1.8

550-EX

Master

PHOTO 1.9 Julie in blue lighting diagram (see photo on page 29).

Tuxedo

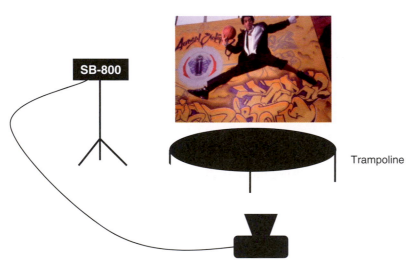

SB-800

Trampoline

Nikon D2X, Programmed Mode

Notes:
Final Speedlight settings:
Master:

PHOTO 1.10 Tuxedo lighting diagram (see photo on page 34).

Computers

(Group A)

1×2 soft box
aimed between
computer screens

gobo

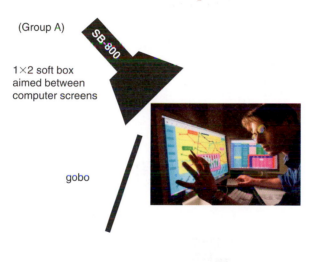

Laptop
with Nikon
Control Pro 2

Nikon D3, 14–24 mm f2.8
S=1/6, f6.3, Exposure comp.= 0

Final Speedlight settings:
Group A: 0

PHOTO 1.11 Computers lighting diagram (see photo on page 37).

Ballet

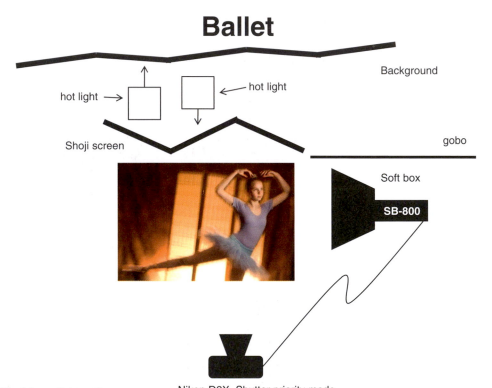

Background

hot light →

← hot light

Shoji screen

gobo

Soft box

SB-800

Nikon D2X, Shutter priority mode, ISO 100, S=1 s

Final Speedlight settings:
Mode: TTL
Flash compensation: 0.0

PHOTO 1.12 Ballet lighting diagram (see photo on page 39).

Lobster traps

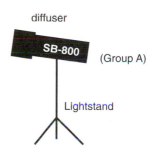

diffuser

SB-800

(Group A)

Lightstand

Final Speedlight settings:
 Master: −2.7
 Group A: +1.0

SB-800

Nikon D2X in programmed Mode,
35–70 mm f2.8 lens
Exposure compensation +0.3

PHOTO 1.13 Lobsterman lighting diagram (see photo on page 49).

Bouquet

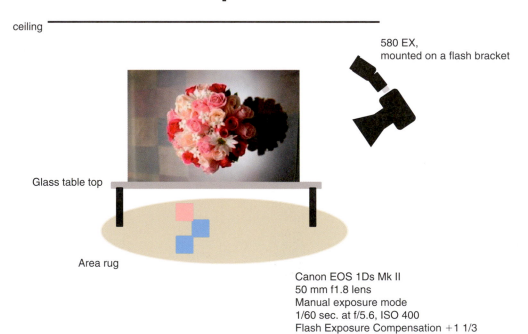

ceiling

580 EX,
mounted on a flash bracket

Glass table top

Area rug

Canon EOS 1Ds Mk II
50 mm f1.8 lens
Manual exposure mode
1/60 sec. at f/5.6, ISO 400
Flash Exposure Compensation +1 1/3

PHOTO 1.14 Bouquet lighting diagram (see photo on page 51).

Anya in white

White wall

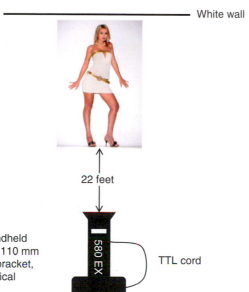

22 feet

Canon EOS 1DS Mk II, handheld
80–200 mm f2.8 "L" lens at 110 mm
580 EX mounted on Flash bracket,
Flash head orientation: vertical

580 EX

TTL cord

Notes:
Manual Exposure mode at 1/125 s at f/4.5, 100 ISO
Flash exposure compensation at +1 2/3

PHOTO 1.15 Anya in white lighting diagram (see photo on page 55).

Emily

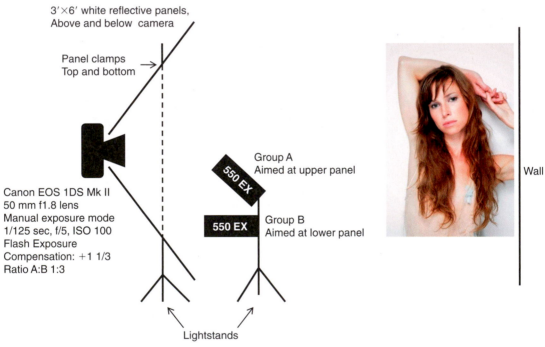

3′×6′ white reflective panels,
Above and below camera

Panel clamps
Top and bottom

Group A
Aimed at upper panel

550 EX

550 EX

Group B
Aimed at lower panel

Wall

Canon EOS 1DS Mk II
50 mm f1.8 lens
Manual exposure mode
1/125 sec, f/5, ISO 100
Flash Exposure
Compensation: +1 1/3
Ratio A:B 1:3

Lightstands

PHOTO 1.16 Emily lighting diagram (see photo on page 58).

Jazz bassist

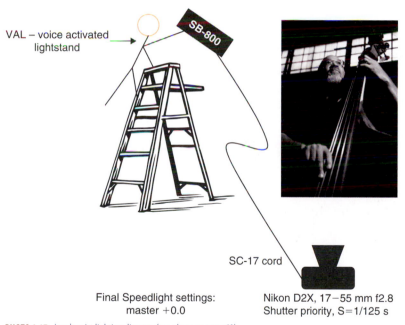

VAL – voice activated lightstand

SB-800

SC-17 cord

Final Speedlight settings:
master +0.0

Nikon D2X, 17–55 mm f2.8
Shutter priority, S=1/125 s

PHOTO 1.17 Jazz bassist lighting diagram (see photo on page 60).

Lucia at sunset

16″×20″ softbox

550 EX

Light stand

Canon EOS 20D
80–200 mm f2.8 lens @ 100 mm
STE-2 Transmitter

STE-2

Notes:
Shutter priority mode at 1/250 s at f/2.8
Exposure compensation at +0.67
Flash exposure compensation at 0

PHOTO 1.18 Lucia at sunset lighting diagram (see photo on page 64).

Lucia Glowing

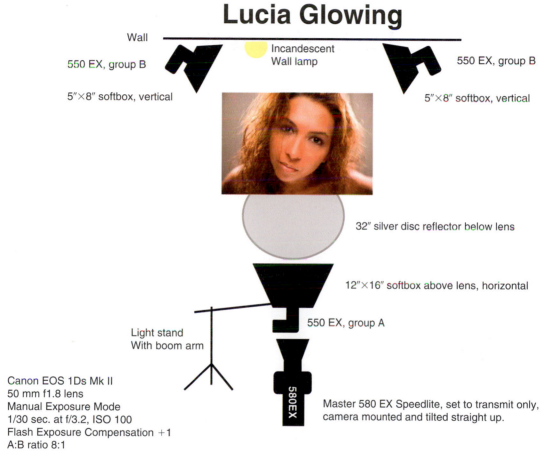

Wall

550 EX, group B

5"×8" softbox, vertical

Incandescent
Wall lamp

550 EX, group B

5"×8" softbox, vertical

32" silver disc reflector below lens

12"×16" softbox above lens, horizontal

550 EX, group A

Light stand
With boom arm

580EX

Canon EOS 1Ds Mk II
50 mm f1.8 lens
Manual Exposure Mode
1/30 sec. at f/3.2, ISO 100
Flash Exposure Compensation +1
A:B ratio 8:1

Master 580 EX Speedlite, set to transmit only,
camera mounted and tilted straight up.

PHOTO 1.19 Lucia glowing lighting diagram (see photo on page 66).

Dylan

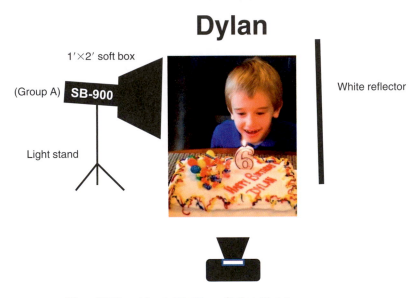

1′×2′ soft box

(Group A) **SB-900**

White reflector

Light stand

Nikon D300 on tripod, 17–55 mm f2.8 at 44 mm
S = 1/20, f2.8, Exposure comp. = 0, White balance = incandescent
Pop-up flash used in commander mode, Slow Sync
SB-900 Speedlight with incandescent filter TN-A2 and Diffusion dome,
Illumination pattern set to Even, Flash Exposure Compensation = −0.7

PHOTO 1.20 Dylan's birthday lighting diagram (see photo on page 69).

Sparkle

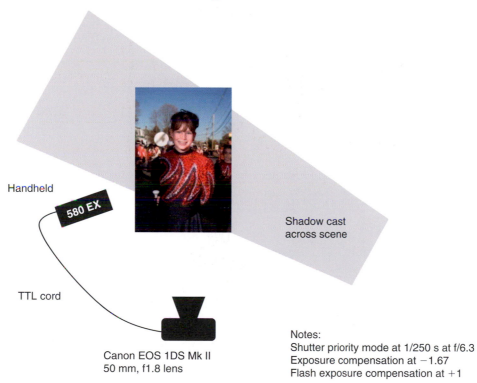

Handheld

580 EX

Shadow cast
across scene

TTL cord

Canon EOS 1DS Mk II
50 mm, f1.8 lens

Notes:
Shutter priority mode at 1/250 s at f/6.3
Exposure compensation at −1.67
Flash exposure compensation at +1

PHOTO 1.21 Sparkle lighting diagram (see photo on page 72).

Wedding cake

Light colored Wall

Canon EOS 1DS MK II
35 mm f2 lens
Canon 580 EX Speedlite

580 EX

Notes:
1/60 s at f/4.5, 400 ISO
Flash Exposure Compensation +1

PHOTO 1.22 Wedding cake lighting diagram (see photo on page 76).

Wedding dress

Wall

Canon EOS 1DS MK II
24 mm f2.8 lens
Canon 580 EX Speedlite

Notes:
1/60 s at f/4.5, 100 ISO

PHOTO 1.23 Wedding gown lighting diagram (see photo on page 80).

Jazz pianist

Background

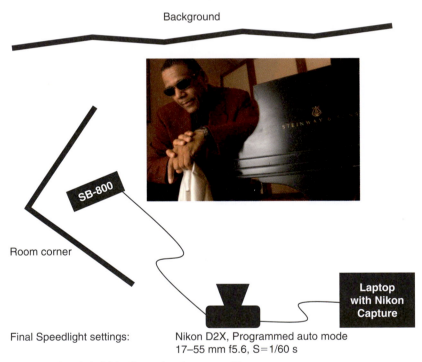

SB-800

Room corner

Laptop
with Nikon
Capture

Final Speedlight settings: Nikon D2X, Programmed auto mode
 17–55 mm f5.6, S=1/60 s

PHOTO 1.24 Jazz pianist lighting diagram (see photo on page 83).

Arianna and Grandpa

Canon EOS 1DS MK II
Canon 580 EX Speedlite

Room
corner

580 EX

Notes:
1/60 s at f/4.5, 100 ISO

PHOTO 1.25 Arianna and Grandpa lighting diagram (see photo on page 84).

Construction shot

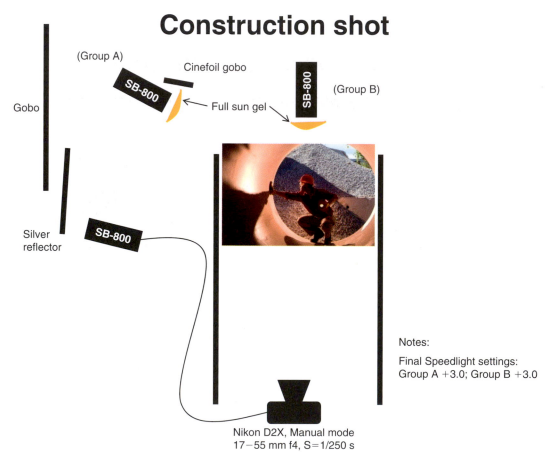

(Group A)

Cinefoil gobo

SB-800

(Group B)

Gobo

Full sun gel

Silver
reflector

SB-800

Notes:

Final Speedlight settings:
Group A +3.0; Group B +3.0

Nikon D2X, Manual mode
17–55 mm f4, S=1/250 s

PHOTO 2.1 Construction worker lighting diagram (see photo on page 90).

Evelyn's headdress

Background

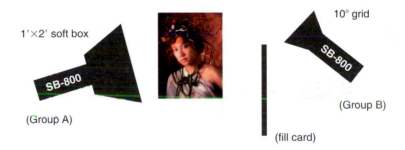

1′×2′ soft box

10° grid

SB-800

(Group A)

SB-800

(Group B)

(fill card)

Final Speedlight settings:
Master −3; Group A +1.7; Group B −1

Nikon D2X, 105 mm f2.8
Programmed Mode

Master SB-800

PHOTO 2.2 Evelyn's headdress lighting diagram (see photo on page 93).

Watch

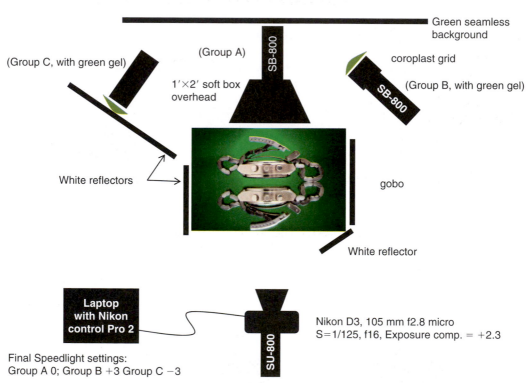

Green seamless background

(Group C, with green gel)

(Group A)

SB-800

coroplast grid

(Group B, with green gel)

SB-800

1′×2′ soft box overhead

White reflectors

gobo

White reflector

Laptop with Nikon control Pro 2

SU-800

Nikon D3, 105 mm f2.8 micro
S=1/125, f16, Exposure comp. = +2.3

Final Speedlight settings:
Group A 0; Group B +3 Group C −3

PHOTO 2.3 Watch with macro techniques lighting diagram (see photo on page 94).

Motorcycle

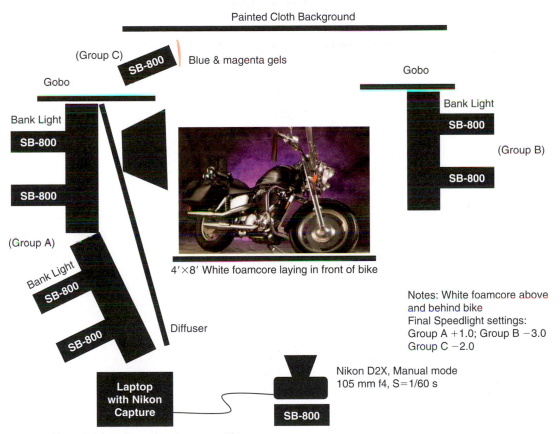

Painted Cloth Background

(Group C) **SB-800** | Blue & magenta gels

Gobo

Bank Light

SB-800

SB-800

(Group A)

Bank Light

SB-800

SB-800

Diffuser

Gobo

Bank Light

SB-800

(Group B)

SB-800

4'×8' White foamcore laying in front of bike

Notes: White foamcore above and behind bike
Final Speedlight settings:
Group A +1.0; Group B −3.0
Group C −2.0

Laptop with Nikon Capture

Nikon D2X, Manual mode
105 mm f4, S=1/60 s

SB-800

PHOTO 2.4 Motorcycle lighting diagram (see photo on page 98).

Eye chart

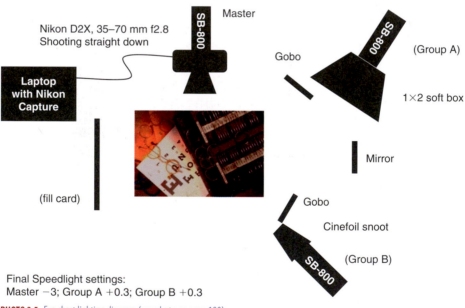

Nikon D2X, 35–70 mm f2.8
Shooting straight down

Master SB-800

Laptop with Nikon Capture

(fill card)

Gobo

SB-800 (Group A)

1×2 soft box

Mirror

Gobo
Cinefoil snoot

SB-800 (Group B)

Final Speedlight settings:
Master −3; Group A +0.3; Group B +0.3

PHOTO 2.5 Eye chart lighting diagram (see photo on page 100).

Trombones

Painted Background

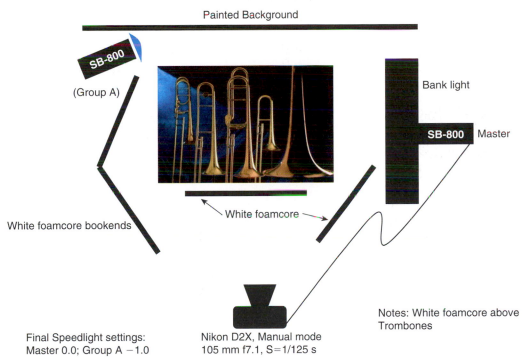

SB-800

(Group A)

Bank light

SB-800 Master

White foamcore bookends

White foamcore

Notes: White foamcore above Trombones

Final Speedlight settings:
Master 0.0; Group A −1.0

Nikon D2X, Manual mode
105 mm f7.1, S=1/125 s

PHOTO 2.6 Trombones lighting diagram (see photo on page 101).

Water pour

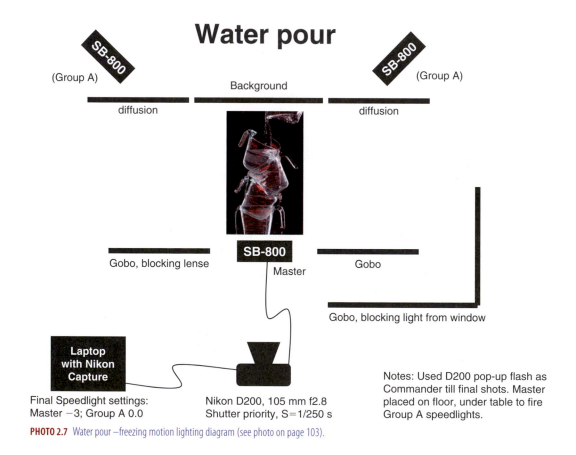

(Group A)

SB-800

Background

SB-800

(Group A)

diffusion

diffusion

Gobo, blocking lense

SB-800

Master

Gobo

Gobo, blocking light from window

Laptop with Nikon Capture

Final Speedlight settings:
Master −3; Group A 0.0

Nikon D200, 105 mm f2.8
Shutter priority, S=1/250 s

Notes: Used D200 pop-up flash as Commander till final shots. Master placed on floor, under table to fire Group A speedlights.

PHOTO 2.7 Water pour −freezing motion lighting diagram (see photo on page 103).

Toys

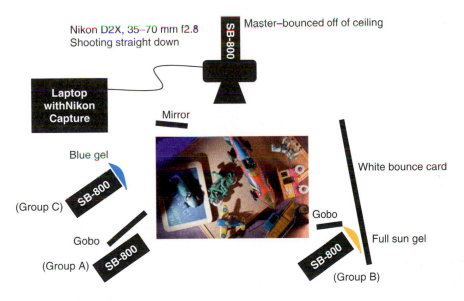

Nikon D2X, 35–70 mm f2.8
Shooting straight down

SB-800 Master–bounced off of ceiling

Laptop withNikon Capture

Mirror

Blue gel

White bounce card

SB-800 (Group C)

Gobo

Gobo

Full sun gel

Gobo (Group A) **SB-800**

SB-800 (Group B)

Final Speedlight settings:
Master −3; Group A +1.3; Group B −1.3; Group C −3

PHOTO 2.8 Toys lighting diagram (see photo on page 107).

Luthier

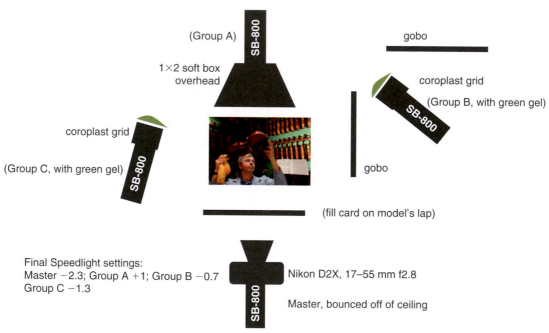

(Group A)

gobo

1×2 soft box
overhead

coroplast grid

(Group B, with green gel)

coroplast grid

(Group C, with green gel)

gobo

(fill card on model's lap)

Final Speedlight settings:
Master −2.3; Group A +1; Group B −0.7
Group C −1.3

Nikon D2X, 17–55 mm f2.8

Master, bounced off of ceiling

PHOTO 2.9 Luthier lighting diagram (see photo on page 109).

Rolled rugs

20″×30″ softbox
Center of light aimed
Farthest rug

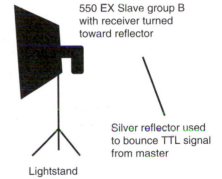

550 EX Slave group B
with receiver turned
toward reflector

Silver reflector used
to bounce TTL signal
from master

Lightstand

Canon EOS 1DS Mk II
50 mm f1.8 lens
Manual exposure mode
1/60 sec, f/8, ISO 100
Flash Exposure
Compensation: −1 1/3
Ratio A:B 1:3

5″×7″ softbox

Master Group A

PHOTO 2.10 Rolled rugs lighting diagram (see photo on page 113).

Julie in green

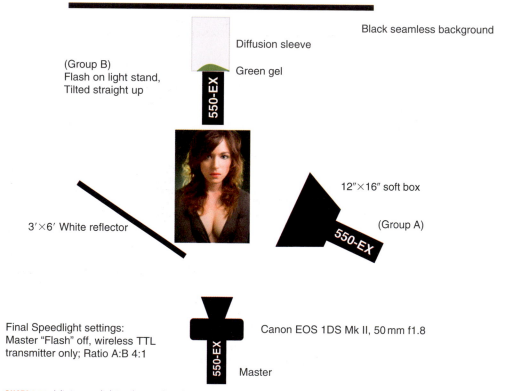

Black seamless background

Diffusion sleeve

(Group B)
Flash on light stand,
Tilted straight up

Green gel

550-EX

12"×16" soft box

(Group A)

3'×6' White reflector

550-EX

550-EX

Final Speedlight settings:
Master "Flash" off, wireless TTL
transmitter only; Ratio A:B 4:1

Canon EOS 1DS Mk II, 50 mm f1.8

Master

PHOTO 2.11 Julie in green lighting diagram (see photo on page 116).

Fish

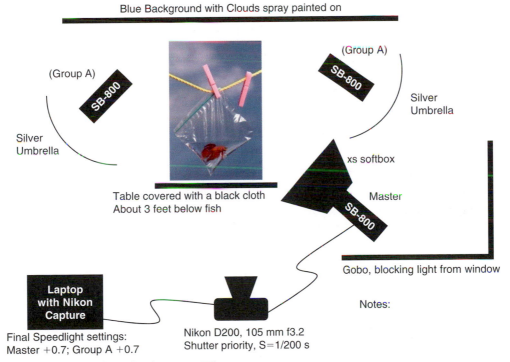

Blue Background with Clouds spray painted on

(Group A)

SB-800

(Group A)

SB-800

Silver
Umbrella

Silver
Umbrella

xs softbox

Master

SB-800

Table covered with a black cloth
About 3 feet below fish

Gobo, blocking light from window

Laptop
with Nikon
Capture

Notes:

Final Speedlight settings:
Master +0.7; Group A +0.7

Nikon D200, 105 mm f3.2
Shutter priority, S=1/200 s

PHOTO 2.12 Fish lighting diagram (see photo on page 122).

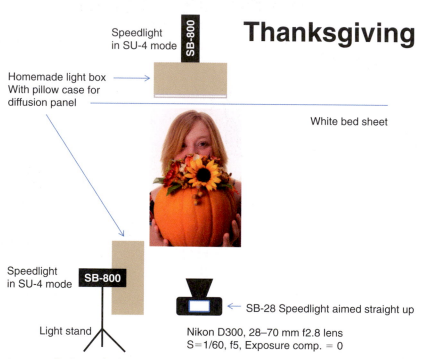

Thanksgiving

Speedlight in SU-4 mode — SB-800

Homemade light box With pillow case for diffusion panel →

White bed sheet

Speedlight in SU-4 mode — SB-800

Light stand

SB-28 Speedlight aimed straight up ←

Nikon D300, 28–70 mm f2.8 lens
S = 1/60, f5, Exposure comp. = 0

PHOTO 2.13 Thanksgiving family portraits diagram (see photo on page 124). All photographs on page 124 were taken by Leah Cornwell.

Architectural shot

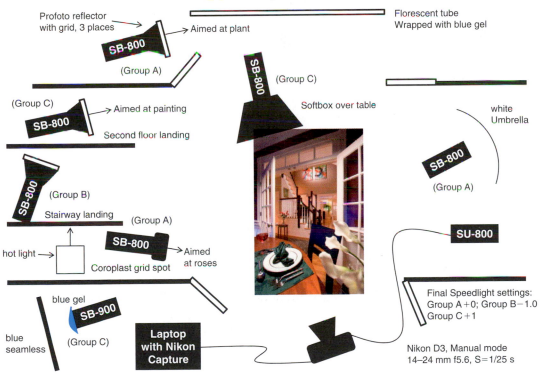

Profoto reflector
with grid, 3 places → ┤ → Aimed at plant

Florescent tube
Wrapped with blue gel

SB-800

(Group A)

SB-800 (Group C)

Softbox over table

white
Umbrella

(Group C) → Aimed at painting

SB-800

Second floor landing

SB-800

(Group A)

SB-800

(Group B)

Stairway landing

(Group A)

hot light →

SB-800 → Aimed
at roses

Coroplast grid spot

SU-800

blue gel

blue
seamless

SB-900

(Group C)

**Laptop
with Nikon
Capture**

Final Speedlight settings:
Group A +0; Group B −1.0
Group C +1

Nikon D3, Manual mode
14–24 mm f5.6, S = 1/25 s

PHOTO 2.14 Architectural shot lighting diagram (see photo on page 130).

Bottles

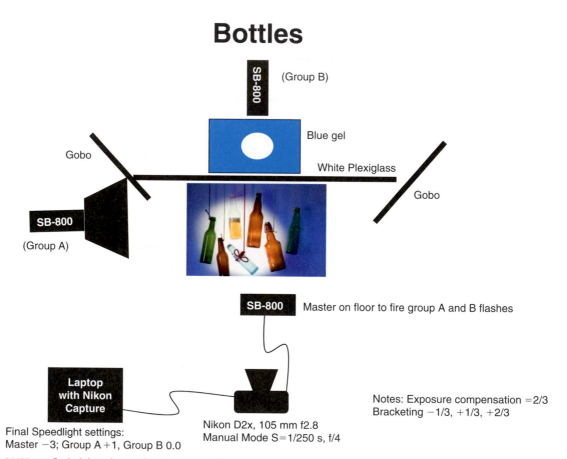

(Group B)

Blue gel

Gobo

White Plexiglass

Gobo

SB-800

(Group A)

SB-800 Master on floor to fire group A and B flashes

Laptop with Nikon Capture

Notes: Exposure compensation =2/3
Bracketing −1/3, +1/3, +2/3

Final Speedlight settings:
Master −3; Group A +1, Group B 0.0

Nikon D2x, 105 mm f2.8
Manual Mode S=1/250 s, f/4

PHOTO 2.15 Bottles lighting diagrams (see photo on page 135).

Dance

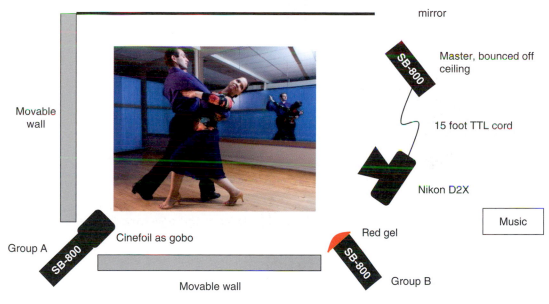

mirror

SB-800 — Master, bounced off ceiling

15 foot TTL cord

Nikon D2X

Music

Movable wall

Cinefoil as gobo

Group A

SB-800

Red gel

SB-800

Group B

Movable wall

Final Speedlight settings:
Mode: TTL Programmed Mode
Flash compensation: 0.0

PHOTO 2.16 Dance photo lighting diagram (see photo on page 138).

Mountain bike

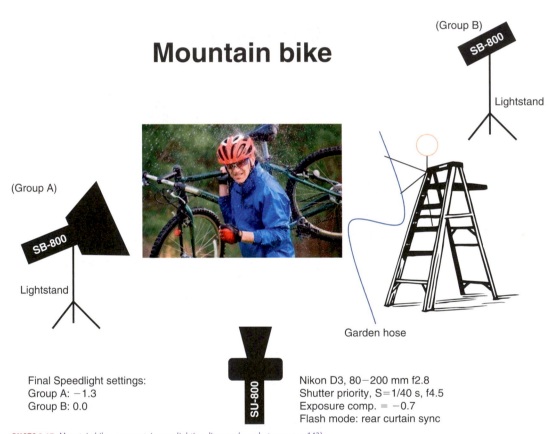

(Group B)
SB-800
Lightstand

(Group A)
SB-800
Lightstand

Garden hose

SU-800

Final Speedlight settings:
Group A: −1.3
Group B: 0.0

Nikon D3, 80−200 mm f2.8
Shutter priority, S=1/40 s, f4.5
Exposure comp. = −0.7
Flash mode: rear curtain sync

PHOTO 2.17 Mountain bike −rear curtain sync lighting diagram (see photo on page 143).

Wedding

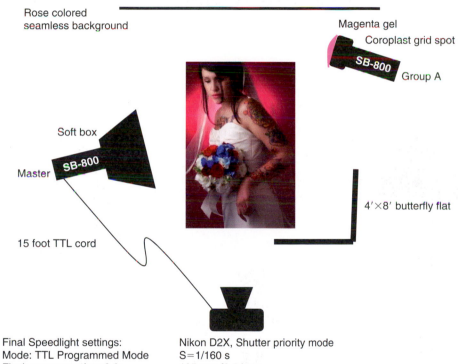

Rose colored
seamless background

Magenta gel

Coroplast grid spot

SB-800

Group A

Soft box

SB-800

Master

4′×8′ butterfly flat

15 foot TTL cord

Final Speedlight settings: Nikon D2X, Shutter priority mode
Mode: TTL Programmed Mode S = 1/160 s
Flash compensation: 0.0 105 mm f2.5 lens

PHOTO 2.18 Wedding lighting diagram (see photo on page 146).

Spiral staircase

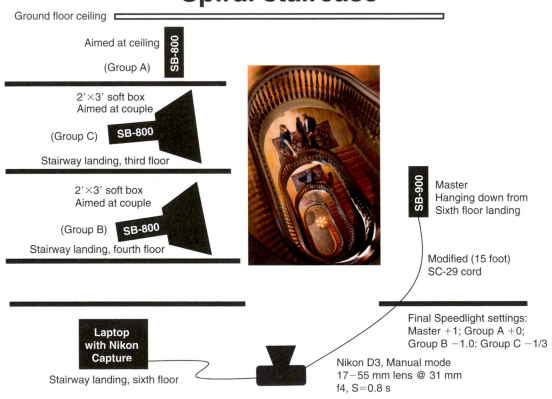

Ground floor ceiling

Aimed at ceiling — SB-800

(Group A)

2'×3' soft box
Aimed at couple

(Group C) — SB-800

Stairway landing, third floor

2'×3' soft box
Aimed at couple

(Group B) — SB-800

Stairway landing, fourth floor

SB-900 — Master
Hanging down from
Sixth floor landing

Modified (15 foot)
SC-29 cord

Final Speedlight settings:
Master +1; Group A +0;
Group B −1.0: Group C −1/3

Laptop
with Nikon
Capture

Stairway landing, sixth floor

Nikon D3, Manual mode
17−55 mm lens @ 31 mm
f4, S=0.8 s

PHOTO 2.19 Spiral staircase lighting diagram (see photo on page 149).

Rubber Ducky

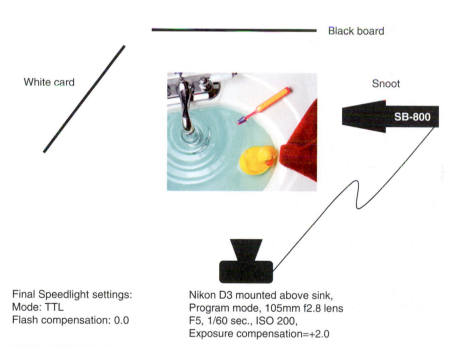

Black board

White card

Snoot

SB-800

Final Speedlight settings:
Mode: TTL
Flash compensation: 0.0

Nikon D3 mounted above sink,
Program mode, 105mm f2.8 lens
F5, 1/60 sec., ISO 200,
Exposure compensation=+2.0

CHAPTER 1 OPENING FIGURE Rubber ducky (see page 1).

Doctor

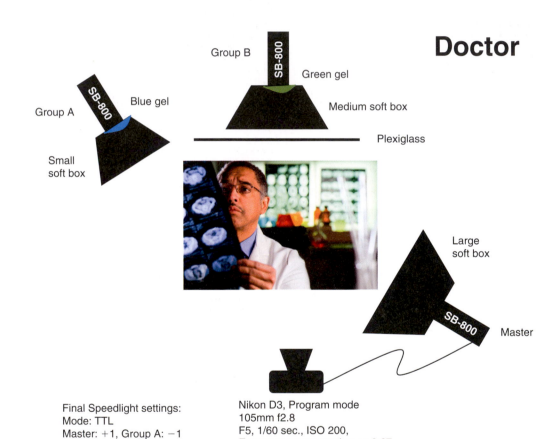

Group B

SB-800

Green gel

Medium soft box

Group A

SB-800

Blue gel

Small
soft box

Plexiglass

Large
soft box

SB-800

Master

Final Speedlight settings:
Mode: TTL
Master: +1, Group A: −1
Group B: +0.3

Nikon D3, Program mode
105mm f2.8
F5, 1/60 sec., ISO 200,
Exposure compensation= +0.67

CHAPTER 2 OPENING FIGURE Doctor (see page 87).

Index

A

AA batteries, handling, 144
Accent lighting
 advantages, 50
 example, 139
 mixing TTL flash, 68
 Wireless TTL, 113–114
Accessories
 A clamps, 148
 diffusion sleeve, 147
 filters/gels, 150
 Glad® bags, 148
 grid spot, 150
 overview, 136
 typing paper, 147
A clamps, 148
Adams, Ansel, 87
AF Assist Beam Emitter, 23
Albert's Dunk
 lighting diagram, 155f
Alkaline batteries, 145
Angle of incidence, 77
Angle of reflection, 77
Anya In White
 lighting diagram, 169f
 lighting setup, 54
 photo example, 55f
Aperture Priority mode
 available light as Main, 68
 Canon cameras, 36
 and exposure compensation, 44–45, 71
 Nikon cameras, 36
 TTL flash as Main light, 70–71
Aperture value
 constant, 36
 flash fundamentals, 9
 and light quantity, 56
 and TTL flash, 17
Architectural Shot
 lighting diagram, 193f
 lighting setup, 131
 photo example, 130f
Arianna and Grandpa
 lighting diagram, 179f
 lighting setup, 85
 photo example, 84f
Auto Focal Plane (FP) Flash
 example, 26
 function, 25
Auto White Balance, 63
Available light
 as Fill, 71
 as Main, 68
 and TTL flash, 68, 73, 75t
Averaging flash meter setting, 153

B

Baby subjects, 151
Background paper, 123, 131, 147
Back-lit, 11, 32–33, 45, 71, 143, 150
Back wall bounce, 82f
Ballet
 lighting diagram, 166f
 lighting setup, 39
 photo example, 39f
Banding, definition, 41
Batteries
 as equipment, 144
 powering the flash, 144
 types, 145, 147
Battery packs, 145
Bernhard, Ruth, 77
Binkies, 31
Bottles
 lighting diagram, 194f
 lighting setup, 135
 photo example, 135f
Bounce and swivel head, 22, 23, 46, 104
Bounce card
 built-in, 23
 function, 23
 and spill, 81
Bounce flash
 Arianna and Grandpa, 85
 back wall bounce, 82f
 corner bounce, 82f
 direction, 77
 and distance, 46
 function, 22
 and light quality, 57
 technique, 75
 Wedding Gown, 81
 Wireless TTL communication, 104
Bounce umbrellas, 136
Bouquet
 lighting diagram, 168f
 lighting setup, 50
 photo example, 51f
Brendan's Trick
 lighting diagram, 160f
 lighting setup, 18
 photo example, 19f
Bright histogram, definition, 40
Brightness
 and background exposure, 12
 Canon Master flash, 117
 constant, 9, 11
 control, 28
 and flash power, 121
 and highlight exposure, 114
 histogram, 40

Brightness (*Continued*)
 and LCD panel, 113
 light characteristics, 54
 lighting story, 139
 and light quality, 59
 Main *vs.* Fill light, 118–119, 120
 Nikon Master flash, 119
 Wireless Manual flash, 128–129
 Wireless TTL, 113–114, 115
Broad light
 and bounce flash, 75
 direction, 67
 example, 28
 flash tipping, 82
 specular reflection, 57, 66
Built-In bounce card, 23
Built-In Light Meters, 32
Built-In Wide Flash Adapter, 23, 142
Built-In Wide Panel, 23, 142
Butler, Arthur Henry Reginald, 14

C

Camera obscura, definition, 119
Camera-rotating brackets, 142f
Canon equipment
 AF Assist Beam Emitter, 24
 Aperture/Shutter Priority modes, 36
 battery packs, 147
 Channels, 108
 color handling, 63
 and diffuser, 133–134
 excessive contrast, 45
 Flash Exposure Bracketing, 25
 Flash Exposure Compensation, 22, 25
 Flash Exposure Lock, 25
 flash head, 3
 flash meter settings, 153
 histogram, 40
 LCD display, 126
 Light Sensor Window, 24
 Manual Flash Mode, 26, 121
 Master flash, 117
 Master ID group, 105
 pilot lamp, 22
 Slow Speed Synchronization, 25
 standard flash exposure, 70
 studio flashes, 131
 TTL cords, 139
 TTL flash as fill, 70
 Wireless TTL Master/Slave, 111
 Wireless TTL receivers, 102
 Wireless TTL transmitters, 99
Caponigro, John Paul, 28
Carte-de-visite, definition, 78
Catchlight panel, 23
Ceilings, bounce flash, 77
Channels, Wireless, 106
Channel settings
 Nikon and Canon, 108
 Wireless Manual flash, 128–129
 Wireless TTL, 106, 108
Characteristics of Light: Analysis and Decisions, 54, 62
 contrast, 54
Chiaroscuro, definition, 73

Chimping, definition, 7
Church lighting, 11
CMY (Cyan, Magenta, Yellow), 65
Color
 light characteristics, 62–63
 TTL flash and available light, 73, 75t
Color channels
 LCD display, 40
 RGB histogram, 43
Color Correction filtration, 63
Color Preset, 75
Color spaces, 65
Color temperatures
 electronic flash definition, 2–3
 and LCD display, 30
 lighting review, 92
Color triangle, 65
Comprehending directions of bounce flash, 77
Comprehending flash exposure, 11
Computers
 lighting diagram, 165f
 lighting setup, 37
 photo example, 37f
Construction Worker
 lighting diagram, 180f
 lighting setup, 90
 photo example, 90f
Continuous light sources, 12
Contrast
 Architecture Shot, 131
 and available light, 71
 bracketing, 89
 Canon Ratio setting, 117
 excessive, 45
 and Fill light, 48, 62
 and Flash Fill, 68
 and gamma, 114
 group lighting, 114
 Julie In Blue, 28
 LCD panel, 31
 light characteristics, 61
 in lighting decisions, 67
 and light quality, 59
 Main *vs.* Fill light, 118–119, 120
 postproduction, 92, 94
 range, 119, 120
 ratio controlled, 139
 reduction, 133–134
 and shadow point, 41, 115
 and shadows, 57
 softboxes, 134
 white-on-white shot, 1
 Wireless TTL, 112
Corner bounce, 82f
Coroplast grid spot, 150f
Custom White Balance
 and bounce flash, 81
 flash and available light, 75
 function, 63

D

Dance Photo
 example, 138f
 lighting diagram, 195f

lighting setup, 138
Dark tones
 background, 42
 light metering, 33
 Rear Curtain Sync, 26
 reflected metering, 45
 reflective metering, 32–33
 repeating flash, 26
 TTL exposure control, 17f
Davis, Miles, 61
Depth of field
 accent lighting, 50
 Architecture shots, 131
 average portrait, 128
 and contrast, 61
 electronic flash definition, 2–3
 and Equivalent Exposures, 38
 and Exposure Value, 38
 and flash power, 126
 and flat light, 67
 and f/stop, 35–36
 and light quantity, 56
 and Manual exposure mode, 71
 manual flash setup, 129
 modeling flash, 24
 portrait techniques, 26
 shadows, 76
Design phase, 91
Diffuser, 133–134
Diffusion, and light quality, 57
Diffusion sleeve
 example, 147f
 function, 147
Digital photography
 chimping, 7
 exposure bias for digital, 44
 gamma, 114
 middle tonal values, 44
 tonal deficiencies, 44
 Wireless TTL, 102
Digital single lens reflex (dSLR) camera
 and color, 63
 light meters, 32
 TTL exposure system, 16
 TTL flash and exposure, 16
Direct flash, 12
Direction of light
 available light, 68, 70, 73
 baby photos, 151
 bounce flash, 75, 77
 and contrast, 62
 dome diffuser, 133–134
 light characteristics, 67
 Main light, 73
 photograph veracity, 52
 and red eye, 140
Disario, George, 67
Distance
 and exposure compensation, 46
 and flash power, 125
 and light source, 57
 manual flash, 126
 and TTL flash, 17
Doctor, 87

lighting diagram, 200f
 photo example, 87f
Dome diffuser, 134f
"Dragging the shutter", 37
Dunn, Jeff, 12
Dylan's Birthday
 lighting diagram, 174f
 lighting setup, 68
 photo example, 69f

E

Electronic Flash
 and aperture, 17
 and available light, 68, 73, 75t
 definition, 2–3, 14
 and distance, 17, 46
 and exposure, 16
 features, 20
 as fill, 68
 fundamentals, 9
 light measurement, 31
 and light meter, 32
 as Main light, 70
 vs. Manual flash, 127
 operation summary, 153
 recycling times, 144
 and shutter speed, 20
 and subject size, 20
 lighting diagram, 170f
 lighting setup, 59
 photo example, 58f
Equations
 focal length, 36
 guide number, 10
 Inverse Square Law, 18
Equipment
 batteries, 144
 battery types, 145
 flash brackets, 139
 overview, 136
 stands, 137
 TTL cords, 137
Equivalent Exposures, 38
Erwitt, Elliott, 73
EV see Exposure Value (EV)
Evaluative metering
 operation summary, 153
 reflective meter, 32–33
 TTL flash as fill, 70
Evelyn's Headdress
 lighting diagram, 181f
 lighting setup, 92
 photo example, 93f
Equipment, accessories, products, 136–150
Execute, 91, 92
Execute stage, lighting, 92
Expose to the Right, definition, 31
Exposure
 bracketing, 89
 continuous light sources, 12
 digital bias, 44
 Sunset Bride, 12
 and TTL flash, 16

Exposure *(Continued)*
 Wireless Manual flash, 129
 Wireless TTL, 112
Exposure Compensation *see also* Flash Exposure Compensation
 camera modes, 71
 contrast adjustment, 45
 and distance, 46
 and EV, 44
 excessive contrast, 45
 Fill light, 48
 flash *see* Flash Exposure Compensation
 histogram adjustment, 33
 main light, 48
 purpose, 17
 reflective meter, 32–33
 and TTL flash, 17
 TTL flash as fill, 70
 TTL flash as Main, 70–71
 TTL flash/available light mixing, 68, 74f
 Wireless TTL, 112
 Wireless TTL receivers, 99
Exposure meter, *vs.* histogram, 43f
Exposure Value (EV)
 definition, 38
 and exposure compensation, 44–45
External battery packs, 145
Eye Chart
 lighting diagram, 184f
 lighting setup, 100
 photo example, 100f

F

Fill light, 48
 available light as, 71
 and contrast, 62
 definition, 48
 Julie In Green, 117
 vs. Main, 118, 119–120
 TTL flash as, 68
 Wireless TTL, 113–114
Filters
 as accessories, 150
 light colors, 75t
Filters/Gels, 150
Fish
 lighting diagram, 191f
 lighting setup, 123
 photo example, 122f
Flash-as-Main, 70
Flash brackets
 camera-rotating, 142f
 flash head tilt, 142f
 function, 139
 and red eye, 140f
Flash Button, 24
Flash direction
 bounce flash, 75, 77
 Main light, 48
 on-camera flash, 52
 stands, 137
 vertical camera shots, 141f
Flash Exposure
 basic concept, 11

 TTL flash as fill, 70
Flash Exposure Bracketing
 definition, 25
 Wireless TTL, 96
Flash Exposure Compensation, 96, 111, 115
 Canon, 117
 and contrast, 112
 function, 22
 and LCD Panel, 24
 Manual flash, 121
 vs. Manual flash mode, 127–128
 Nikon, 119
 purpose, 17
 Remote/Slave flash, 96
 Remote/Slave ID Groups, 105
 shaded subjects, 71
 Sunset Bride, 12
 TTL flash as Fill, 70
 TTL flash mode, 127–128
 Wireless Manual Flash, 128–129
Flash Exposure Lock
 function, 25
 Wireless TTL, 96
Flash group
 activation, 105
 brightness value, 115, 118
 exposure and contrast, 112
 for large jobs, 98
 lighting ratio, 59
 with Main and Fill, 119–120
 Manual flash, 121
 relative brightness, 28
 Remote/Slave flashes, 105
 Speedlight assignments, 3
 Wireless Manual flash, 128–129
 Wireless TTL transmitters, 99
Flash head
 with brackets, 142f
 manual flash, 126
 operation, 3, 153
 tilt and spill, 78
Flash meter
 averaging, 153
 handheld, 127
Flash orientation, example, 47f
Flash power
 and aperture, 17
 definition, 123
 reduction, 123
 Wireless Manual flash, 129
Flash-rotating brackets, example, 141f
Flash sequence, multi-group metering, 105f
Flash shoe, 137
Flash tilt
 and camera angle, 79f
 example, 47f
Flash Value Lock
 function, 25
 Wireless TTL, 96
Flat Fill, definition, 48
Flat light, definition, 67
Flower Girl, lighting diagram, 156f
Fluorescent light, and color, 63
Fluorescent light, definition, 11

Foamcore®, 95, 101
Focal length, equation, 36
Focal Plane (FP) Flash
 function, 25
 TTL flash, 20
 Wireless TTL, 96
Form Fill
 definition, 48
 Julie In Blue, 28
Fox, Donal, 83
FP Flash *see* Focal Plane (FP) Flash
Freezing motion, *Water Pour* lighting diagram, 186f
Front-lit, 52, 67, 82
F/stops, definition, 35–36
Fundamentals of electronic flash, 9

G

Gamma, definition, 114
Gels
 as accessories, 150
 light colors, 75t
General guidelines, 73
Gicle'e, definition, 111
Glad® bags, 148
Grid spot, 150
Group lighting
 activation, 105–106
 brightness value, 115, 118
 exposure and contrast, 112
 for large jobs, 98
 lighting ratio, 59
 with Main and Fill, 119–120
 Manual flash, 121
 relative brightness, 28
 Remote/Slave flashes, 105
 Speedlight assignments, 3
 Wireless Manual flash, 128–129
 Wireless TTL transmitters, 99
Group settings, Wireless Manual flash, 128–129
Guide number
 electronic flash fundamentals, 10
 and flash power, 125

H

Hair light, 50, 66–67
Halogen light, and color, 63
Handheld flash meter, 127
Hard light
 and Channels feature, 108
 and contrast, 62
 definition, 56
 and light source, 57
 production, 59
HDR technique *see* High dynamic range
 (HDR) technique
High dynamic range (HDR) technique
 and excessive contrast, 46
 lighting execute stage, 92
Highlight point, definition, 41
High Speed Synchronization
 function, 25

 TTL flash, 20
 Wireless TTL, 96
Histogram
 bright histogram, 40
 and contrast, 62
 definition, 40
 dynamic range, 42f
 vs. exposure meter, 43f
 and LCD panel, 40
 lighting review, 92
 luminosity histogram, 40
 RGB histogram, 43
 and tonal values, 41f
 and underexposure, 42
Holocaust victim, lighting story, 61

I

Image quality, and light quantity, 56
Incandescent lights, *Ballet*, 39
Incident light
 characteristics, 54, 56
 light meter function, 32
Incident light meter, 32, 54, 56
Intensity
 and flash power, 125
 light characteristics, 54
Inverse Square Law
 and bounce flash, 75
 equations, 18
ISO
 definition, 121
 and Exposure Value, 38
 and flash power, 125
 and light quantity, 56
 and stops, 35

J

Jazz Bassist
 lighting diagram, 171f
 lighting setup, 61
 photo example, 60f
Jazz Pianist
 lighting diagram, 178f
 lighting setup, 83
 photo example, 83f
Jpeg format, 30
Julie In Blue
 lighting diagram, 163f
 lighting setup, 28
 photo example, 29f
Julie In Green
 lighting diagram, 190f
 lighting setup, 117
 photo example, 116f

K

Key light, definition, 48
Krist, Bob, 102
Kunhardt, Amelia, 21

L

LCD display, 113
 Canon Speedlite, 126
 Nikon Speedlight, 127
 bounce flash, 78
 Canon, 126
 Canon Master flash, 117
 characteristics, 30
 color channels, 40
 color suitability, 75
 features, 24
 histogram, 40
 lighting review, 92
 manual flash, 126
 Nikon, 127
 RGB histogram, 43
Lee Filter, 75t
Light
 bounce flash, 75
 characteristics, 54
 characteristics and components, 50
 color, 62–63
 contrast, 61
 direction, 67
 measurement, 31
 moving light, 77
 quality, 56
 quantity, 54
 reflection, 77f
 and stops, 35
 two lights, 89
Lighting basics
 approach, 91
 design phase, 91
 execute stage, 92
 nuance from tech, 88
 postproduction, 92
 review stage, 92
Lighting in practice
 art director requests, 139
 babies, 151
 CEOs, 121
 Church, 11
 exposure bracketing, 89
 high school photo examples, 53
 Holocaust victim, 61
 jail photo examples, 95
 jerryrigging Speedlights, 132
 mansions, 97
 Texas Prison, 104
 travel, 108
Lighting ratio
 and contrast, 61, 117
 group lights, 59
Light meters
 and Exposure Value system, 38
 light characteristics, 54, 56
 modern dSLRs, 16
 multi-group metering, 105f
 Sparkle photo, 73
 TTL reflected, 16
 types and function, 32
Light Sensor Window, 24
Light sink, 11

Light sources
 continuous, 12
 and distance, 57
 flash exposure, 11
 hard and soft light, 57
 and light quantity, 56
 multiple, 48, 62, 88
Light tones
 Anya In White, 54
 Arianna and Grandpa, 85
 Rear Curtain Sync, 26
 reflective metering, 33, 45
 repeating flash, 26
 TTL exposure control, 17f
 and wall bounce, 77, 82
Line of Sight, Wireless TTL communication, 102
Lithium batteries, 145
Lobster Traps
 lighting diagram, 167f
 lighting setup, 49
 photo example, 49f
Long lens, and red eye, 141f
Lucia At Sunset
 lighting diagram, 172f
 lighting setup, 65
 photo example, 64f
Lucia Glowing
 lighting diagram, 173f
 lighting setup, 66
 photo example, 66f
Luminosity histogram, definition, 40
Luthier
 lighting diagram, 188f
 lighting setup, 109
 photo example, 109f

M

MacGyver, 136–137
Macro techniques, 95, 182f
Main light
 available light as, 68
 and contrast, 62
 definition, 48
 vs. Fill, 118, 119–120
 Julie In Green, 117
 TTL flash as, 70
 Wireless TTL, 113–114
Maisel, Jay, 97
Manet, Edouard, 62
Manual exposure
 available light as main, 68
 general flash photo examplegraphy, 71
 Sunset Bride, 12
 TTL flash as Main light, 70–71
Manual flash
 characteristics, 121
 function, 26, 121
 and handheld flash meter, 127
 LCD panel, 126
 in static situations, 128
 Wireless, 128
 Wireless TTL, 96
Manual Zoom, Wireless TTL communication, 104

Master flash
 brightness, 118–119
 Canon, 105, 117
 Exposure Compensation, 28
 and light quality, 132
 Main light, 66
 manual flash, 126
 Nikon, 105, 119
 Wireless Manual flash, 128–129
 Wireless TTL, 105, 110
 Wireless TTL communication, 104
 Wireless TTL transmitters, 99
 Mastering distance: near and far, 46
Matrix metering, 33
McCree, Brian, 61
McNally, Joe, 8, 75
McRae, Carmen, 61
Metamerism, definition, 50
Measuring light, 31
Michals, Duane, 52
Middle tonal values, definition, 44
Mingus, Charlie, 61
Modeling Flash
 function, 24
 Wireless TTL, 96
Mixing TTL Flash with available light, 68
Modeling Illuminator Button, 24
Modifying flash, 132
Motorcycle
 lighting diagram 183f
 lighting setup, 98
 photo example, 98f
Mountain Bike
 lighting diagram, 196f
 lighting setup, 143
 photo example, 143f
Multi-group metering, flash sequence, 105f
Multiple light source photography
 common wisdom, 88
 and contrast, 62
 definition, 48
 Wireless TTL, 112
Multi Stroboscopic Flash, 26

N

Nickel-cadmium (NiCd) batteries, 145
Nickel metal hydride (NiMH) batteries, 145
Night photos, exposure compensation, 45
Nikon equipment
 Aperture/Shutter Priority modes, 36
 bounce card, 23
 Channels, 108
 color balancing, 74
 and diffuser, 133–134
 excessive contrast, 45
 Flash Exposure Bracketing, 25
 Flash Exposure Compensation, 22, 25
 flash head, 3
 flash meter settings, 153
 Flash Value Lock, 25
 histogram, 40
 LCD display, 127
 Light Sensor Window, 24

 manual flash, 121
 Master flash, 119
 Master ID group, 105
 Modeling Flash, 24
 pilot lamp, 22
 Slow Speed Synchronizatio, 25
 standard flash exposure, 70
 studio flashes, 129
 SU-4 mode, 97
 TTL cords, 139
 TTL flash as fill, 70
 Wireless TTL Master/Slave, 110
 Wireless TTL receivers, 102
 Wireless TTL transmitters, 99
Noise, and light quantity, 56
Not-lit-look, 61
Nykvist, Sven, 53

O

On-camera flash, light characteristics, 52
One TTL flash, electronic flash definition, 2–3
Operating Room
 lighting diagram, 157f
 lighting setup, 8
 photo example, 8f

P

Paparazzi, definition 142
Parallax, definition, 97
Paramount Cords, 137
PC cord, definition, 129
Photography basics
 batteries, 144
 chiaroscuro, 73
 color use, 63
 contrast, 61
 correct exposure, 32
 dance, 138
 definition, 53
 definitions and terms, 35
 digital see Digital photography
 exposure basics, 54, 56
 filters/gels, 150
 Flash-as-Main, 70
 lighting requirements, 94
 light use, 89
 macro, 95
 Manual exposure, 71
 Manual Flash, 121, 128
 multiple light source, 48, 62, 88, 112
 paradigm shifts, 28
 parallax, 97
 philosophy of light, 50
 pigeon equipment, 102
 rotogravure, 131
 shooting, 92
 small flashes, 52
 and smart flash, 14
 still life, 106
 TTL electronic flash, 14
 two-light positioning, 87

Photography basics *(Continued)*
 veracity, 52
 white balance, 63
 Wireless TTL, 115
Photoillustration, definition, 123
Pigeon, definition, 102
Pilot lamp, 20
Pixels, histogram, 40
Polacontrast, 89
Portrait
 average specs, 128
 background softening, 26
 and bounce cards, 23
 carte-de-visite, 78
 classic lighting, 92
 dramatizing, 3
 Form Fill, 48
 formula, 49
 Holocaust victim story, 61
 illumination patterns, 18
 intimacy, 14
 light patterns, 67, 85
 with Manual flash, 128
 softbox, 134
 strip boxes, 134
Postproduction, lighting stages, 92
Power, and light quantity, 56
Privacy, Wireless TTL, 108
Program Mode
 exposure compensation, 71
 operating room lighting, 8
 TTL flash as Main light, 70–71
 Tuxedo, 34

Q

Quality of light
 bounce flash, 75
 flash modification, 132
 light characteristics, 56
 and light contrast, 62
Quantity, intensity, or brightness, 54
Quantity of light
 light characteristics, 54
 and light quality, 59
 TTL flash with available light, 68

R

Ratio settings
 Canon, 117
 Wireless TTL, 112
RAW format, 30, 94
Ready light, 20
Rear Curtain Sync
 function, 25
 Mountain Bike, 143f, 196f
 TTL flash, 20
Rechargeable batteries, 145
Recycling time, 20, 144
Red eye
 causes, 140
 definition, 139
 example, 140f

 with long lens, 141f
 reduction, 140f
Reflection
 bounce flash, 77
 light basics, 77f
Reflective meters
 and exposure compensation, 45
 function, 32
 and light quantity, 54, 56
Remote/Slave flash
 Canon, 117
 exposure and contrast, 112
 ID groups, 105
 Julie In Blue, 28
 and light quality, 132
 manual flash, 126
 multiple TTL flashes, 136
 operation, 22
 and stands, 137
 testing, 120
 Wireless Manual flash, 128–129
 Wireless TTL, 96, 110
 Wireless TTL communication, 102
 Wireless TTL receivers, 99
Repeating Flash, 26
Review phase, lighting, 92
RGB (Red, Green, Blue)
 CMY conversion, 65
 histogram characteristics, 43
Rim light, 50, 66
Rolled Rugs
 lighting diagram, 189f
 lighting setup, 113
 photo example, 113f
Rolston, Matthew, 33
Rosco Filter, 75t
Rotogravure, definition, 131
Rubber ducky, 1
 lighting diagram, 199f
 photo example, 1
Ryan with High Speed Sync
 lighting diagram, 162f
 lighting setup, 26
 photo example, 27f

S

Sammon, Rick, 99
Scale focusing, definition, 127–128
Scheimpflug rule, definition, 94
Second Curtain Synchronization
 function, 25
 TTL flash, 20
Shadow point, definition, 41
Shadows
 and exposure compensation, 45
 light characteristics, 52
 and light direction, 67
Short light
 bounce flash, 81
 direction, 67
Short out
 batteries, 144
 TTL flash, 137

Shutter, dragging the, 37
Shutter Priority mode
 available light as main, 68
 Ballet, 39
 Canon cameras, 36
 and exposure compensation, 44–45, 71
 Nikon cameras, 36
 TTL flash as Main light, 70–71
Shutter speed
 electronic flash fundamentals, 9
 and light quantity, 56
 photo example flash lamp sync, 16f
 and TTL flash, 20
Side-lit, 45, 67
Skin tone
 average portrait, 128
 Emily, 59
 Julie In Green, 117
 tonal values, 42
Slave flash *see* Remote/Slave flash
Slow Speed Synchronization
 function, 25
 TTL flash, 20
Softbox
 and dome diffuser, 134f
 example, 133f
 function, 132
 and studio flash, 133f
Soft light
 Channels, 108
 and contrast, 62
 definition, 56
 and light source, 57
 production, 59
Sparkle
 lighting diagram, 175f
 lighting setup, 73
 photo example, 72f
Specularity, light characteristics, 56
Speedlight basics
 attributes, 3
 components, 20
 definition, 3
Spill
 avoidance, 79f
 and bounce card, 81
 bounce flash, 78
 example, 78f
Spiral Staircase
 lighting diagram, 198f
 lighting setup, 148
 photo example, 149f
Spot-lit, 45
Stack lighting, *Emily*, 59
Stands, 137
Still life photography, 106
Still photography, 139
Stops, definition, 35
Strip box, definition, 134
Strobes, *vs.* speedlights, 94
Studio flash
 with softbox, 133f
 and Speedlights, 129
 Wireless TTL as, 136
Subject size, and TTL flash, 20

SU-4 mode, Nikon, 97
Sun-lit, 12, 50, 71
Sunrise light, and color, 63
Sunset Bride
 lighting diagram, 158f
 lighting setup, 12
 photo example, 13f
Sunset light, and color, 63
Swivel Head
 bounce flash, 78
 and distance, 46
 function, 22
 Wireless TTL communication, 104
Synchronization, TTL flash and shutter speed, 20

T

Tanzi With Veil
 lighting diagram, 159f
 lighting setup, 14
 photo example, 15f
Thanksgiving family portrait, 125
 lighting diagram, 192
 photo example, 124
Tonal values
 dark-toned backgrounds, 42
 excessive contrast, 45
 histograms, 40, 41f, 42
 and light meters, 32
 middle, 33, 44
 reflective meters, 17
 RGB histogram, 43
 testing, 120
 TTL flash modes, 127–128
Tones
 chiaroscuro, 73
 dark *see* Dark tones
 digital deficiencies, 44
 light *see* Light tones
 skin tone, 42, 59, 117, 128
 white tones, 33, 54, 77
Top-lit, 45
Toys
 lighting diagram, 187f
 lighting setup, 106
 photo example, 107f
Transmitters, master, 99
Trigger devices, Wireless TTL, 96
Trombones
 lighting diagram, 185f
 lighting setup, 101
 photo example, 101f
TTL BL setting
 operation summary, 153
 TTL flash as fill, 70
TTL cords
 custom-made, 8, 34
 and flash bracket, 140
 and flash LCD, 126
 function, 137
 Group lighting setup, 118, 119–120
 jerryrigging, 132
 manual flash, 126
 Tuxedo, 34

TTL cords *(Continued)*
 Wireless TTL, 96
 Wireless TTL communication, 104
 Wireless TTL transmitters, 99
TTL Electronic Flash
 and aperture, 17
 and available light, 68, 73, 75t
 definition, 14
 and distance, 17, 46
 and exposure, 16
 features, 20
 as fill, 68
 light measurement, 31
 and light meter, 32
 as Main light, 70
 vs. Manual flash, 127
 operation summary, 153
 recycling times, 144
 and shutter speed, 20
 and subject size, 20
TTL exposure system, characteristics, 16
TTL flash and exposure: a primer, 16
TTL flash: flash anatomy and features, 20
Tungsten light, and color, 63
Tuxedo
 lighting diagram, 164f
 lighting setup, 34
 photo example, 34f
Typing paper, 147

U

Underexposure, and histogram, 42

V

VAL *see* Voice Activated Lightstand (VAL)
Vertical camera shots, flash direction, 141f
Visible light, variations, 50
Voice Activated Lightstand (VAL), 142

W

Walls, bounce flash, 77
Watch
 lighting diagram, 182f
 lighting setup, 95
 photo example, 94f
Water Pour
 lighting diagram, 186f
 lighting setup, 102
 photo example, 102f
Wattage, and light quantity, 56
Wedding
 lighting diagram, 197f
 lighting setup, 145
 photo example, 146f
Wedding Cake
 lighting diagram, 176f
 lighting setup, 76

 photo example, 76f
Wedding Gown
 lighting diagram, 177f
 lighting setup, 81
 photo example, 80f
Wedding Shower
 lighting diagram, 161f
 lighting setup, 21
 photo example, 21f
White balance
 and color, 63
 filters and gels, 75t
White Balance Preset
 and bounce flash, 81
 function, 63
White Balance Shift, Canon cameras, 63
White tones
 Anya In White, 54
 and exposure, 33
 and wall bounce, 77
Wide Area AF Assist Illuminator, 23
Wide Flash Adapter, 23, 142
Wide Panel, 23, 142
Window light, creation, 81f
Wireless Manual Flash
 characteristics, 128
 and handheld flash meter, 127
Wireless Remote Flash, 24
Wireless TTL
 and bounce umbrellas, 136
 channels, 108
 communication, 102
 exposure and contrast, 112
 Master/Slave settings, 110
 privacy, 108
 receivers, 99
 remote/slave flash, 96
 remote/slave ID groups, 105
 as studio flashes, 136
 testing, 120
 transmitters, 99
 trigger devices, 96
Wolinsky, Cary, 61, 95

X

Xenon, electronic flash fundamentals, 9

Y

Yamashita, Michael, 14

Z

Zoom Head
 and diffusion, 136
 and distance, 46
 and flash power, 125
 function, 23
Zoom lenses, f/stops, 36